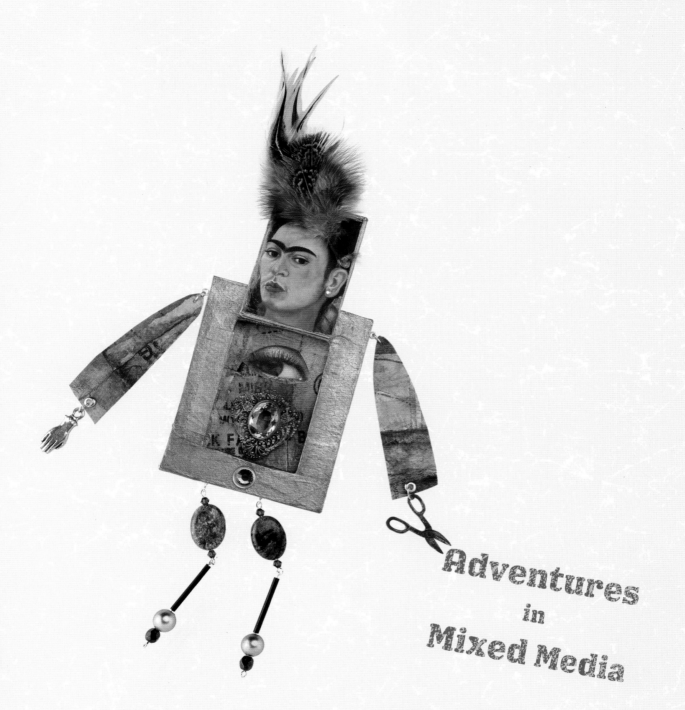

Adventures
in
Mixed Media

Adventures
in
Mixed Media

COLLAGE, STITCH, FUSE,
AND JOURNAL YOUR WAY TO
A MORE CREATIVE LIFE

POTTER
CRAFT

Jane Davies

Published in the United States by Potter Craft,
an imprint of the Crown Publishing Group,
a division of Random House, Inc., New York.

www.crownpublishing.com

www.pottercraft.com

POTTER CRAFT and colophon is a registered
trademark of Random House, Inc.

Library of Congress CIP data is available from
the Library of Congress.

978-0-8230-0081-4

Printed in China

Design by veést design

10 9 8 7 6 5 4 3 2 1

First Edition

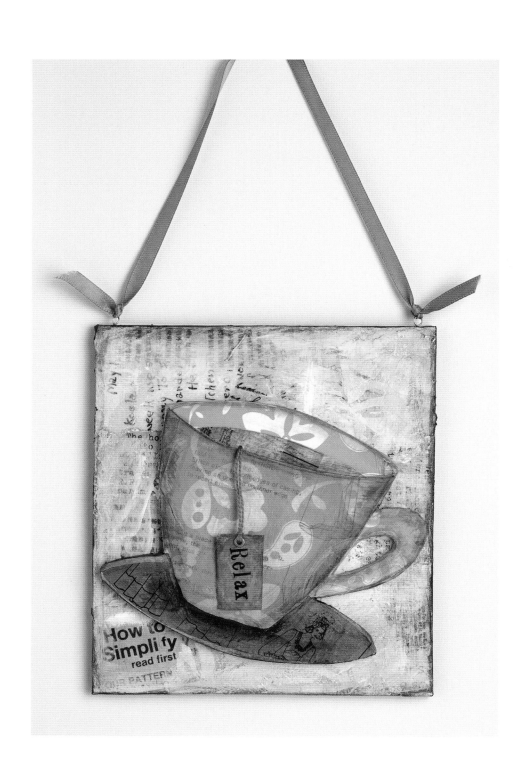

Acknowledgments

I would like to thank Joy Aquilino, Executive Editor at Potter Craft, for her help bringing this book's concept into focus; the contributing artists for their generosity in allowing me to use their work and share some of their thoughts and processes: Jill Abilock, Sue Bleiweiss, Elissa Campbell, Ingrid Dijkers, Pamela Hastings, Autumn Hathaway, Sherrill Kahn, Dawne Polis, and Carol Owen; the photographers John Polak and George Bouret for bringing the artwork and techniques to life with their skillful work; my project editor, Autumn Kindlespire, for her insightful organization of the material; assistant editor Caitlin Harpin for her excellent attention to detail; Vera Fong (veést design), the book's designer, for her clarity of presentation; and Jess Morphew for her art direction. I would also like to thank my parents, Beverly and Jim Davies, for their help with manuscript revisions; Gloria Barrett for her lifelong inspiration; and my Sweetie, John LaVecchia, for being there.

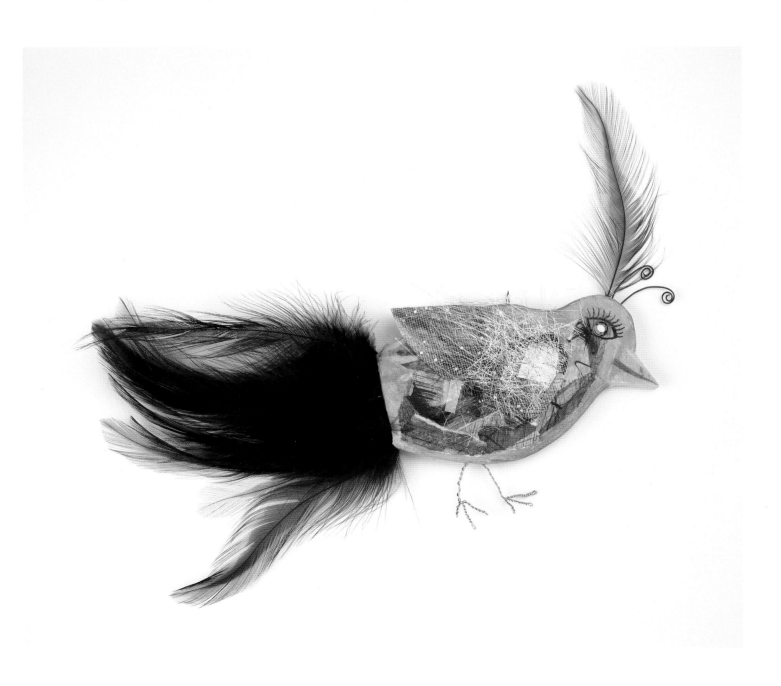

Contents

■ = Technique
■ = Project

Introduction

WHAT IS MIXED MEDIA?

What is mixed media? What does it mean to say we are making mixed-media art? I sometimes see pieces at my local arts center labeled "mixed media," yet they look to me like paintings. Maybe they include watercolor and pastel, or acrylic and oil, such that the artist is straying from traditional one-medium work very slightly. What do you think of as "mixed media"? A particular look? Found objects? Three-dimensional work? Paper and cloth? Wood and metal?

I'm not suggesting that it's necessary to define mixed media, to nail it down once and for all, but rather that it's an open-ended concept. One person's mixed-media piece may be another's sculpture, handmade book, or collage. In other words, "mixed media" embraces a wide variety of materials, techniques, and formats for artistic expression.

I think of mixed media as a jack-of-all-trades/master-of-none way of approaching art, rather than as a set of particular materials and techniques. You can certainly come to mixed media with finely honed skills such as drawing or painting, jewelry making or weaving, but it doesn't require you to have specific skills or specific expertise in materials. What I like about mixed media is that you get to explore all kinds of materials and techniques without having to become an expert at any one of them or use them in traditional ways. Which isn't to say that there's no skill involved in mixed media. The skill, aside from the endless techniques you can employ, is mainly in putting things together to effectively express ideas or make beautiful objects.

ART AND EMBELLISHMENT

"Embellishment" is decoration, and "decoration" can suggest all kinds of superfluous details. When I was growing up amidst the heady academic culture of art colleges, I often heard students and sometimes professors criticizing a painting by calling it "merely decorative," as if every stroke of paint had to carry special meaning or add significantly to the composition. "Decoration" had a bad rap in these circles. If you were a craftsperson involved in the "decorative arts"—such as making pottery, glass, furniture, or textiles—it was okay to be decorative. But for painters, sculptors, and other fine artists, it was a no-no. While I was a potter selling my work at craft shows, I often heard the same discussion about "craft" versus "fine art," as if there were some kind of hierarchy based on what is decorative and what is "serious" art.

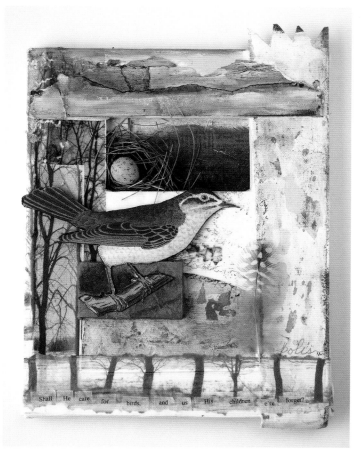

▲ **DAWNE POLIS:** Foam core collage.

In mixed media we get to ignore all of that. We get to play across boundaries of painting, sculpture, quilting, art, craft, and so forth. Your mixed-media piece isn't defined in these terms. If you love the look and feel of hand stitching or beading, then by all means bring this skill to your mixed-media work and embellish to your heart's content. If you have more fun juxtaposing imagery for its metaphorical impact, then go ahead and allow your mixed-media pieces to express meaning through imagery.

The projects in this book can be decorative, functional, meaningful, expressive, or all of the above. You can make a gift box with paper you've decorated yourself with paint and ink. Period. You have a beautiful handmade piece. You can create a collage on the box, adding to the visual content and enriching the meaning of the piece, perhaps focusing it a bit more. Using personal photos and imagery that connect to the person receiving the box adds further to the focus and meaning of the piece. No matter what level of meaning you choose to express, just the act of making something is a valid creative endeavor.

CREATING HANDMADE GIFTS

Creating things is my life, it's who I am, but it's also my job. As a freelance artist I create artwork that goes on calendars, greeting cards, paper plates, invitations, ceramics, fabrics, and many other manufactured products. This involves not only making the original art but also developing it to an art director's specifications, meeting deadlines, and delivering the goods. It's a collaboration with the outside world, the consumer, and the market. Fun, creative, and challenging, yes, but not terribly personal. As a collage artist and teacher, I experiment with materials, techniques, and concepts that I can pass on to my students and readers. So while I work on a series of pieces, I'm thinking not only about how to express my ideas but about how I can translate this experience into something useful for other collage artists—and perhaps something inspiring to those who haven't yet begun their collage journey. I gain such pleasure and fulfillment from making things, I want to share it with others, bring others along my happy adventure. But this also counts as "work."

It's when I'm making gifts that I really let my hair down as an artist and let my creative side out to play. Every autumn I find myself drawing on my collage, design, and mixed-media skills to make unique and personal gifts for everyone on my holiday list, and I do the same for birthdays, weddings, and other gift-worthy occasions. Making gifts allows me the freedom to experiment with new materials and forms without worrying about whether they'll work as workshop projects

▲ **SHERRILL KAHN:** Mixed-media collage with embossed Angelina fiber.

or whether they will sell. I suspect that the gifts I've made—mixed-media doll portraits, silly poems copiously illustrated, handmade boxes with messages or personal photos on the inside—constitute my best creative work, if personal fulfillment is any guide.

I write this book not only to share my enthusiasm for making gifts but also to explore the realm of meaning and content in modes of creative expression. My hope is that it will not only introduce you to techniques and projects in mixed media but also inspire you to mix and match them to your own ends and experiment with the expressive possibilities of each format. Making something as a gift is often just the inspiration you need to focus your creative energy, and it's a great starting point for making work with meaning and personal content, generally. The goal of making a particular object for a particular person is just the beginning. It should be seen as a moving target. Just like life, the goal serves as an organizing principle, a way to set parameters and priorities. Allow it to be fluid, and your creative spirit can flow.

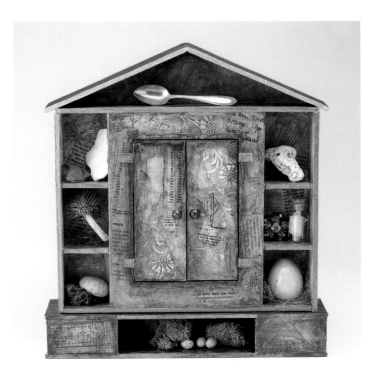

◄ **JANE DAVIES:** Foam core spirit house.

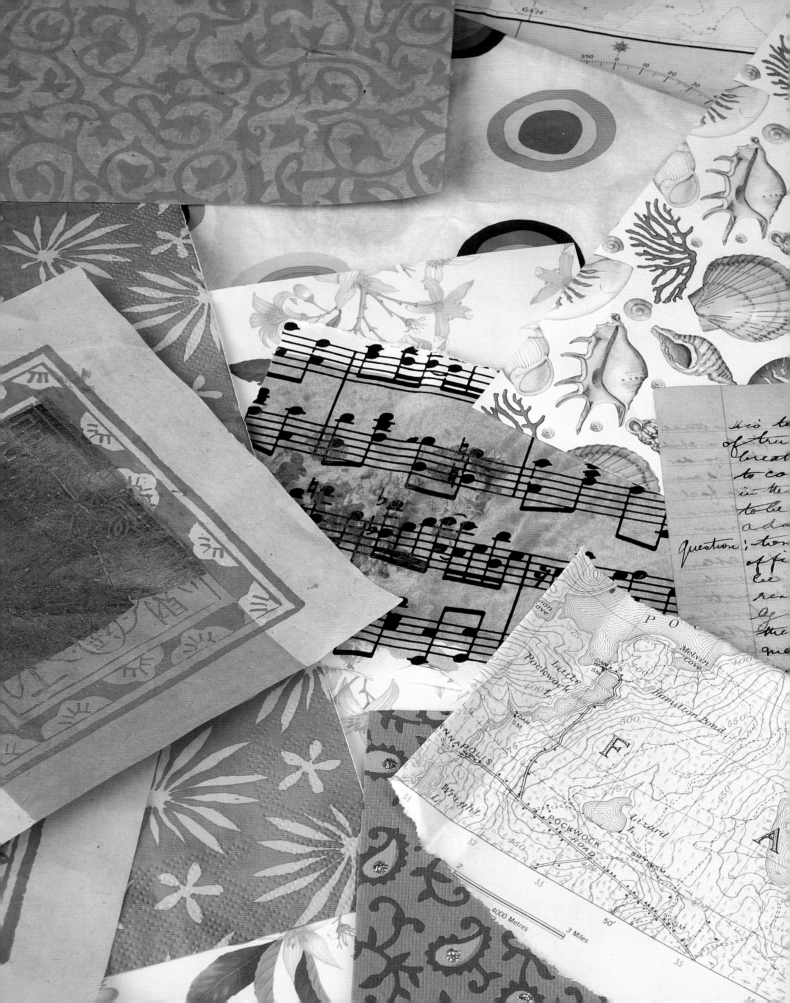

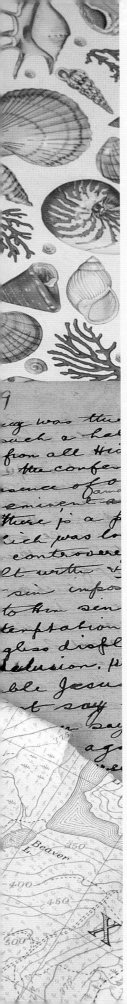

Materials and Tools

Don't let the lack of a few supplies keep you from jumping into mixed media. Even if you are an absolute beginner, you can probably get your hands on paper, glue, scissors, and a few other basics without going too far. This chapter gives you an overview of materials and tools referred to in the projects. It is meant to be a set of guidelines, not a list of Must Haves for the mixed media studio. Feel free to improvise where necessity or inspiration dictates, and you'll soon develop your own vocabulary of materials and tools that make your work unique.

◄ Found, printed, and embellished papers. For information on decorating paper, see page 24.

PAPER

Paper is probably the most fundamental material in mixed media and collage. We use it as a support and as a structural material. For collage we use it for its imagery, texture, color, weight, pattern, origin, or visual association. I'll say more about collage papers specifically in chapter 2 and about papers appropriate for handmade books and boxes in chapter 3. Here I want to go over some of the basic papers that you should have in your mixed-media "pantry."

Your Basic Paper

For many projects I use a lightweight (90-lb) watercolor or printmaking paper for the support. I use a *hot press* or smooth surface paper. Watercolor paper is also available with slightly textured surfaces: *cold press* and *rough*. Watercolor and print-making papers come in various sizes, the most common of which is 22 x 30 inches. It also comes in heavier weights more appropriate to painting and printmaking or to larger collage works. I get my basic paper from various art supply stores (see Resources, page 142) and always shop around for the best deal. Heavyweight drawing paper or two-ply Bristol paper are also good choices. If you have an art supply store nearby, or a store that offers fine art papers, check out the different brands and find what suits your sensibility and budget best. In the materials lists, I'll refer to the type of paper described here as "your basic paper."

Cheap Drawing Paper

Cheap drawing paper is another essential in my studio. I use it for sketching, for protecting my work surface (in which capacity it acquires lots of scribbled notes and excess paint and glue), making templates, and also for painting on (see "Decorating Your Own Papers," page 24. It also works for text paper in handmade books. This type of paper comes in various weights—50-lb, 60-lb, and so forth—and various sizes. I use 70-lb or 80-lb in sheets that are 18 x 24 inches. Art supply stores are the best place to go for cheap drawing paper.

Inkjet Printers

For printing out images on my inkjet printer, I use a matte-surface photo paper. For some applications, heavyweight paper is preferable, but good-quality lightweight photo paper is adequate for most projects. Photo paper is available at office supply stores. It's not cheap, so I try to gang up a bunch of images on one sheet (in Photoshop) instead of printing out one image per sheet. If I'm printing out images just for reference and not to use in collages, I just use the cheapest printer paper available.

Lokta

Lokta paper is handmade by the sheet in Nepal from the fibrous bark of the *Daphne cannabina* bush. It's very strong with long fibers and four beautiful deckle edges. Because of its strength and beauty, lokta is perfect for making covers for books, boxes, photo frames, and even handles for bags.

◄ Lokta papers in a variety of colors.

FABRIC

In chapters 4, 5, and 7 we make extensive use of fabrics, and I'll discuss the particulars in those chapters. But for the purposes of stocking your mixed-media pantry, I recommend keeping on hand plenty of plain cotton muslin (which can be used as a collage support, fabric-paper background, doll-making material, fusion fabric base, and many other uses I'm sure you'll find) and a variety of cotton prints that appeal to you for color and pattern. Depending on the projects you're interested in, and how much stitching, sewing, gluing, or fusing you plan to do, it's a good idea to keep on hand fabrics with a variety of qualities: sheers, metallic fabrics, satins, eyelets, glittery fabrics (I love to go into the bridal or costume section of the fabric store and pick out a whole bunch of over-the-top glitz!), felt (craft or wool), textured fabrics, and whatever else appeals to you. Often I buy just ¼ yard each of many different specialty fabrics, as a little can go a long way. In addition to fabrics, I like to keep a variety of ribbons and trims on hand.

ADHESIVES

Adhesives come in two basic types: glues and pastes. Most commonly used glues are made with synthetic materials such as polyvinyl acetate (or PVA), though glues were originally made (some still are) by boiling down animal connective tissue (think rabbit skin glue and hide glue). Glues generally form a permanent bond. Pastes, on the other hand, are made from vegetable starches such as wheat starch or methylcellulose. They are often used in bookbinding because they don't cause curling or warping of the paper on which they are used, and because they can be easily washed off even after drying.

Glue

Plain white glue, such as Elmer's or Sobo, is what I use most often for collage and mixed-media projects. When buying white glue, make sure not to get the washable variety, which is made for kids and not permanent.

PVA (polyvinyl acetate) is similar to white glue, but it's often archival—acid free—so your pieces will age less noticeably. PVA can be found in the bookbinding section of an art or craft supply store. If it's important to you that the glue be archival, make sure it says so on the label.

Another useful application of PVA or white glue is for its *anti-adhesive* effect: If you've painted pages of a journal with acrylic paint or matte medium (see "Accordion-Purse Book," page 38), they'll have a tendency to stick together when the book is stored closed. To prevent this, coat the pages with PVA glue, diluted with water in an approximately one-to-one ratio.

Glue sticks are great if you're taking your collage work out of the studio. They're available in archival and non-archival formulas. Like Yes Paste, they tend not to warp your paper.

A hot glue gun is ideal for adding heavy embellishments. There are other adhesives, such as two-part epoxy, E-6000, and Gorilla Glue, that have plenty of strength for holding objects to your collage surface or mixed-media project, but they're probably much stronger than you need, and they require good ventilation because they contain volatile organic compounds. Hot glue is relatively safe and amply strong for most projects. I also use a hot glue gun for making glue gems (see "Glue Gems," page 60).

◄ Specialty fabrics: lame, taffeta, glitter tulle, nylon organza, lace, and bengaline.

Yes Paste

Yes Paste is better for projects where flatness is essential, as one drawback of white glue is that the glued surface will curl if a collage piece isn't weighted down during drying. Yes Paste is a "stikflat" glue and promises not to buckle your paper. Yes Paste is thick and becomes even thicker in the jar with age, even if you keep the lid on tight, so it often requires thinning slightly with water. But adding water reduces its "stikflat" quality, and your paper may warp a little. Yes Paste doesn't seem to be as strong as PVA or white glue, but I do use it on collage greeting cards so they stay nice and flat.

Acrylic Matte Medium

Acrylic matte medium is useful as an adhesive and as a top coat in collage when I'm using light- to medium-weight papers. For heavier-weight papers, white glue or PVA is preferable. Matte medium dries quickly to a clear satin finish, which is water resistant. Most acrylic paint manufacturers (though not those of craft acrylics) also make various acrylic mediums, including matte medium, and offer it in 4-ounce through gallon sizes. Brands of matte medium vary a little in consistency and sheen, but mostly they behave the same way.

A note on drying time: Many of the projects in this book require you to let the glue you've just applied dry before moving to the next step. How long do you have to wait? The drying time will depend on how much glue you use, but you can also use a hair dryer to speed up this process.

THREADS AND FIBERS

Even if you're not sewing or stitching, threads and fibers can provide texture and color to your mixed-media pieces. I keep on hand a box full of embroidery floss. I buy it when it's on sale, and pick out all my favorite colors, then pick out a few that I don't like at all just to see where they'll end up. I use embroidery floss for tassels, bookbinding, doll hair, and sometimes beading. In addition to the standard cotton floss, I buy a few metallics and rayons if I can find them. Just looking at all those colors cozying up together in the box makes me want to *make* something!

If you're sewing by machine, then a palette of machine thread is a must. For decorative work, such as free-motion stitching or any top-stitching, I like the 100 percent polyester shiny thread. Rayon thread, which has the same beautiful luster, isn't as strong, and it often breaks on my sewing machine. If you're an experienced sewer and have success with rayon, then by all means use it! You may want to get other specialty threads, such as metallics or variegated, for specific projects. I use machine-sewing thread for tassels as well.

For bead embroidery or fine beading, a strong yet fine thread is essential. There are many beading threads on the market that are suitable. I use Nymo, and I buy it in black and white. So far, that seems to be enough.

Loose fibers of various kinds are used in specific projects in this book, so I'll cover them in the appropriate chapters. In general, though, if you see yarns or fibers that speak to you, buy them. They won't go to waste!

◄ Embroidery floss and machine sewing thread.

FOAM CORE AND ILLUSTRATION BOARD

Foam core is a polystyrene board laminated on both sides with smooth, clay-coated paper. The standard thickness is ³⁄₁₆ inch, which is what I recommend in chapter 6 for constructing spirit houses and picture frames, but it's also available in ⅛-inch thickness, which can be used for smaller projects such as ornaments or jewelry. Foam core is lightweight but very strong, and it resists warping when coated on both sides with matte medium. Both archival and non-archival foam cores are available at art and craft supply stores.

Illustration board is a dense board with a smooth, white surface on one side. It's available in various sizes—15 x 20 inches up to 30 x 40 inches—and in several different thicknesses. I use a medium-thickness board for bookbinding and box making, and I use the scraps as cutting mats. You can also use discarded cardboard or chipboard (which is made from recycled paper but isn't archival) for these projects, but illustration board is the gold standard. It's available as an archival material and is more durable than cardboard or chipboard. Matboard—the material used for matting artwork before framing—is another alternative. Your local frame shop may have scraps of matboard they're willing to part with for free, and those may be large enough for boxes and small books.

PAPERCLAY AND OTHER MODELING MATERIALS

Creative PaperClay is an air-drying modeling material not to be confused with paper clay, which is a ceramic material that requires firing. I use PaperClay for making doll faces, whether in a mold or modeled by hand, and for various other types of embellishments. Once dry, it's very lightweight and pretty durable. It can be sanded, carved, and then painted with any type of paint. It's nontoxic and easy to clean up. The one drawback that I find with PaperClay is that it requires a long drying time. Even for small pieces such as doll faces or buttons, you should let it dry at least overnight. But unlike polymer clay, it doesn't require baking. There are various other brands of air-dry modeling materials on the market that function approximately the same as PaperClay. Use whichever one you prefer. Most of them accept acrylic paints when dry.

Polymer clay can also be used for molding and modeling. It requires baking (a dedicated toaster oven in the studio works well), but it doesn't require any drying time. In fact, it doesn't actually dry—it stays workable until baked. The different brands of polymer clay vary slightly in baking time and temperature, so be sure to follow the manufacturer's directions. Polymer clay comes in a huge range of colors, including metallics and glitters, but you can also get a neutral color and paint it after baking.

▼ A selection of beads and beading accessories.

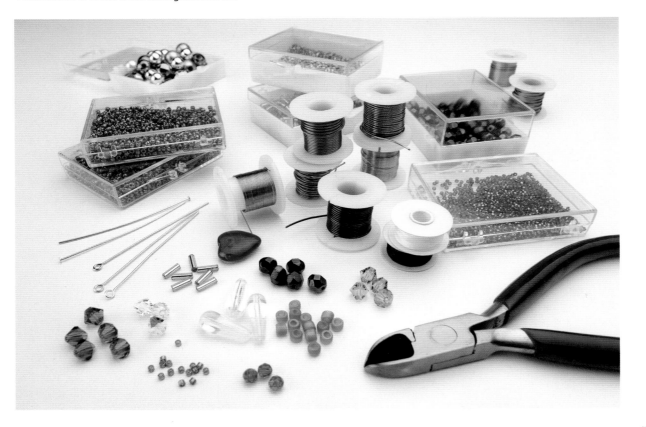

EMBELLISHMENTS

By "embellishment," I mean small objects or materials that you attach or apply to your piece to add emphasis, dimension, or sparkle. Often, beads, charms, or glitter give your piece just the finishing touch it needs to really come into its own.

Beads

I've been fascinated with beads ever since I was a child, though in my current work I use them only peripherally. I've occasionally ventured into learning a complex-looking beading technique just because I *have* to know how it's done, but making a regular practice of beading seems to be beyond me. I get the occasional obsession with beads, but my particular level of patience doesn't seem to support making those gorgeous, time-consuming beaded objects I see done by real bead artists. Still, I keep a pretty good inventory of beads in my studio and use them wherever I can find an excuse. Mostly I use beads for bead embroidery (see "Bead Embroidery," page 62), for fringe, for beaded tassels, and on hanging ornaments. If you catch the bead bug from any of the projects in this book, I encourage you to browse through the sources I list for beads and start collecting. There are many very useful books on beading as well. To get you started in the meantime, here are a few bead basics.

Seed beads are those little tiny glass beads used most widely in bead weaving and bead embroidery, as well as for jewelry and other bead projects. They're available in many shapes—round, cylindrical, square, hexagonal, or otherwise faceted—and come in hundreds of colors and finishes. Most seed beads are made either in Japan or the Czech Republic, the Japanese being the more consistent in size and shape (which is important for bead weaving, but not as much so for other projects).

Seed bead sizes aren't completely consistent among brands, but they generally come in 15°, 11°, 10°, 8°, and 6°, from smallest to largest. For the bead embroidery technique in chapter 3, I use size 15° seed beads. 11°s work well for this type of bead embroidery as well, but larger sizes are more appropriate for accents, such as on my fabric-paper mini-quilt (see page 97). The red beads stitched along the vertical sides of the central image are 8°s.

Delica beads are a popular brand of Japanese cylindrical seed beads. They're known for their consistency in size and shape and are available in a huge range of colors and finishes. Sometimes the word "Delica" is used as if it describes a type of bead, not a brand.

Rocailles are round or donut-shaped seed beads. Some retailers distinguish Delicas from rocailles to indicate the difference in shape.

Crystal beads, such as those used in the "Fusion Fabric Fan" project (see page 72), come in many different sizes and shapes. The size is expressed in millimeters. The shapes I use most are round, which means a faceted sphere, and bi-cone. A bi-cone bead is like two faceted cones attached at their broad bases. A few other embellishment materials I keep on hand are the following:

Sequins. I keep both loose sequins and sequin trim on hand. They add a luxurious note to fusion fabric, dolls, and any kind of bead embroidery. They come flat or cupped, and in so many sizes, shapes, and colors that it's hard to choose just a few. Loose sequins are available in large assortments from craft supply stores and also in individual colors/sizes. Trim comes in single strands and more elaborate versions.

Charms. Those little metal objects with a hanging loop can be pretty seductive. Charms, by their nature, function as symbols, whether obvious or obscure. One simple charm can provide a focus for a piece, both visually and in terms of its interpretation, and it can also suggest a little mystery and intrigue.

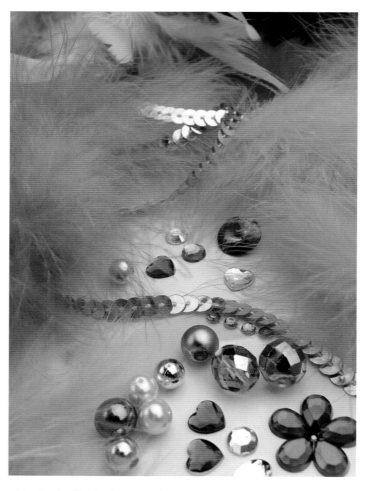

▲ Your basic glitz: feathers, marabou, rhinestones, and sequins. Oh, and some crystal, pearl, and metallic beads.

Rhinestones. Plastic or crystal; round, square, oval, or heart shaped; clear or colored; self-adhesive or requiring glue; tiny and elegant or huge and gaudy—I have to admit that I really love rhinestones. I keep all of the above on hand, and I use them to embellish cards, ornaments, dolls, and many other projects. They're widely available in a great range of quality and price, so there's no excuse not to indulge if rhinestones appeal to you.

Craft wire. Craft wire is available in many different colors and thicknesses, or gauges. For most projects, a medium-gauge wire, such as 20-gauge (0.8mm), is both strong enough and pliable enough, though you may want to experiment with thicker and thinner wires as well. Remember, the higher the gauge number, the thinner the wire. I use craft wire mostly for hanging loops on ornaments (see page 102), but I also use it for embellishments on dolls and for jewelry.

Glitter. Like rhinestones and sequins, I do enjoy the sparkle of glitter, and I keep a wide range of colors in my mixed-media pantry. I find glitter glue to be the most convenient form of this fairy dust, as it's easy to apply and stays where you put it. I use glitter embossing powder for glue gems and paper gems (see page 60).

Craft foil. There are many types of craft foil, but the one that I specifically refer to in this book is transfer foil paper. Jones Tones is a well-known brand of this type of foil. It can be transferred with a specific adhesive made for it, with adhesive transfers, or, as demonstrated in chapter 4, with fusible web and an iron.

Feathers. I love to use dyed feathers for various projects for a little gaudy, flirty, or luxurious accent. A trim of marabou turns a decorated paper gift bag into a fashion accessory (see "Oval Bag," page 31); a feather headdress crowns my Janno doll (page 124), giving her a regal bearing; the bird ornaments in chapter 6 are completely dependent on the attached feathers for their punch line. Feathers are usually available in craft supply stores in either boas or packaged. Online you can find many sources that specialize in feathers for hats and costumes.

Found objects. Shells, sticks, pebbles, natural feathers, as well as artifacts such as jewelry pieces, game pieces, broken tiles, buttons, sea glass, keys . . . I stash these sorts of objects in a box in the studio and browse through them frequently. Flea markets and firehouse auctions are good sources of little trinkets that may seem useless until you're looking for just the right thing to complete your mixed-media project. You can buy all kinds of new found objects in craft supply stores, of course, such as "antique" keys, game pieces, and Scrabble tiles. If you're looking for something specific, purchasing it may be the way to go, but you shouldn't neglect collecting your own authentic "junk."

PAINT

For most projects, I use acrylic paints, though I keep liquid watercolors and acrylic inks on hand as well, using them mainly for scribble painting (page 25). Acrylics are probably the most versatile of painting media, as they can be applied in thin washes resembling watercolor, in thick impasto with lots of texture, or anything in between. They're widely available in a huge variety of colors and finishes. From the finest professional artist-grade acrylic with high pigment loads, to inexpensive "craft" paints, it's not hard to find acrylic paints that suit your budget.

Here's what I keep on hand:

Tubes of artist-grade paints in colors that I use frequently, including titanium white, which has more opacity than white craft acrylic. The brands I use most are Utrecht, because their products are reasonably priced, and Golden, because they offer colors I can't get elsewhere. There are many other manufacturers of good-quality acrylic paints. Try the brands that are available at your local art supply or crafts store or your favorite mail-order supplier.

Craft acrylics. I use these for scribble painting mostly but often for other applications as well. They come in such a wide variety of colors and are so inexpensive that it's easy to stock up on your favorites.

Metallic paints. Though you can get high-quality metallic acrylic paints in tubes, and low-quality ones as craft paints (and I use both), my favorites are Lumière liquid metallic paints made by Jacquard. I haven't found anything else quite like them, though other kinds may be available. They have an unusually rich sparkle to them, and their fluidity allows flat, even application.

Liquid watercolors. These are dye-based, rather than pigment-based, paints and are subject to fading and discoloration with exposure to light. But they're particularly brilliant, and they react beautifully to spritzes of water after they're dry (see page 26). They bleed through a top coat of acrylic paint or medium, creating interesting effects. I use them in conjunction with acrylics and inks in scribble painting, just to throw a monkey wrench into the works. They're available in a "student grade" at very low prices from several paint manufacturers (I use Utrecht and Dick Blick), but you can also get much better quality liquid watercolors in small glass bottles with eyedropper applicators (Dr. Ph. Martin's and Luma are two prominent brands) from art supply stores. I mostly use the cheap ones,

but the higher-quality watercolors are available in a much wider range of colors.

Acrylic inks and India ink. I use these mostly for scribble painting, applying them much as I do the liquid watercolors. But unlike the watercolors, these inks are permanent when dry, not subject to further alteration with water application. They're also relatively lightfast.

Watercolor sprays and mists. There are many versions of shimmering sprays on the market now, either as watercolors or inks. I don't find these to be absolute necessities, but they're fun to play around with. Most craft supply stores carry some variety of shimmery mists and sparkly sprays.

TOOLS

Beyond scissors, rulers, brushes, and craft knives, each artist develops his or her toolbox to suit their individual needs. Like materials, one usually collects tools over time, as the need arises. My toolbox includes the following:

Brushes for glue and for paint. I keep a variety of brushes on hand, but I find myself using flat synthetic ones the most for both glue and paint. I keep them in a jar of water between uses so they don't dry out. Even with the most thorough washing, I find it hard to keep brushes supple after using them for glue and acrylic paint.

Foam brushes. I use these mostly for fabric paper (see page 92) but occasionally for applying washes of color to journal pages. I keep various sizes on hand. They're inexpensive and available in most hardware stores.

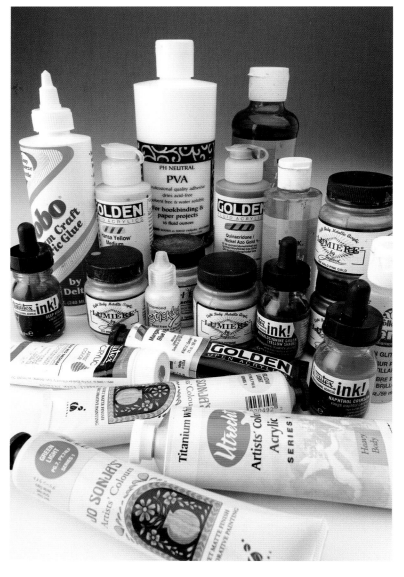

◄ Paints, inks, glitter, and glue.

Craft knives. Like scissors and rulers, I keep multiple craft knives on hand, as well as a box of new blades. They're invaluable for cutting cardboard, paper, and foam core, as well as for cleaning off your palette knives and trimming your fingernails. You'll also need a cutting surface—you can either purchase a cutting mat or use scraps of matboard.

Palette knives. I use palette knives for mixing paints with matte medium or glazing medium on the palette, but they come in handy for other things as well. For example, if you have magnetic letter stamps, a palette knife is a good metal surface on which to build a word before stamping it. I prefer the small trowel-like palette knives with a diamond-shaped blade, but this is just personal preference. Try out a few shapes and see which suits your style.

Disposable palettes. While some might prefer plastic or glass palettes, I love the disposable ones that are like a pad of paper. Not only are they convenient (you never have to clean them—just tear off the used sheet and you have a new one ready), but they're light and portable. I move mine around to wherever I'm working. A sheet of glass also makes a great palette surface if you do a lot of painting all in one place and don't want to throw away all that paper.

Bone folder. This is a bookbinding tool used for scoring and creasing paper, as well as tearing it (think letter opener). It isn't absolutely necessary if you've found another method of scoring and reinforcing a fold, but once most people try a bone folder, they won't be caught in the studio without it.

Scissors. I keep on hand one pair of good quality fabric scissors and use them only for fabric. For paper scissors, I keep several inexpensive pairs on hand and have at least one pair at every work area of my studio. One by the sewing machine, one at my desk, and several at my painting and collage areas.

Rulers. I prefer clear plastic rulers, 2-inch-wide rulers in 12-, 18-, and 24-inch lengths. Like the scissors, I keep one or two rulers at each workstation.

Beading tools. Small pliers and wire cutters are essential for working with craft wire. They're available at craft supply stores or beading suppliers and are pretty inexpensive.

For many of the projects in the following chapters, you'll need scissors, a ruler, a craft knife (and a surface for cutting), and a brush for glue. I'll call this foursome the "basic tool kit" and refer to it as such in the tools and materials lists at the beginning of each project.

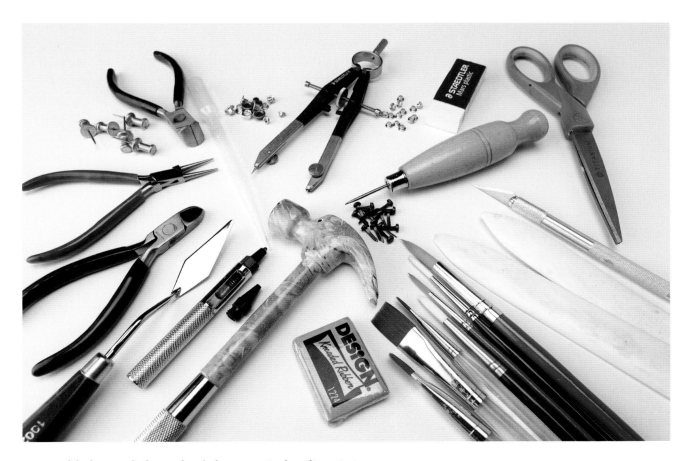

▲ Some of the basic tools that are handy for many mixed-media projects.

STARTING POINTS

In mixed media and collage, there are so many possibilities it's difficult to decide where to start. Many of the materials themselves—paper, fabric, threads and fibers, foils, beads, and gorgeous paints—look so inviting, you just want to pick them up and do something with them. But what? That's often how I feel, anyway, and I know a lot of artists who run up against this question. On the other hand, you may have ideas you want to express—so many ideas that it's impossible to choose which one to explore. How do you choose? You may even have a specific idea in mind but are not sure how to begin to build an object around it. Should it be a collage? A painting? A book? A quilt? From whatever direction you come to mixed media and collage, finding a starting point can be a challenge. Once you do find it, though, you're over the hump and on your way!

Here are some ways to consider starting. I like to think about collage and mixed-media projects in terms of two distinct approaches:

* Starting with materials and techniques and moving toward expression of ideas
* Starting with ideas, and allowing those to inform choices of materials and techniques

Once you start, the process is likely to take you back and forth between a focus on materials and a focus on concepts.

Starting with Materials

Most of the projects in this book start with a focus on materials and techniques, but each one allows the opportunity to incorporate concepts and express ideas. If you don't have specific ideas in mind, you may want to start with a technique or project that interests you. Ideas for content may occur to you along the way, or you may simply take pleasure in making beautiful objects or learning something new. A particular technique or material can intrigue you and get you juiced up for creating. Go with this urge, wherever it may take you. Let ideas happen at their own pace. If an idea takes hold, go with it. If not, then enjoy the process of creating for its own sake.

My experience with making dolls illustrates the point. Handmade dolls, whether paper, fabric, or otherwise, have always been fascinating to me, but I used to draw a total blank every time I decided to make a doll. I had the urge to create one but couldn't come up with a concept that would "justify" its making or determine its materials. I felt as if I needed a well-defined idea before I could begin to make choices about construction techniques. Finally, I let go of that need and just went with my impulse to make dolls. Once I started putting things together and trying different approaches (thank you to Pamela Hastings and Autumn Hathaway, among others, for their inspiration to try new techniques), the dolls began to speak for themselves. During the construction, an idea would present itself, and from there I could follow it through. The idea can be as simple as "This doll is about the color pink," or as complex as "This doll expresses the ideals of my friend for whom I made it."

This doesn't always happen, though. Sometimes I don't get beyond the materials and techniques; I play around, but concepts don't show up on cue. They don't have to, though, for a mixed-media piece to be successful. In making fusion fabrics, for example (page 66), I often just go with the idea of making beautiful, decorative pieces. No ideas necessary. Not that the process excludes the possibility of concept development; it's just that it lends itself so well to exuberant embellishment! Sometimes I just want to make gorgeous things that simply express gorgeousness, with their yummy surfaces and eye-catching embellishment. Still, themes sometimes start to creep in when I'm not looking.

The "success" of your pieces largely depends on your goals. I encourage you to keep your goals loose, at least at the beginning. Sometimes a goal can be your biggest obstacle! (You can quote me on that.)

Starting with a Concept

Starting with a concept is like entering your creative zone through the opposite door. Instead of letting the materials and techniques guide your creativity, you let the concept guide your choices about materials and techniques. If you're making a gift for a particular person in your life, that person, or some aspect of that person, can be the starting point. What message or feeling do you want to convey to that person? What materials would he or she particularly relate to? What colors would be especially suited to that person? You may be making a gift for yourself: a decorative piece to hang on your wall, or a box in which you keep your secrets. In this case you get to be your own inspiration. What are *your* colors? What kind of message do you want to convey to yourself?

If you have an idea but aren't sure what format is best suited to expressing it, consider the projects in this book as possibilities. For example, if you wanted to make a piece about memories of a trip you made, and you have collected material from that trip—photos, tickets, maps, brochures, etc.—you could consider creating a pamphlet-stitch journal (page 48) in which you write about the trip and use the ephemera as collage material, much like a scrap book or travel journal. You might find the "Accordion-Purse Book" project (page 38)

better for your needs, making the "purse" into a travel bag. You could make a memory box using box techniques in chapter 3 or use your ephemera in a fabric-paper mini-quilt (page 97) . . . and so forth. Any of the projects using the ephemera from your trip could make a beautiful and meaningful piece, whether it's a gift or a keepsake for yourself.

The projects in this book don't specify colors or brands of materials in most cases. I leave a lot of room for you to choose and create your own materials so that you can express your own vision in each project. While this is intended to ensure that your piece is unique and truly yours, I'm aware that it requires more of you than simply following directions. Though I encourage you to think about meaning and visual impact when choosing materials, I don't want you to overthink every decision. Like much of the creative process, this is a balancing act. Go with your gut, and be decisive. You can always revise, and you can always make another piece.

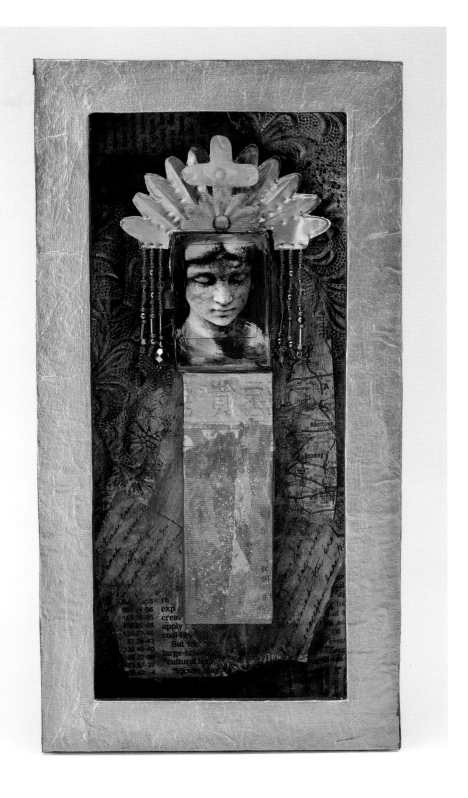

▲ **JANE DAVIES:** *Our Lady of Mixed Media.*

This piece is an example of something I began from a materials/techniques standpoint when feeling a little lacking in ideas. I chose a foam core shadowbox as the format because I was hoping that some ideas would show up in the time it would take to construct it. (See Chapter 6 and "Project: Spirit House or Shrine" on pages 109–110 for more information.) I collaged, painted, beaded, and found-objected my way to what I considered a finished piece, but it remained conceptually unfinished in my mind until a title came to me.

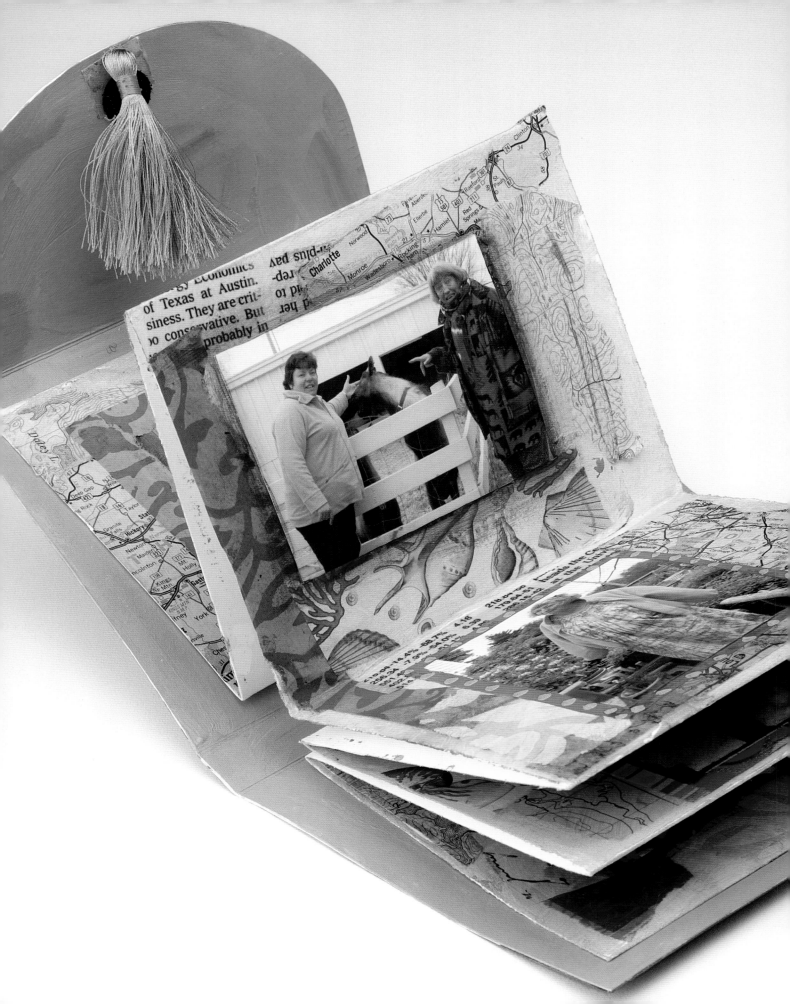

Paper Constructions

In this chapter we explore the world of paper—as a structural material for projects, as collage material, and as a surface for scribble painting, my particular take on decorating your own paper. These collage and painting techniques are used in many of the projects in later chapters and form the foundation of mixed-media collage. For example, collaged and scribble-painted papers can be used for book covers, book pages, and boxes; bits of scribble-painted papers make a unique addition to fusion fabrics and fabric paper; and the foam core projects and dolls make extensive use of painted and collaged paper as well.

◄ **JANE DAVIES:** *Junk and Myth,* accordion-fold purse book.
See pages 38–39 for step-by-step instructions.

DECORATING PAPER

Paper is all around us: Newspapers, magazines, junk mail, good mail, books, gift wrap, greeting cards, shopping bags, various types of packaging, maps, letters, and tissue paper are just a few examples of potential collage materials that are practically free and readily available. The list can be extended by adding papers acquired specifically for collage: decorative papers, scrapbook papers, textured papers, and images or patterns you purchase or print out from your computer. In addition to these, you can also create your own collage materials by painting, stamping, or otherwise decorating existing papers.

On the pages that follow are just a few examples of ways to add color and pattern to papers that you can incorporate into the projects in this and subsequent chapters. There are many resources for learning decorative painting techniques (including my book *Collage with Color*), so I won't go into too much detail here. The key to making your own collage papers is to experiment and have fun. There's no one right way, and there are no rules. Try combining materials in new ways: Layer watercolor over acrylic, or acrylic over crayon over charcoal; make handprints all over the paper with craft paint, or fold the paper in half while the paint or ink is still wet, for a Rorschach-like image. Apply paint with a sponge, blot it with paper towel, use a rubberstamp to create a pattern wet-in-wet (letting the wet paint disperse into the wet paper), or make potato prints. Get some inexpensive drawing paper, craft acrylic paints, a few inks and watercolors, and let yourself play!

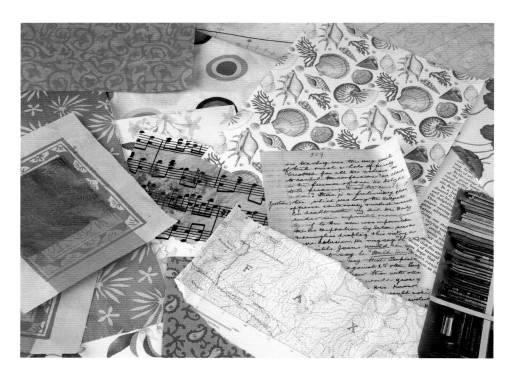

▲ Collage papers including joss paper, decorative papers, printed tissue paper, paper napkins, maps, sheet music, book pages, and magazine images.

YOUR CREATIVE PRACTICE

Making art is like maintaining a yoga practice. Do you want to have peace and calm in your life, reach some kind of enlightenment? The first step in yoga is practicing postures, or *asanas*. You work with the body and breath, the physical materials and techniques of yoga, and that begins to allow you access to the more subtle benefits of the discipline. Whether you're feeling calm and enlightened or agitated and dull, you can always do the physical practice. In art, do you want to make brilliantly, deeply meaningful pieces that express ideas on multiple levels? Well, I suppose some people can do this right off the bat, but most of us need to practice. Not practice in the sense of doing something over and over again to perfect it, but practice in the sense of *doing*, engaging frequently in creative activities. The practice of doing/making art—not brilliant art, not masterpieces, just art—keeps the creative pathways open and available in the long term.

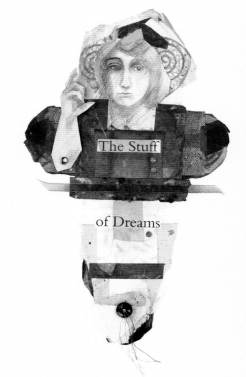

▲ **PAMELA HASTINGS:** *The Stuff of Dreams.*

TECHNIQUE: **SCRIBBLE PAINTING**

My current favorite way to make collage or book-cover paper is to combine a few techniques, building up layers of color and texture. I call this "scribble painting." I start with a piece of brown paper, a grocery bag cut open and ironed, or a sheet of plain white drawing paper. Here are some step-by-step instructions that you can follow to get the hang of this improvisatory style of painting. Make up your own variations as you go. Many other techniques will fit nicely into this process as well, so if you love stamping, stenciling, sponging, and other techniques, go ahead and try them here.

You'll need:

- Inexpensive drawing paper or an ironed brown paper bag (cut open and laid flat)
- Craft acrylic paint in three or four colors (try using various sheens, such as matte, gloss, metallic, and glitter)
- A discarded credit card or gift card to use as a squeegee
- A spray bottle of water
- Paper towels
- Liquid watercolor in one or more colors
- Metallic acrylic paint, such as Lumière (I like Lumière because of its fluidity and brilliant sparkle)
- A toothbrush dedicated to painting
- Hair dryer (optional, but nice to have)
- Iron and baking parchment (optional)

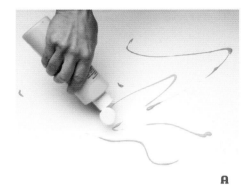
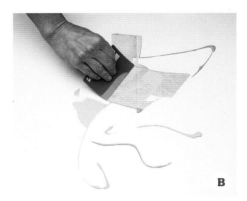

1. Squeeze out two colors of craft paint in little squiggles over parts of your paper. Be sparing here; it's easy to add more paint but difficult to subtract it. (See photo **A**.)

2. Scrape the paint around with the credit card, making short scrapes. (See photo **B**.) As you scrape, the credit card picks up paint, which you can then add somewhere else on the paper to spread it out further. Notice how there are distinct areas of each of your colors. (See photo **C**.)

3. Add one or two more colors of paint and scrape again as in step 2. While this second application of paint is still a bit wet, spray water droplets onto it with your spray bottle. Let the paint dry (except where the water is, of course), or dry it with a hair dryer, and then blot it with a paper towel. This will create negative water droplets, so that you can see the layer of paint underneath. (See photo **D**.)

4. Drip liquid watercolor paint onto your paper, and then tip the paper in various directions to encourage the paint to make long drip lines.

5. Spatter some metallic paints over parts of your paper. To do this, squeeze a little paint out onto a palette, dip the bristle ends of a toothbrush in a little water, then into the paint. The water ensures that the paint is liquid enough to spatter easily. Holding the toothbrush over the paper, draw your thumb over the paint-coated bristles so that the paint spatters over the paper. (See photo **E**.) Make sure to protect your workspace, as the spattering will go farther than you expect.

6. When the piece is complete and dry, iron it on medium heat between two sheets of baking parchment. This step is optional, but it gives your sheet of paper a finished look. If you're working on a brown paper bag, ironing it makes a big difference.

A few other techniques to try:

- Squeeze craft paint onto your paper as in step 1, then fold your paper in half. Unfold it, and fold it again in a different direction.
- Crumple up your paper, then smooth it out again at one or more points during scribble-painting process. If you do this, iron the piece after it's finished.
- Apply liquid watercolor over acrylic paint that isn't dry. Dry slightly with a hair dryer and then blot up some, or all, of the watercolor.
- Before your first application of acrylic paint, scribble over the paper with wax crayons.
- Try the following ink and chenille-stem painting technique on a blank sheet of paper, and then begin your layers of paint as described above.

▲ Another technique is to apply a wash of liquid watercolor and let it dry, then spritz with water.

TECHNIQUE: INK AND CHENILLE-STEM PAINTING

This technique offers a lovely feathery look and inspires spontaneity with color and line.

You'll need:

- A sheet of inexpensive drawing paper or any other paper you choose to work on
- Black India ink or any color of acrylic ink
- Chenille stem (formerly known as a pipe cleaner)
- A plastic pipette or eyedropper (optional; only needed if your ink doesn't come with this type of applicator)

1. Fill an eyedropper or plastic pipette with ink. Apply the ink to your paper in a spontaneous scribble. I like to apply the ink fast and without too much thought, which can result in very expressive lines and scribbles. (See photo **A**.)

2. While the ink is wet, drag a chenille stem through it perpendicular to the ink line. The chenille stem draws the ink out into beautiful wispy lines. (See photo **B**.)

3. Once the ink is dry you can apply paint or more ink over it using whatever techniques you choose.

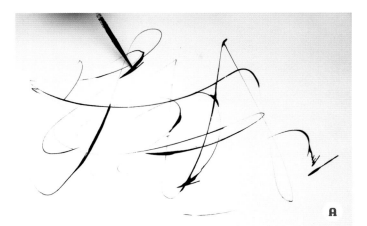

A

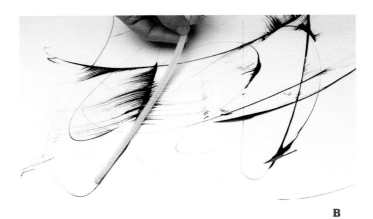

B

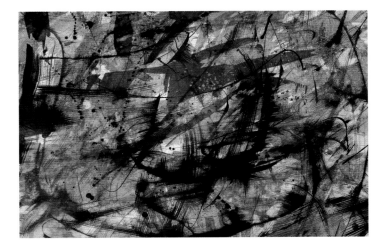

▲ These "scribble paintings" were made using the ink and chenille-stem technique described above.

This is about the simplest of projects, and it's a quick and easy way to use your collage or scribble-painted papers. If you've never set eyelets before, this project includes a demonstration of the technique.

Your eyelet-setting tool comes with interchangeable tips in several sizes. For each size eyelet, you have a hole punch and a cone tip that flattens the backside of the eyelet. Make sure you have the right size tips for the eyelets you're using. When you punch a hole with the hole-punch tip, the cylinder part of your eyelet should go through it easily. Eyelets are useful for making attachments of all kinds. Once you own an eyelet-setting tool and some eyelets, you'll find lots of uses for them.

The instructions here are for a basic tassel made with cotton embroidery floss, but you can elaborate as you wish by experimenting with different materials.

You'll need:
- Collage or painted-paper for the bookmark (this can be scribble-painted paper, collage, fabric paper, or store-bought decorative paper)
- Paper for the back of the bookmark
- White glue or PVA and glue brush
- An eyelet-setting tool and one eyelet
- A small craft or ordinary hammer
- Small piece of matboard, cutting mat, or other cutting surface
- Foam core
- Embroidery floss, cotton or rayon, in two colors—one for the tassel and one for the tassel neck (the wrapped part just below the head)
- Scissors
- Several inches of waxed linen thread or dental floss

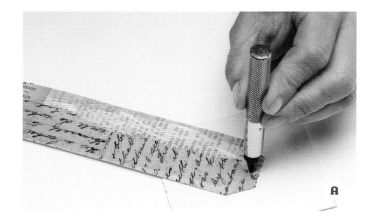

1. First create your bookmark. This can be as simple as cutting a rectangle out of a collaged paper or as complex as anything you can dream up. I recommend making a two-sided bookmark. If you make a one-sided bookmark, back the collage or painted paper with a coordinating paper using white glue or PVA.

2. Punch a hole in the top of the bookmark with the eyelet-setting tool. Use the matboard to protect your work surface. (See photo **A.**)

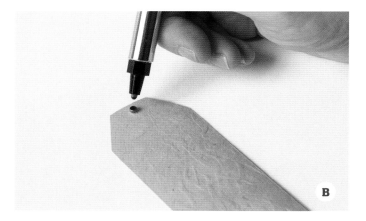

3. Place the eyelet in the hole, turn it over, and place the cone tip of your eyelet tool in the eyelet. (See photo **B.**) Tap it with a hammer to secure the eyelet. (See photo **C.**)

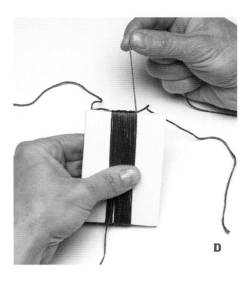

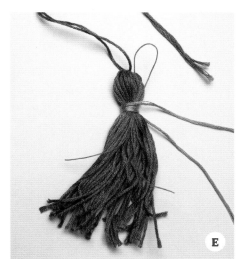

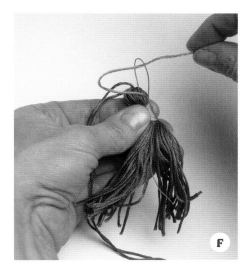

4. To make the tassel, first cut out a rectangle of foam core (cardboard or illustration board will work, too) about 3 inches long and a little wider than the length of your finished tassel.

5. Lay a strand of your tassel thread, approximately 4 inches long, across the top of the foam core, and wrap the thread around the foam core enclosing the strand at the top. There are no rules as to how much thread you need for a tassel; just wrap until it looks to be about the right weight. (See photo **D**.)

6. Snip the thread, then cut through the threads on the bottom of the foam core with a craft knife (this is easier to do if you use foam core rather than other materials). Tie the threads together with the strand at the top, making a secure knot.

7. Choose another color of embroidery thread for the neck of the tassel. Place a loop of waxed thread or dental floss against the tassel threads, loop side toward the head. Wrap the neck thread around the tassel threads close to the head, leaving a few inches of a tail and enclosing the loop of waxed thread. (See photo **E**.)

8. Thread the neck thread through the loop of waxed thread, then pull it through with the loose ends of the loop so that you end up with both ends of the neck thread coming out the bottom of the neck. Snip both threads flush with the neck. (See photo **F**.)

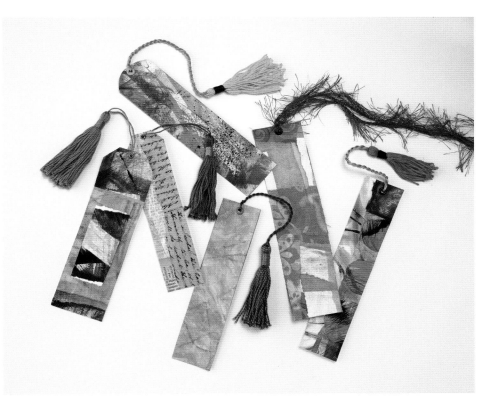

PAPER BAGS

Have you ever wanted to create fancy handbags but felt a little intimidated by the many techniques and materials involved? Here's a way to fulfill the fantasy, but the bags are much quicker and require only basic cutting and gluing skills. You can decorate them to the nines with glitz, or use them as a format for any kind of creative expression. Here are a couple of basic paper bag structures to get you started. I'm sure if handbags are your thing, you'll come up with many more ideas and variations. Use them as gift bags, filling them with chocolates, bath accessories, art supplies, handmade cards, or gift certificates.

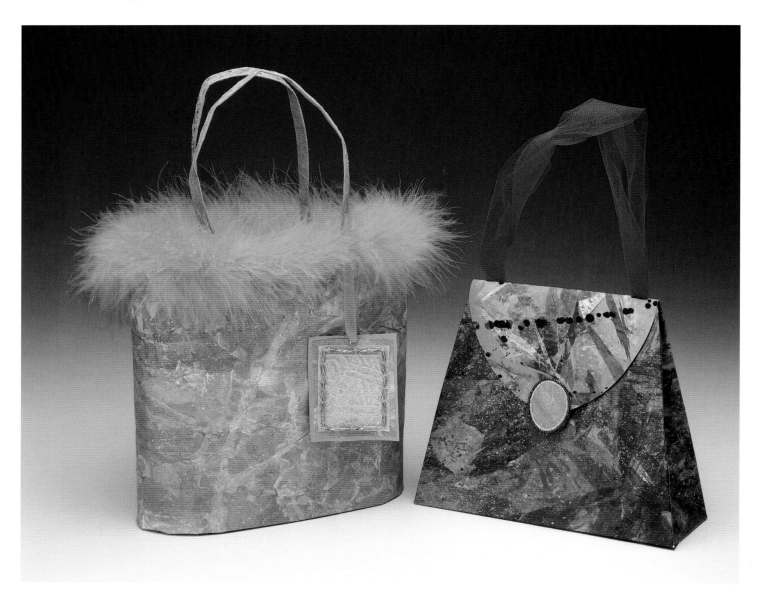

▲ Making a bag by hand is a luxurious way to present a gift. It only takes a few little embellishments to make an ordinary paper bag into something special.

PROJECT: OVAL BAG

This bag is basically an oval cylinder, as it has an oval base and straight sides.

You'll need:

- Template 1 (see page 128)
- Basic tool kit (see Tools, page 18)
- Cheap drawing paper for the pattern
- A sheet of your hand-painted paper
- White glue or PVA
- A sheet of lokta paper for the inside of the bag (see page 12 for an explanation of lokta paper)
- Two pieces of lokta paper big enough for the bottom oval
- Your basic paper (see Paper, page 12) or other stiff paper for the bottom of the bag
- A length of marabou slightly longer than the circumference of your oval
- Needle and regular sewing thread for tacking on the marabou
- Extra lokta (or you can use ribbons or cord) for making handles
- Glitter glue, rhinestones, etc. for embellishing your bag (optional)

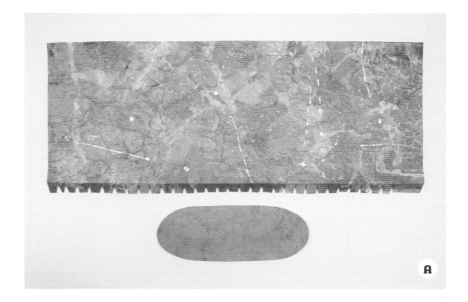

1. You can either use the template provided in the appendix or create your own template. If you're making your own template, start by making the oval for the bottom the size and shape you want, and measure its perimeter. Then make a rectangle that's the length of the oval's perimeter plus 1 inch for the overlap, and the desired height of the bag plus a ½ inch for the fold-under at the bottom.

2. Cut a piece of your painted paper a couple of inches larger than the rectangle pattern piece. Back it with the sheet of lokta using white glue. Let dry, then cut out the rectangle from the backed painted paper. Back one of your smaller pieces of lokta with your basic paper and cut out the oval for the bottom of the bag. This lokta will be the inside of your bag. I used a contrasting color so that the images are easier to read, but you could use the same color. Fold under a ½ inch along the bottom edge and cut notches as shown. (See photo **A**.) I find cutting notches easier with a craft knife than with scissors. This notching trick will be familiar to anybody who has sewn clothing or anything with curved seams, and it cuts down on the bulk as you fold and tuck the folded edge over the bottom of the bag.

3. Glue the notched, folded-over edge of the bag to the oval bottom. (See photo **B**.) Do this a few notches at a time, starting at the back of the bag where the seam will be.

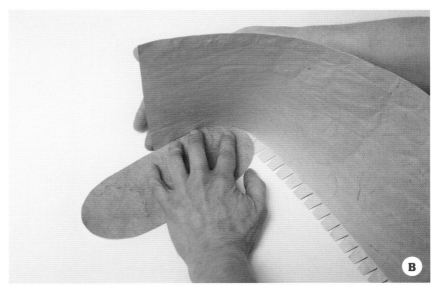

4. After you get halfway around, it may be easier to work from the outside of the bag. (See photo **C**.) Make sure the edge of the oval exactly meets the fold in the bag. When you've glued all the notches, there should be about an inch of overlap at the back seam. Glue this seam closed.

5. Cut the same oval shape, using your pattern piece, from your other small piece of lokta. Trim about ⅛ inch all the way around the edge. Glue this to the bottom of the bag. (See photo **D**.)

6. Now it's time to embellish your bag. Thread a needle with a comfortable length of thread that's the same color as your marabou. Hold the marabou along the top edge of the bag and stitch it on using tack stitches (whipstitches with some distance between them) about every inch or so. The ends of the marabou should overlap a little.

7. Make handles for the bag using lengths of lokta about 1¼ inch wide. Make an envelope fold along the length of each paper and glue in place. Cut to the desired length for the handles. Decorate them with glitter glue, sequins, or other embellishments of your choice. Then attach the handles to the inside of the bag with glue, making sure not to get glue on the marabou. (I cover the marabou with wax paper as I glue the handles in place.) For my paper bag, I made a little tag using a small sheet of embossed Angelina fiber (page 78) glued to paper, with a little bead embroidery (page 62). You could make a tag or embellish the bag further with tassels, beads, etc.

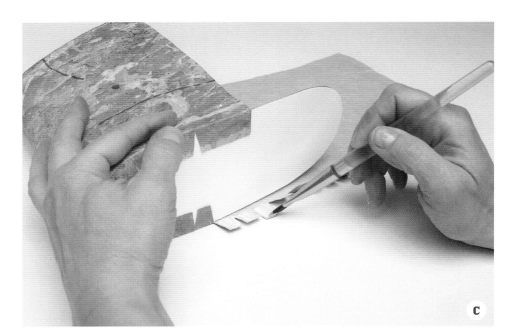

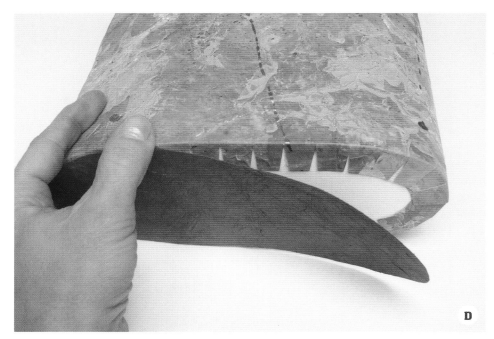

PROJECT: **PURSE-SHAPED BAG**

This bag is constructed like an ordinary paper grocery bag, with folded gussets in the sides. The difference is that it angles in from the bottom to the top, giving it a more elegant look. You could use the same sheet of hand-painted paper for the flap and the body of the bag, but I like to mix and match.

You'll need:

- Template 2 (see page 129)
- The basic tool kit (see Tools, page 18)
- A sheet of hand-painted paper big enough for two of pattern A, the bag body
- A sheet of lokta to back the above
- A small sheet of contrasting hand-painted paper for the flap
- Lokta for the back of the flap (which could be the same as the above, or a contrasting color)
- A paper gem (page 61) or other embellishment for the flap
- A two-sided Velcro tab for the closure
- A short length of tulle or ribbon for the handle
- Bone folder
- White glue or PVA

1. Cut a sheet of your hand-painted paper large enough to accommodate two pieces of pattern A plus some overhang. Back this sheet with lokta using white glue or PVA. Let dry. Cut out two pieces of pattern A (identical, not mirror image) from your lokta-backed sheet. Score and fold where indicated. Do the same with pattern B using your other sheet of hand-painted paper and lokta. (See photo **A**.)

2. Starting with one A piece, fold the gusset in and the bottom pieces under as shown in photo **B**. Glue in place. Do the same with the second A piece. Notice how the bottom flap extending from the side gusset is cut as a square, with right angles. This makes it easy to establish a right angle between the side and front of the bag. Make sure the bottom flap extending from the side gusset fits right into the fold between the bag front and the bottom flap.

3. Place the two A pieces with insides facing together, and one bottom nesting on top of the other. Glue the bottoms together. Now glue the side tabs in place as shown. You can hold them in place with clothespins if the glue doesn't dry fast enough. (See photo **C**.)

4. Glue your embellishment to the front of the flap (pattern B) so that it overhangs the edge. This is, of course, optional, and you can place your embellishment however you want to. (See photo **D**.)

5. Cover the back of the embellishment with a piece of the paper used for the flap or other decorative paper. (See photo **E**.)

6. Glue the folded tab on the flap to the back of the bag. Cut two slits in the fold of the flap, and insert the ends of your handle, whether it's tulle, as shown in the photograph on page 30, or ribbon or another material of your choice. Secure the handle either by tying the two ends together or gluing them in place.

A

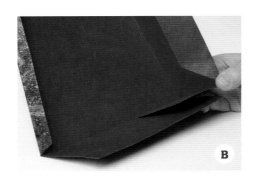
B

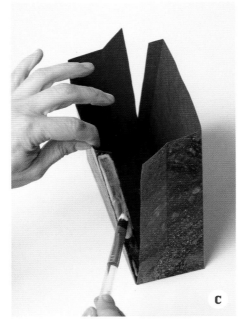
C

D

E

PROJECT: BOX-WITHIN-A-BOX

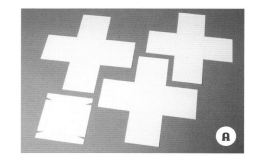

This little variation on a basic paper box offers many possibilities for embellishment, writing, collaging, or tucking in little messages to the recipient, whether that's yourself or a friend. It's like a little book in the form of a box, with lots of "pages" as well as a volume for containment. The box-within-a-box starts with three "box" pieces, which nest inside each other, and one piece for the lid.

You'll need:
- Template 3 (see page 130)
- Your basic paper (see Paper, page 12)
- The basic tool kit (see Tools, page 18)
- Bone folder
- Paint and/or collage materials
- White glue or PVA
- Any embellishments you care to use
- Rubber stamps for lettering, if you like

1. Using the template provided, or creating your own template, cut out three nesting boxes and one lid from your basic paper. Score and fold each piece as indicated, using a bone folder. (See photo **A**.)

2. Paint and/or collage each of your box parts and the lid, both inside and outside. (See photo **B**.)

3. Glue the box parts together at the bottom so that they nest into one another. (See photo **C**.) Apply glue to the corner tabs of lid and fold and glue in place. You can use clothespins to hold these in place while the glue dries, or just hold each one with your fingers as you glue it if you're using a fast-drying glue (I use white glue or PVA). If they don't line up exactly, you can trim a little with scissors or a craft knife.

4. You can write, paint, and collage further if you wish.

5. Put the lid on the box, and you're finished!

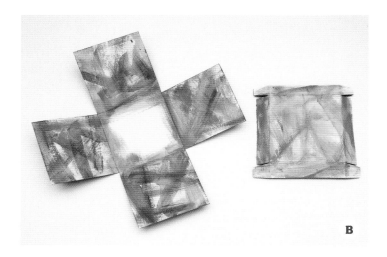

B

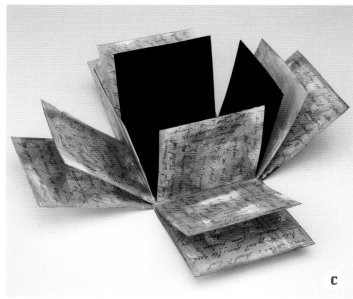

C

◄ **JANE DAVIES:** *Find Your Own Way box.*

The outside of this box says "Find Your Own Way," with one word on each side. I used some map imagery on the outside and made a decorative compass on the top. It was a gift to myself on an occasion when I was feeling overly influenced by the directions of others. I needed to find my own way, and this was my compass.

TECHNIQUE: **BASIC COLLAGE TECHNIQUE**

This is the process that I most often use to make a collage background or an overall pattern. It's very much like decoupage, in that you use the same medium, in this case acrylic matte medium, for the adhesive and also the top coat. I like this method because it's pretty spontaneous and doesn't give me too much time to think or agonize over which paper goes where. The finished collage can be used as the background for an image, for book covers and boxes, or as material for any of the projects in this chapter. You can also use the same technique for building collage images using light-weight papers.

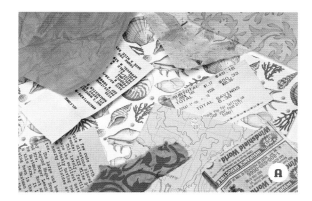

This demonstration is for an all-over random collage using a variety of papers. These can be anything from discarded maps to gift wrap, pages from discarded books, decorative papers, bits from magazines and catalogs . . . anything you like. Your collage papers should be no heavier than the support, ideally. Choose papers that have either a personal connection to you or have some personal appeal—colors that express a particular mood, imagery that has personal meaning, bits of paper from events in your everyday life, text that speaks to you, or materials that, for whatever reason, have become part of your visual vocabulary. I chose a Nova Scotia map, a sheet of decorative paper with a seashell motif, a few receipts, a page from a Rupert Historical Society report, and various odds and ends.

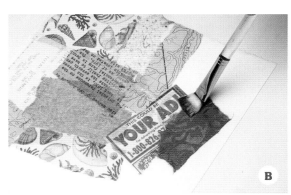

You'll need:

- Your basic paper, or other paper for the support (see Paper, page 12)
- Collage papers
- A flat brush
- Acrylic matte medium
- Scissors (optional)

1. Cut and tear your collage papers into bits and pieces. (See photo **A**.)

2. Using a flat brush, apply matte medium to the support paper, lay down a piece of collage paper, and apply more matte medium over that. Don't pay too much attention to composition just now. At this stage, the collage papers just set the tone for subsequent layers. (See photo **B**.)

3. Work in small sections at a time, applying each piece of collage paper and top-coating it as you go. Easy enough?

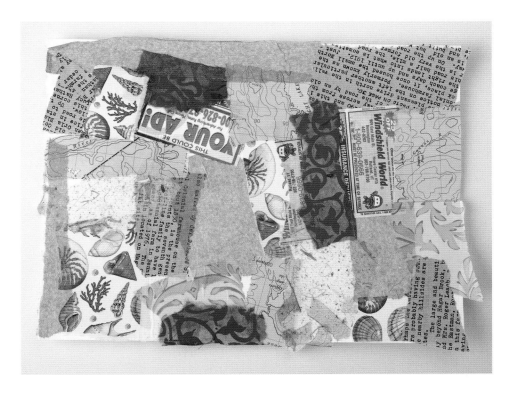

TECHNIQUE: **PAINTED COLLAGE PAPERS**

To create interesting solid color collage papers with depth and texture I make all-over collages on a lightweight paper support such as Hosho, Kozo, or Unryu (pronounced "un-RYE-you"). These are inexpensive Japanese papers used for Sumi-e painting or Shoji screens, often referred to as "rice paper." Despite their light, translucent quality, these papers are strong but will not add a lot of bulk to your collage-paint papers. For the collage, I stick to relatively neutral-colored materials: I used maps, dress patterns, old diary pages, and other bits of ephemera for this collage paper. This way, the color I apply over the collage stays fairly uniform but has a lot of texture from the underlying collage.

You'll need:
- Rice paper, as described above, for the support
- A collection of neutral collage papers (i.e., not strong colors)
- Acrylic paints
- Matte medium
- Brushes
- Scissors (optional)
- Paper towels

1. Apply the collage materials to your rice paper support with matte medium (see "Basic Collage Technique," page 35). Let it dry. I like to make four or five sheets of collage before painting.

2. Paint with acrylic paints using whatever techniques you choose. For these papers, I use several techniques to apply the paint.
- Apply paint with a brush, then wipe it off with a paper towel. This gives you a lot of control over how much you see the collage through the paint and how dense the color is. You can build up layers of color gradually this way, and wipe away paint where you want the texture to show through more clearly.
- Use a sponge to apply paint, wiping it at the same time.
- Apply the paint and then scrape it with a credit card. (See "Scribble Painting," page 25.)

Make yourself a rainbow of collage paint papers. They're great for using on the inside of boxes or for book covers or any of your collage projects.

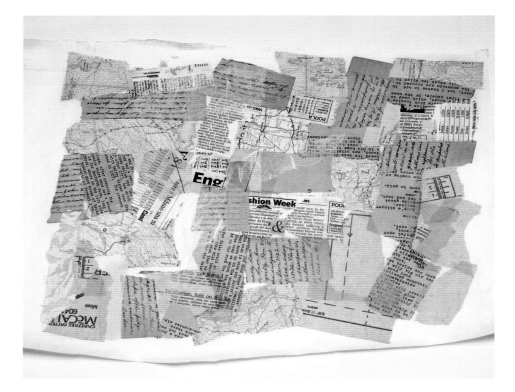

TECHNIQUE: **COLOR COLLAGE PAPERS**

For some projects, I like to make a group of what I call *color collage papers*—collage papers made with scraps that are various shades of a single color. These are all-over patterns to be cut up and used in other collage compositions, such as the one on the jointed paper doll on page 123.

For this color collage paper I used magazine papers, decorative paper, and other bits of ephemera. Making color collage papers is very relaxing and fun to do in a group. It doesn't require a lot of concentration or decision making, and yet the results can be rich and surprising.

You'll need:
- Papers from lots of different sources: magazines, catalogs, decorative papers, maps, discarded picture books and greeting cards, etc. (the papers should have lots of color)
- Rice paper for the support
- Matte medium
- Brushes
- Scissors (optional)

1. Start cutting up your papers and sorting the pieces according to color. Put all the blues in one pile, greens in another, etc. You may divide a single image into several color piles and use only parts of other images. With decorative papers that are already one main color, just snip small pieces of them for your color stashes. You can choose how specific you want to be in your color groupings. For example, you may want to put all reds in one pile, or you may want to divide reds into magentas, true reds, and red-oranges. I prefer to keep my categories pretty broad. This cutting and sorting is a pretty relaxing activity in itself, and it makes you see everything in terms of color.

2. As in the collage-paint technique, I like to use inexpensive Japanese rice papers for the support. Start with sheets that are a manageable size, say 9 x 12 inches or so, and start making collage sheets in each of your color groupings, using the matte medium collage technique described on page TK.

3. Once you have your finished papers, you can use them for collage, book covers, hand-made boxes, or any other paper projects.

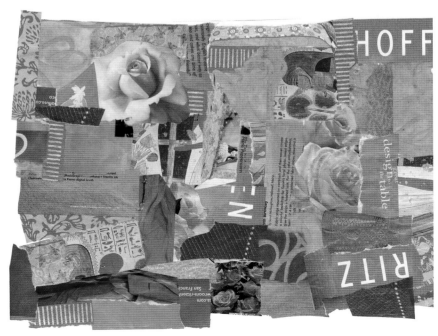

PROJECT: ACCORDION-PURSE BOOK

This project makes a lovely and creative presentation for a series of personal photos, but you could use the format for other types of content as well. It's a book, after all, and as such is open to interpretation. I include it here rather than in chapter 3, Books and Boxes, because it incorporates the collage and paint techniques demonstrated earlier. The book projects in chapter 3 focus on sewing and hardcover bookbinding techniques.

You'll need:

- Template 4 (see page 131)
- Your basic paper (see Paper, page 12)
- The basic tool kit (see Tools, page 18)
- Bone folder
- Collage papers
- Matte medium
- Acrylic paints
- White glue or PVA
- Photos or other materials for content
- A round or square tab of Velcro

1. Either trace the template provided or create your own template. Cut the cover out of your basic paper, and score and fold where indicated.

2. Choose the dimensions of your pages so that they fit comfortably inside the cover. Mine are 5½ x 4½ inches. Cut one piece of paper the width of your pages (5½ inches) and four times the height of the pages (18 inches). Fold it in half lengthwise, then fold the two halves in the opposite direction so that the ends meet the center fold. You should have a four-part accordion-fold paper.

3. Repeat step 2, but add a ½-inch tab to the length of your second piece of paper. Remember to fold *to the inside edge* of the tab, not the outside. I've made my accordion pages so that they unfold vertically from the top of the purse book cover. Another option is to orient them horizontally. (See photo **A** for steps 1–3.)

4. Collage the outside of your cover using the basic collage technique (see page 35). (See photo **B**.) Trim the edges flush with the cover paper. Then paint the inside of the cover. (See photo **C**.)

5. Glue the two four-part sections of pages together at the folded tab. Paint and/or collage the pages on the front side. Make sure

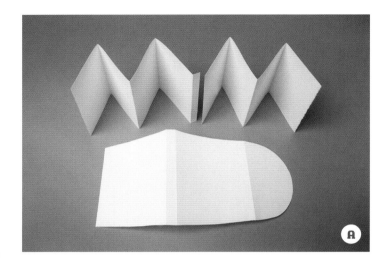

A

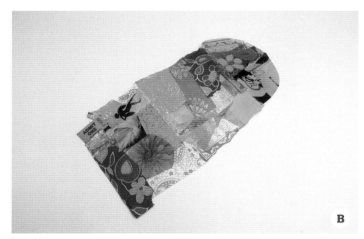

B

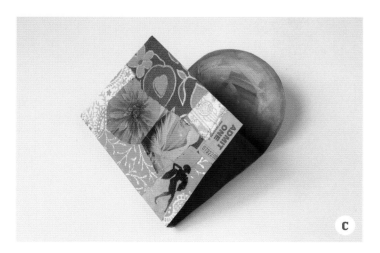

C

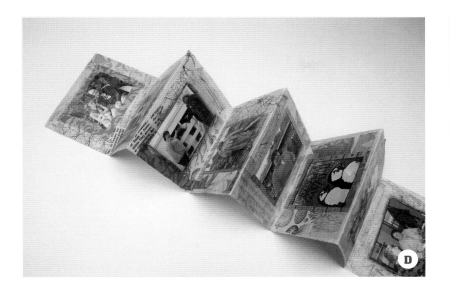

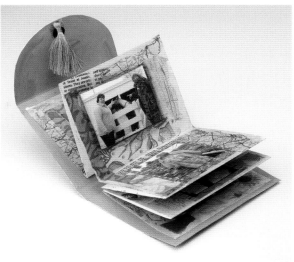

that the top page is folded like the left-hand side of a book, so that its folded edge is at the bottom of the purse cover. (See photo **D**.)

6. Dry overnight. When the pages are completely dry, apply a little diluted PVA to the painted or collaged surface so that they don't stick together when the book is closed. (See page 13.)

7. Glue the top page to the inside back of the cover and the bottom page to the inside front of the cover.

8. Put a piece of self-adhesive Velcro on the inside of the flap such that its opposite side sticks to the front cover.

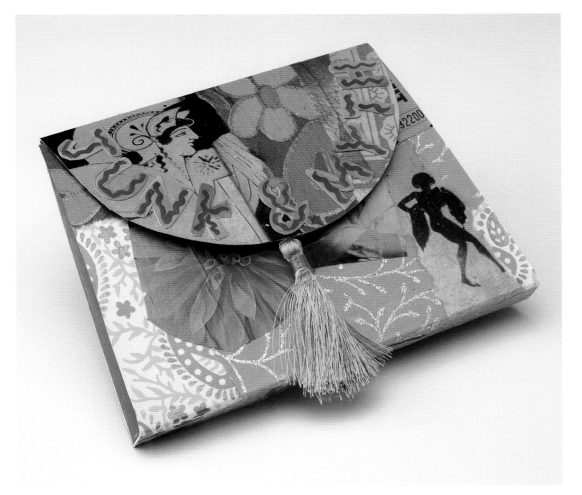

◄ **JANE DAVIES:** *Junk and Myth.*

This accordion-purse book is a memento of two visits we had with our friends Gloria and Patti in 2009. Here we see Gloria and Patti petting the goats at Consider Bardwell Farm, which is a farmstead cheese company just down the road from me. Junk and Myth is the name of Gloria's store, where she sells her paintings along with exotic objects from her world travels. I thought it an appropriate name for this book.

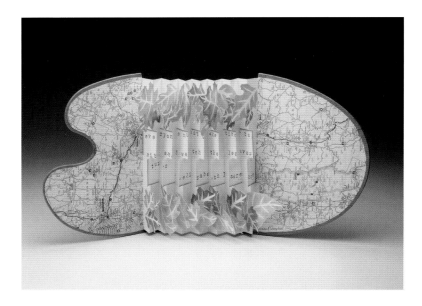

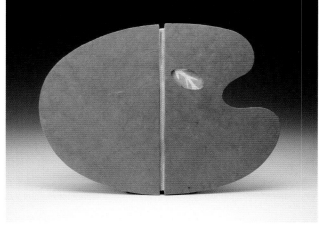

▲ **Elissa Campbell:** *Local Color.* The "flags" attached to the folds give this accordion-purse book a "pop-up" feel. The text says, "everyone must take time to sit and watch the leaves turn. —elizabeth lawrence." The covers were made from a wooden palette.

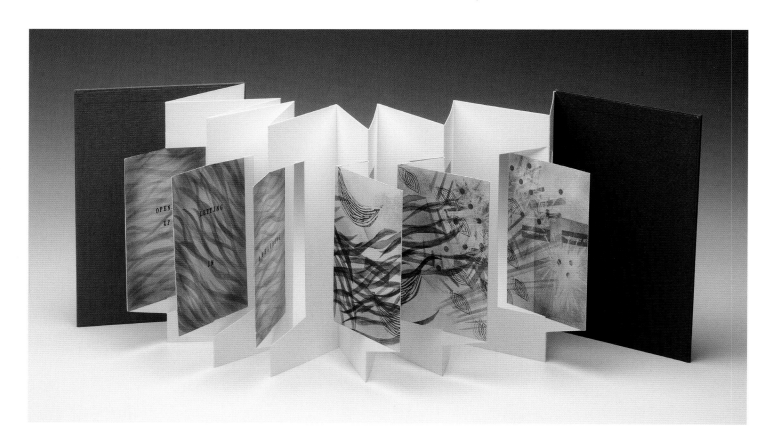

▲ **Elissa Campbell:** *The Life of a Life.* This "panel book" has an accordion structure but with a special cut-and-fold feature that results in separate panels within each outward fold. The text reads "opening up / letting in / absorbing / overwhelming / closing down."

PROJECT: GIFT BOX WITH COLLAGE CARDS

A set of collage note cards not only makes a beautiful gift, but it's a format that allows infinite artistic play in creating a series of small compositions. The collage cards aren't intended to be art on the wall; they're meant to bear messages that are sent in the mail. This makes it easier to make the pieces light and playful and not get too hung up on each one.

The measurements of the box and cards are determined by the size of your envelopes. The size of the box should be ½ inch bigger in length and width and the cards ¼ inch smaller than your envelopes. You can use the provided template, or create your own gift box using the template as a guide.

You'll need:

- Template 5 (see page 132)
- Your basic paper (see Paper, page 12)
- The basic tool kit (see Tools, page 18)
- Paint and paint application tools
- Collage materials
- White glue or PVA
- Yes Paste or other "stikflat" paste or glue stick
- Envelopes (ready-made, or you can make your own)

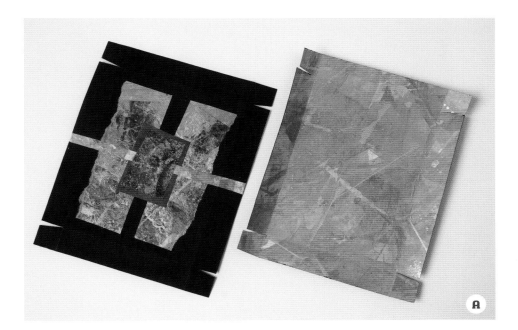

1. Cut two pieces of your basic paper a few inches larger than your box top and bottom, and paint or collage them to your liking. This will be the inside of the box. Trace the box templates onto your painted/collaged paper, and cut them out. Score and fold as indicated on the template. Paint or collage the outside of the box parts. This is a good time to make a collage or paint composition on the box top, as you can see where the folded edges are. (See photo **A**.)

2. Assemble your lid the same way as you did for the Box-Within-a-Box project (see page 34). (See photo **B**.)

3. Now it's time to make your cards. For folded cards, cut and fold your basic paper into cards that measure ¼ inch smaller than your envelopes. I usually start with a set of six or eight cards.

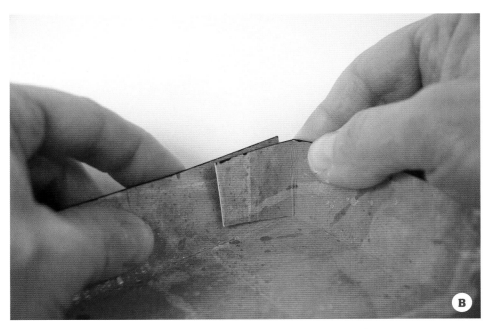

4. Gather your collage materials, a cup of tea, perhaps some meditative music, and begin collaging your cards. Work on them one at a time, or all at once assembly-line style. You may want to work on them over the course of a few days, or you may want to do them all in one session. For this part I use Yes Paste or a glue stick because it resists warping and your cards are more likely to remain flat.

5. Put envelopes in the box, the cards on top, and then the lid. Finished!

◄ This gift box is made with scribble-painted paper (see page 25) laminated to lokta. The outside of the top and the inside of the bottom are the painted surfaces.

GIFT CERTIFICATES

When the economy—or your personal economy—discourages you from spending actual money on gifts, or if there's someone on your list who "has everything," a gift certificate for service or some other nonmonetary commodity is often just the ticket. You can give lawn mowing, leaf raking, grocery shopping, household chores, or a gallon of blueberries (or a bushel of tomatoes, a quart of raspberries) from your garden when they ripen. (You could give this at Christmas, and the recipient would anticipate the fresh produce for months in advance, adding to the pleasure.)

You could stretch your gift out over time and make a "poem of the month" or "homemade cookies of the month" gift. A coupon book for hugs, lunches or dinners delivered, babysitting service, dog walking or grooming, or bouquets from your garden would make a thoughtful gift as well.

Any of the projects in this chapter (or the next) would make creative formats for gift certificates. A summer's worth of lawn-mowing service could be presented as an accordion-purse book, with photos (or other images) of lawns, lawn mowers, the recipient, yourself with a lawn mower, etc. A gift certificate could be tucked into a glitzy paper bag or rolled up inside the box-within-a-box. Make a simple pamphlet book of coupons or a gift box with a stack of collaged cards, each of which is redeemable for a specified service or gift. If someone is moving to a new house or apartment, why not make a housewarming gift certificate for moving help? A house-shaped card or pamphlet book would make a lovely presentation, especially collaged with personal photos or a map of the new location. Once you start pairing gift certificate ideas with project formats, I'm sure you'll come up with many ideas of your own.

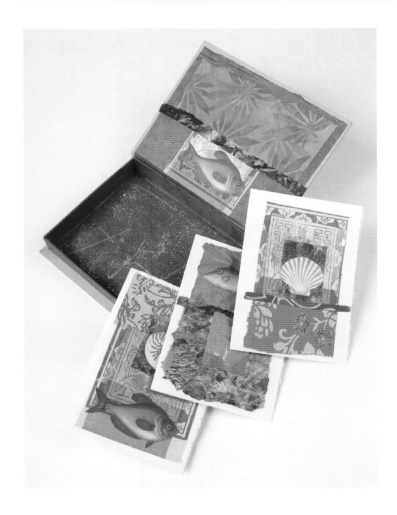

◄ This is another variation of a hardcover gift box (see page 56) made with scribble-painted paper. It holds an assortment of sealife-themed cards that coordinate with the box itself.

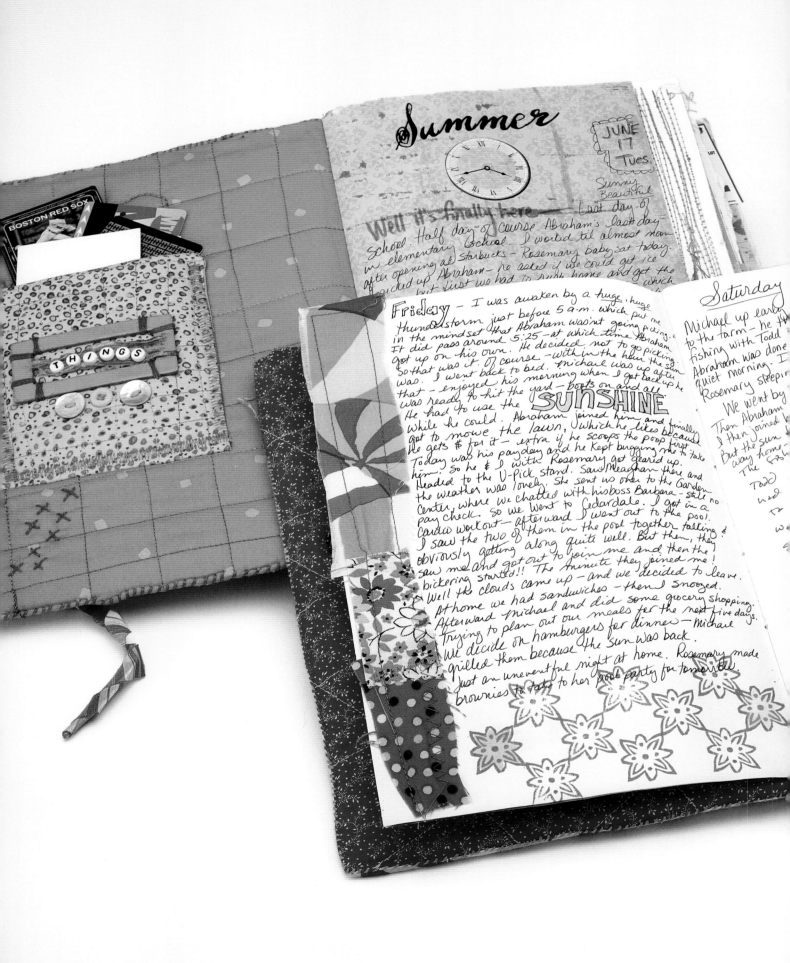

Summer

JUNE
17
Tues.

Sunny
Beautiful

Well it's finally here — Last day of
School. Half day - of course. Abraham's last day -
in elementary School - I worked til almost noon
after opening at Starbucks - Rosemary baby sat today.
I picked up Abraham - he asked if we could get ice
but first we had to rush home and get the — which

Friday - I was awaken by a huge, huge
thunderstorm just before 5 a.m. which put me
in the mindset that Abraham wasn't going picking.
It did pass around 5:25 - at which time Abraham
got up on his own. He decided not to go picking
so that was it. Of course - within the hour the sun
was. I went back to bed. Michael was up after
that - enjoyed his morning when I got back up he
was ready to hit the yard - boots on and all.
He had to use the **SUNSHINE**
while he could. Abraham joined him and finally
got to mowe the lawn, which he likes because
he gets $ for it - extra if he scoops the poop first to take
Today was his payday and he kept bugging me to take
him. So he & I with Rosemary got geared up.
Headed to the U-Pick stand. Saw Meaghan there and
the weather was lovely. She sent us over to the Garden
Center, where we chatted with his boss Barbara - still no
pay check. So we went to Cedardale. I got in a
cardio workout - afterward I went out to the pool.
I saw the two of them in the pool together falling &
obviously getting along quite well. But then, they
saw me and got out to join me and then the
bickering started!! The minute they joined me -
Well the clouds came up - and we decided to leave.
At home we had sandwiches - then I snoozed.
Afterward Michael and did some grocery shopping.
Trying to plan out our meals for the next five days.
We decide on hamburgers for dinner - Michael
grilled them because the sun was back.
Just an uneventful night at home. Rosemary made
brownies to take to her pool party for tomorrow.

Saturday
Michael up early
to the farm - he t
fishing with Todd
Abraham was done
quiet morning. I
Rosemary sleepi

We went by
Then Abraham
I then joined b
But the sun
way home.
The fish

Todd
used
to
w

THINGS

BOSTON RED SOX

Books and Boxes

Handmade books and boxes offer a wealth of possibilities for creative expression in mixed media, combining not only a wide variety of materials, but—with their many surfaces, interiors and exteriors, pages, covers, and endpapers—they offer much opportunity for combining content with structure. I am combining books and boxes in one chapter because the techniques I demonstrate for both are very similar. Once you learn these basic structures, you can make endless variations to suit your creative imagination.

◄ **AUTUMN HATHAWAY:** Summer journals.

BOOKS

In this section I demonstrate a few fundamental bookbinding techniques, including variations on the basic *pamphlet stitch* and creating hard covers for books.

Papers for Text Blocks

Paper used for the *text block*—the stack of pages that make up the interior of your book—is called *text paper*. Usually text paper is lighter weight than "cover paper," which, you guessed it, is the paper used for the cover. The paper you choose for the text block depends on how you intend to use the book. For writing or light painting and collage, I find that inexpensive drawing paper or paper marketed specifically as text paper for bookbinders (which will be more expensive than drawing paper) is adequate. For an art journal, one in which I'll be doing a lot of collage, painting, and embellishing, a heavier paper will work better. Watercolor or printmaking papers are best if you're going to paint in your book. Unlike drawing papers, they absorb water easily without buckling and warping.

The Weight of Paper

Papers are often described in weights—140-lb watercolor paper or 80-lb drawing paper, for example. The pound measurement for paper, otherwise known as its *basis weight,* refers to the weight of a *ream* (five hundred sheets) of that paper at its standard size. This isn't a useful measurement if you're comparing papers of different standard sizes. Grams per square meter (gsm), however, is the same whether your paper is 22 x 30 inches or a square mile. The problem is that many papers are not labeled this way. So here are a few guidelines for the papers I find most useful:

- For art journals, I use a 90-lb printmaking paper, which is about 250 gsm.
- For lighter-weight paper, I use an 80-lb drawing paper, which is about 124 gsm.

Generally when buying paper, you get what you pay for. If you're ordering from a catalog or online and can't feel the paper yourself, a more expensive paper of the same size and weight as a cheaper one will usually have a nicer surface, will hold up better to wet applications, and will generally look and feel more luxurious. So shop around, but bear in mind that if you're creating a book by hand, the materials should be worthy of your efforts.

Papers for a Soft Cover

The first project in this chapter is a simple pamphlet-stitch journal with a soft cover. Though the subsequent projects indicate hardcovers, the same binding techniques can be used with soft covers, too. For my softcover books, I generally use lokta paper. Though it's made in a very wide variety of colors, it's hard to find the whole range available from one retailer (see Resources, page 142). It also comes in a few different weights. I prefer the heavier weight for book covers, but the lightweight lokta is strong enough if you back it to another sheet of paper.

To make a soft cover for a book, you can simply use one sheet of cover paper of an appropriate weight, but it's fun to laminate two sheets together for a contrasting interior. I like to start with one sheet of lokta and laminate either a decorative paper or one of my hand-painted papers to it. Another option is to collage the whole surface of your cover paper and then choose which is the inside and which is the outside.

Measuring Paper and Cover

I usually start a book by making the pages first and then fitting the cover to the pages. I start with a full sheet of text-weight paper such as 80-lb drawing paper, fold it in half, and tear it with my bone folder. I then repeat with each half, and again with each quarter. Each eighth folded in half makes a *folio*. A group of folios nested together makes a *signature*. If I divide and fold my paper into eight folios, I could make one signature of eight folios or two signatures of four folios each. With this method, the size of the original sheet of paper determines the size of your book pages. If this isn't the size you want, I recommend cutting the original sheet of paper before cutting it down and folding it into folios.

Machine-made paper usually has a grain, which means that the fibers lie mostly in one direction, making it easier to fold in one direction than the other. The grain usually runs along the length of the rough, or deckle, edges. If your paper has no deckle edges, you can determine which way the grain runs by simply bending it in one direction and then bending it in the other direction. One way will feel distinctly easier than the other. This is the way you want your folios to fold if your book is to lie flat comfortably. Handmade papers, made one sheet at a time, usually have four deckle edges and no grain. Lokta, for example, will fold as easily in one direction as the other.

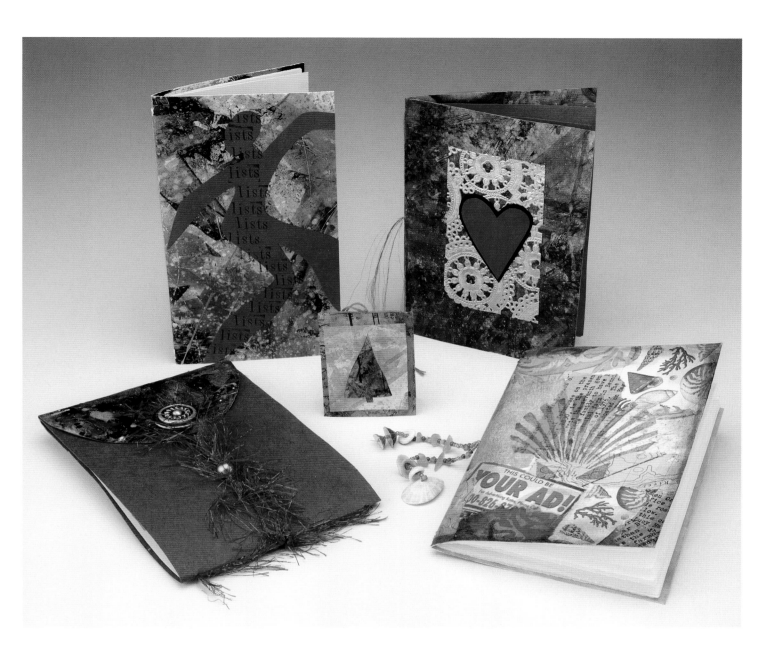

Sometimes the desired size of your book and the grain of the paper are at odds; you get exactly the size you want from a given sheet of paper cut in eighths, but with the grain running the wrong way, against the folds rather than with them. What to do? Either ignore the rule of folding on the grain and let your book suffer a little discomfort, or cut your sheets of paper so that you end up with the right size and the correct orientation of the grain. I do both, depending on the project. For a labor-intensive journal intended as a gift, I take the trouble to cut down the paper; if it's an art journal for me to spill ideas, I'll let the pages be less than bookbinder perfect.

▲ This group of pamphlet books, tags, and cards demonstrates the versatility of pamphlet-stitch construction.

PROJECT: PAMPHLET-STITCH JOURNAL

This project demonstrates basic three-hole pamphlet-stitch construction, which is one of the simplest and most versatile techniques for creating a book. It's a beautiful way to use your hand-painted and collaged papers and to make a unique journal, artist's book, multipage greeting card, or gift tag.

You'll need:

- One sheet of text paper, approximately 18 x 24 inches, for the pages of the book
- Bone folder (not necessary, but helpful)
- Cover paper—collaged or painted if you like, laminated if you choose
- Thread—embroidery floss, waxed linen thread, or any decorative but strong thread or fine cord
- Binder's needle, or any other needle that will hold your chosen thread
- Awl or heavy-duty pushpin

1. Fold and tear a sheet of text paper as described in "Measuring Paper and Cover" (page 46), to make a group of folios. (See photo **A**.) If you have one, use the bone folder to get a crisp fold. Nest the folios together so that they form a signature.

2. For the cover, use a heavier paper, one that you have embellished or collaged, or a decorative paper of your choosing. If the paper isn't heavier than your signature paper, laminate it with another sheet of coordinating paper. Cut the cover paper slightly bigger than your folios so that it overhangs the signature by about 1/8 inch on top, bottom, and the fore edge. Alternately, you can give it an extra inch or two on either end and fold back the fore edges for extra stability. Fold it in half along what will be the spine of the book.

3. Nest the signatures, centered, inside the cover. Holding the book open, mark the center of the fold, and two points about 1/4 inch from either end of the signature. Use an awl or a sturdy pushpin to poke a hole through the spine of the book at each mark. This is easier if you hold the signature open at 90 degrees and poke the hole at a 45-degree angle. (See photo **B**.)

4. Cut a length of thread that's about three times the length of the spine, and thread your needle. Begin sewing by passing the needle from the outside to the inside through the center hole. Leave a tail of about 6 inches. (See photo **C**.)

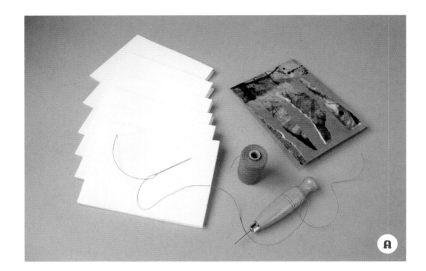

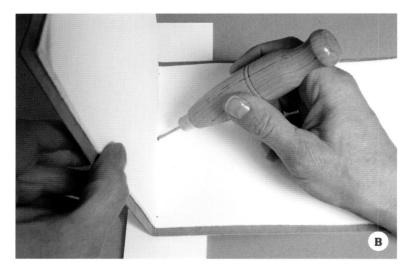

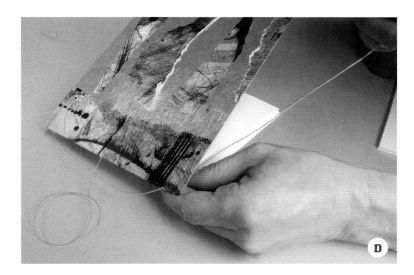

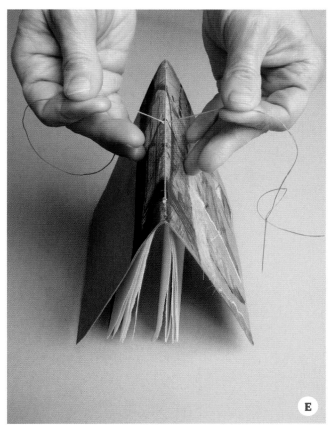

5. Now sew from the inside to the outside through the top hole and then through the bottom hole from the outside to the inside. (See photo **D**.)

6. Sew back through the center hole from the inside to the outside. Make sure that the tail and the needle ends of the thread are on opposite sides of the thread going down the spine. Snug up the thread and tie a knot. (See photo **E**.)

Note: You can also do this sewing by starting from the inside of the center hole and concealing the knot inside the book rather than showing it off on the spine. If you have the knot on the spine, it's an opportunity to add beads or tassels to the tails.

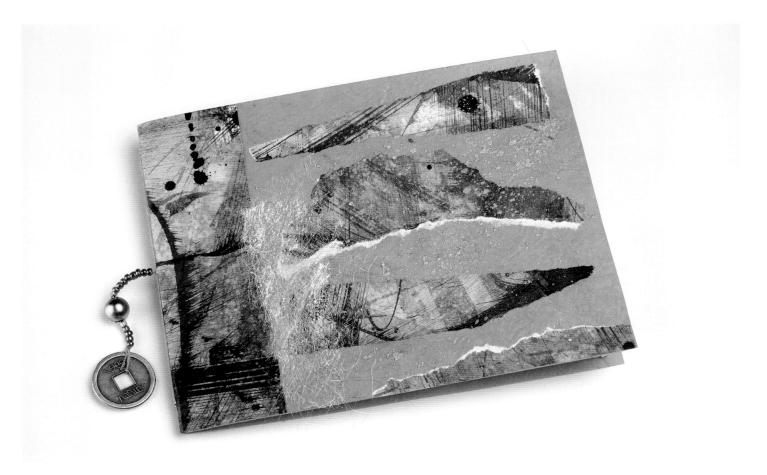

The pamphlet stitch can also be used to sew two signatures together as well as to a cover paper or endpaper. In this project we will sew two signatures to an endpaper, which will then be glued into a hard cover. The resulting book is much more substantial than the simple one-signature pamphlet book, and yet the sewing is just as simple.

You'll need:

- Two sheets of text paper, for your text block
- Paper for covering the cover boards, or "cover paper"
- Illustration board, matboard, chipboard, or book board for the covers
- Decorative, collaged, or hand-painted paper for your endpaper
- Bone folder
- The basic tool kit (see Tools, page 18)
- An awl or pushpin
- Waxed linen or other strong thread
- Needle

1. Cut your book boards so that they extend about ⅛ inch beyond your signatures on the top, bottom, and fore edge but are flush with the spines. Cut two cover papers big enough so that they extend at least 1 inch beyond the top, bottom, and fore edge of each book cover and about ¼ inch shy of the spine edge. The spine edge will be covered with a contrasting spine paper. Glue the book boards to the cover paper. (See photo **A**.)

2. Working with one board at a time, apply glue to the exposed edges of the cover paper at the corners, and fold over the corners at the fore. Apply glue to the top and bottom exposed edges of the cover paper and fold them over; then do the same with the fore edge. (See photos **B** and **C**.) Do the same for the second board.

3. Cut a piece of paper for the spine that measures the length of the spine plus an inch overhang on each end; the width should be the width of the spine (usually ½ to ⅝ inch for this type of double-pamphlet binding; check by measuring the width of your two signatures comfortably stacked) plus ½ inch overhang so that it overlaps the cover paper at the spine edge. (See photo **D**.) Glue the covered book boards to the spine paper, then fold over and glue the top and bottom of the spine paper. (See photo **E**.)

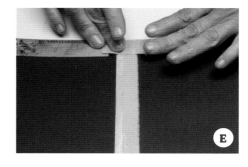

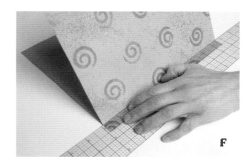

4. Fold your endpaper in half along what will be the spine of the book (lengthwise) so that the right side of the paper is facing out. Measure ½ inch from the fold, and from there fold the front and back in the opposite direction, creating a ½-inch accordion fold at the spine. (See photo **F**.)

5. Nest the two signatures into either side of this fold as shown to make sure they fit properly. (See photo **G**.)

6. Mark and poke holes in the two signatures as described in the "Pamphlet-Stitch Journal" project (see page 48). Mark and poke corresponding holes in the accordion fold of the endpaper. (See photo **H**.)

7. Starting the sewing from the inside of either signature. Pamphlet-stitch through both signatures and the accordion fold of the endpaper. (See photo **I**.)

8. Cut the endpaper flush with the fore edge of the signatures. Place the text block inside the book cover. If the endpaper extends beyond the edges of the cover, trim it down.

9. With the book placed on the worktable in front of you, open the front cover. Slip a sheet of scrap paper under the front endpaper so that it extends beyond the edge by at least 1 inch. Apply glue to the endpaper all the way to the edges. (See photo **J**.)

10. Remove the scrap paper, and carefully close the front cover of the book. (See photo **K**.) Turn the book over and repeat step 9 on the back endpaper.

11. Place sheets of waxed paper inside the front and back covers, and then wrap another sheet around the outside of the book. (See photo **L**.) Place it under a stack of heavy books and let it sit under the weight for several days.

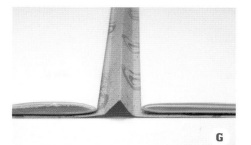

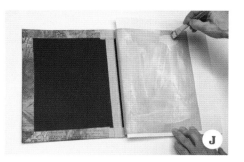

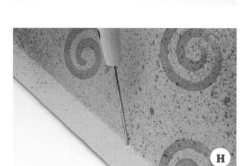

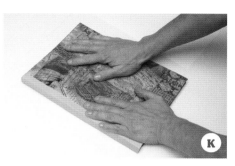

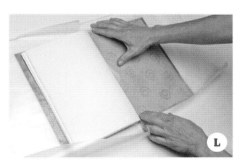

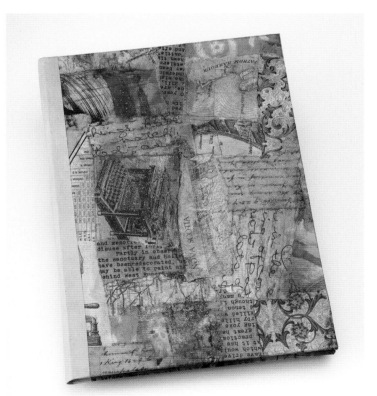

PROJECT: MULTI-SIGNATURE HARDCOVER BOOK

You can use the simple pamphlet stitch to create a book with more than two signatures by making a hard cover as described above (or a soft cover if you prefer) and then sewing a group of signatures to the spine, side by side. The endpaper in this project is different from the "Double-Pamphlet-Stitch Journal with Hard Cover" project. Here, you'll first cut a sheet of decorative or collaged paper about 1/8 inch all around smaller than the book cover and glue this sheet to the inside of the book cover. This will serve as your endpaper.

You'll need:
- Text paper—enough for five signatures
- Book covers—illustration board, mat-board, chipboard, or book board
- Cover paper
- Endpaper
- White glue or PVA
- The basic tool kit (see Tools, page 18)
- An awl or pushpin
- Waxed linen or other strong thread
- Needle
- Bone folder

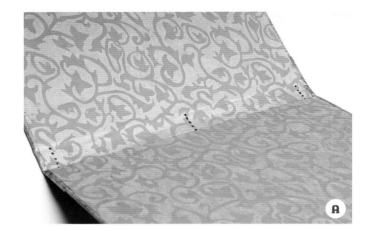

1. Prepare five signatures (see "Measuring Paper and Cover," page 46). Of course, you can make a book with more or fewer signatures, but five is an easy number to handle, and it also makes marking the sewing holes in the spine a little easier. Make a hard cover with a soft spine (see the "Double-Pamphlet-Stitch Journal with Hard Cover" project, page 50). Make the spine wide enough to accommodate your signatures comfortably.

2. Glue your endpaper to the inside of the book cover. Make folds along both sides of the spine, and mark with a pencil if the folds are not adequately visible.

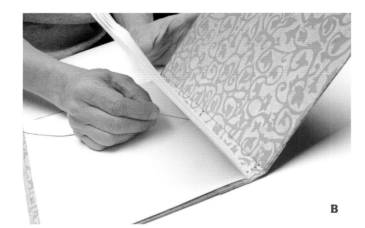

3. Punch three holes in the spine of each signature as described in "Pamphlet-Stitch Journal" (see page 48) for pamphlet stitching. Punch corresponding holes in the spine of the cover, spacing them equidistant from each other as shown, with one hole in the middle of the spine and two on either side, the outside holes being just inside the folds of the spine. (See photo **A**.)

4. Working with one signature at a time starting at the back, use pamphlet stitch to sew each signature to the spine. (See photo **B**.) For this book, I started the pamphlet stitch from the inside so that the knots are concealed. (See photo **C**.) Make sure when sewing the signatures that you're going through the correct corresponding holes in the spine. If you miss one, the rest of the sewing will be off. This is a fairly quick sewing, however, and mistakes don't take long to correct.

5. Wrap the book in wax paper as described in the "Double-Pamphlet-Stitch Journal with Hard Cover" project (see page 50), and weight it for a day or two under heavy books. This will help the book stay flat when closed.

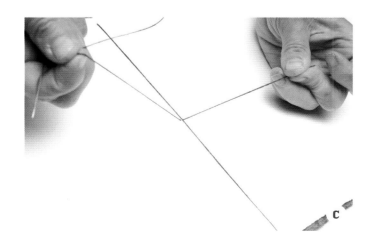

◄ The exterior spine of the finished book.

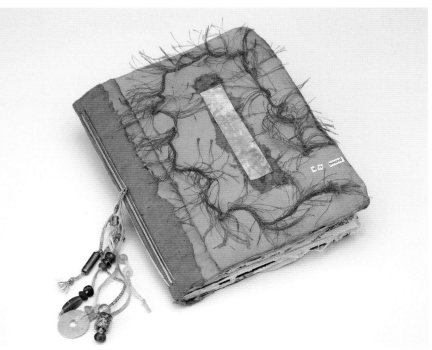

◄ **JILL ABILOCK:** Softcover book.

Jill used the same construction method as the one used for a hardcover, but on a softcover book. She started the pamphlet stitch from the outside of the book and embellished the remaining tails of thread with beads. She used a different colored thread to sew each signature.

▲ **AUTUMN HATHAWAY:** *Summer Journal* 2008.

A SEASON OF INSPIRATIONS

Autumn Hathaway creates her book covers by attaching two book boards (usually discarded cardboard) to a spine made from a used manila file folder. Then she covers this with stitched and embellished fabric and sews around the edges by hand with a whipstitch. She always sews quilted pockets into the inside front and back covers for memorabilia. Autumn makes her signatures from a heavy watercolor paper and randomly embellishes them with fabric scraps, stitching, collage, and painting, leaving plenty of room for writing and more embellishment. Then she binds them into the cover using the multi-signature pamphlet stitch. Her summer journals are documentary as well as visual feasts.

"I don't worry about where certain embellished pages land as I bind the book," she says. "As I write in it, whatever embellishment appears on the page the day I'm making an entry is just perfect. I carry along a box of watercolor crayons, assorted pens, a few stickers, a little jar of gel medium (for serious bonding), and a glue stick, along with the journal on all our summer outings, including the beach, vacations, and camping."

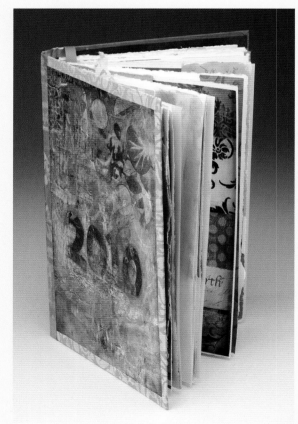

▶ **JANE DAVIES:** *2010 seasons journal detail.*

Inspired by Autumn Hathaway's summer journals, I made a series of collaged and painted folios to create a 2010 seasons journal. I used designs I had created for freelance projects as well as fabrics, tissue papers, and hand-painted papers.

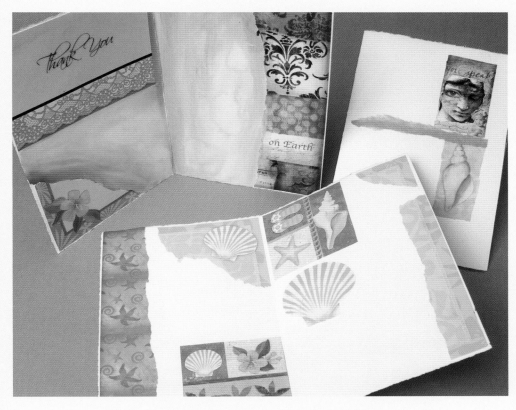

JANE DAVIES: This is a group of folios that I prepared for a journal inspired by Autumn's summer journals. For this journal I used old print-outs of designs I'd made for freelance projects as well as other collage material. On most, but not all, of the pages I added washes of color, and on some I sewed bits of fabric and trim. The intention was to create a realm in which my design work integrates with my collage in a meaningful way.

AUTUMN HATHAWAY: *Summer journals.*

In addition to her own journaling, Autumn's summer journals sport an occasional entry by her husband or one of her children. You can see the change in the handwriting on the page with the starfish.

HARDCOVER BOXES

The box format gives us an opportunity to consider the question of content in both its physical and aesthetic senses. At the same time, the techniques I demonstrate form a strong foundation for taking box-making to more complex levels. Making a hinged lid hardcover box is very much like making a hard cover for a book. The box itself is like the text block, and the lid, bottom, and "spine" of the box are analogous to the book cover. The Message Box is tiny, 2 ½ inches square and 1¼ inches high, but you can make boxes of this construction up to any reasonable dimension. I use fairly thin cardboard for this box, the packaging for large-format printer paper. If you want to make a box much bigger than this, say over 8 inches in either dimension, you'll get better results with a studier board, such as heavy illustration board or chipboard. If you're concerned with the archival quality of your box, use illustration board that's archival, museum board, matboard, or book board (which looks like chipboard, but it's archival and made specifically for bookbinding).

There are as many ways to make boxes as there are box makers. Many of those ways are much more precise and exacting than mine, but they're also more time-consuming. My method requires precise measuring and cutting but leaves enough wiggle room to be accessible to the novice box maker.

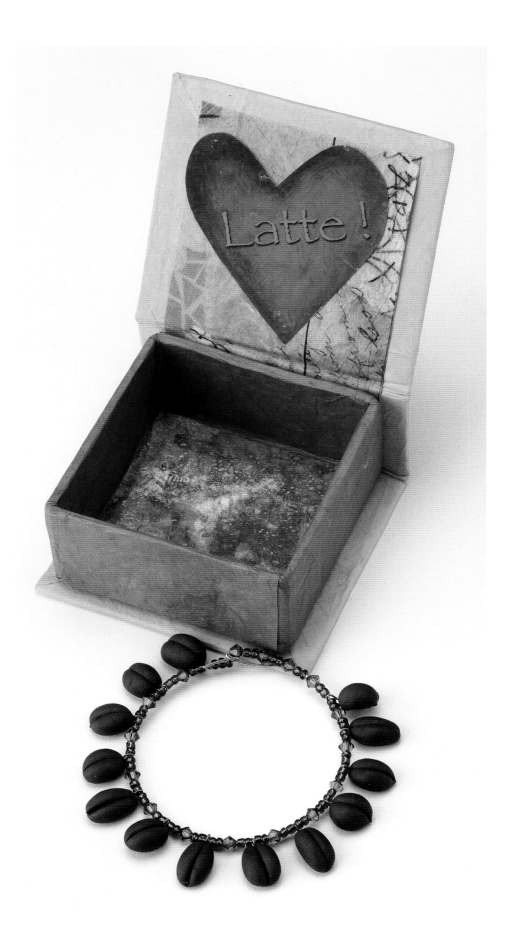

▶ **Jane Davies:** *Live, Love . . . Latte* box.

I had made these polymer clay coffee beans years ago, figuring I would use them for something. They worked beautifully for this bracelet inside the coffee-themed "message box."

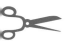

PROJECT: MESSAGE BOX

This project takes us through the process of creating a hinged hardcover box. The technique is similar to that of making a hard cover for a book. The box structure consists of two parts: the box itself, plus the bottom, back, and hinged top that are part of one piece I'll call the "cover." The box piece is covered with four folded pieces of paper, while the cover is wrapped in one sheet of paper like a book cover.

You'll need:

- Template 6 (see page 133)
- A piece of cardboard (I used the cardboard packaging from printer paper), matboard, illustration board, or chipboard
- Lokta in one or two colors
- A bone folder
- The basic tool kit (see Tools, page 18)
- White glue or PVA
- Paper to cover the inside of the lid. I used a scrap of fabric paper. (See page 92).

1. Cut out a piece of cardboard from the template provided, or make your own template if you wish to make a box with different dimensions. Measure a square or rectangle the length and width of your box, and then add "wings" that are the height of your box. We'll call this part A.

2. Cut out the pieces of part B (the top and bottom of the box cover) in the diagram. These pieces are all 3 inches wide; two of them are 2¾ inches long, and the other (the back of the box) is 1¼ inches. The top and bottom overhang the box by ¼ inch on front and sides but are flush with the back. (See photo **A**.)

3. Using a craft knife, core part A along the four lines defining the central square. Be sure to cut only partway through the cardboard. If you accidentally go all the way through, you can make a simple repair with tape. Fold up the four "wings" and tape at the corners. (See photo **B**.)

4. Cut a piece of lokta 3½ inches wide and about 12 inches long. This width is equal to twice the height of the box plus an inch. Fold it along its length. Cut two lengths that are 3 inches (the width of the box plus about ½ inch). Cut two more pieces that are 2½ inches wide.

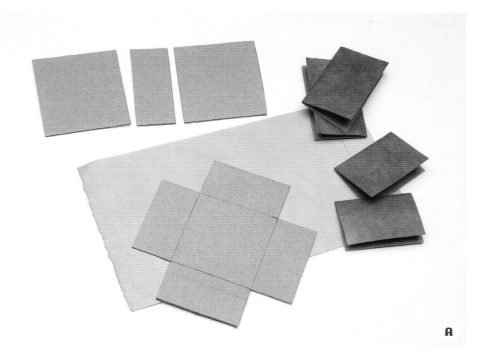

A

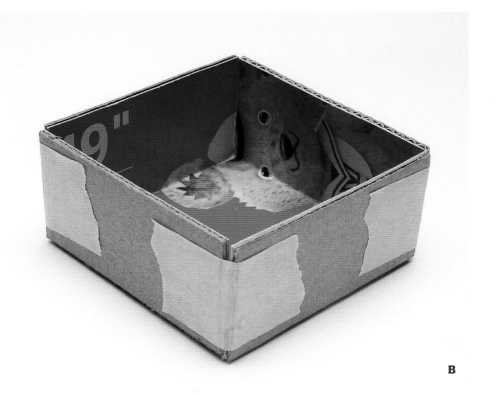

B

5. Apply glue to the inside of one of the 3-inch pieces of lokta, and glue it over one of the box's sides so that the fold lies along the top edge. (See photo **C**.) This piece should wrap around the corners. Use your bone folder to smooth it down on both sides of the box and work it into the corners. Repeat with the other longer piece of lokta on the opposite side of the box.

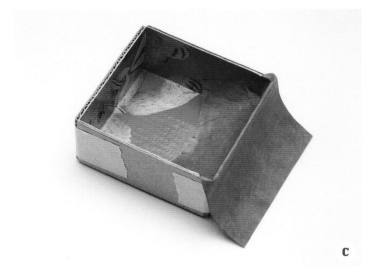

6. Check the shorter pieces of lokta to see that they'll fold over the other two sides of the box easily, without overlapping the corners. Trim if necessary. Glue them in place. (See photos **D** and **E**.)

7. To make the box cover, lay out your remaining three pieces of cardboard on a sheet of lokta. The space between the box parts should be about double the width of the cardboard. So if you're using thicker illustration board or chipboard, space them accordingly. (See photo **F**.) Mark their positions, and cut the lokta so that it overhangs about an inch on all four sides. Glue the box pieces to the lokta, and cut the corners to 45-degree angles. Fold over and glue all four sides of the lokta. (See photo **G**.)

8. Glue a small sheet of lokta or other paper to the inside of the lid so that it extends beyond the hinge onto the back of the box cover. I used a scrap of fabric-paper (see "Making a sheet of fabric-paper," page 92). Place the box on the cover so that the back of the box lines up with the back edge of the box cover and is centered on the box cover. Glue the bottom of the box to the box cover. (See photo **H**.)

9. Apply glue to the back of the box, and then fold up the box cover to adhere it. (See photo **I**.) Cut a square of lokta or other paper that fits inside the bottom of the box, and glue it in place. Now it's time to decorate and collage your box.

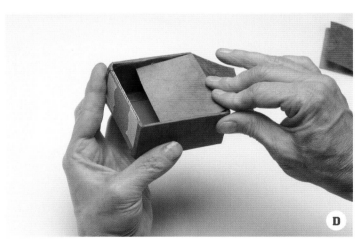

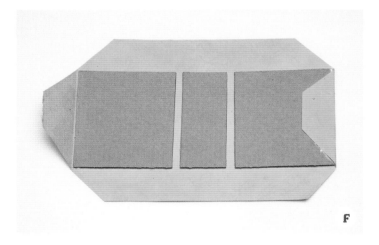

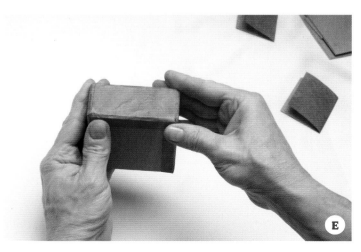

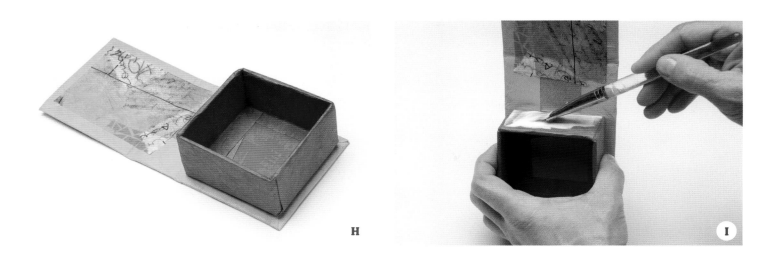

H

I

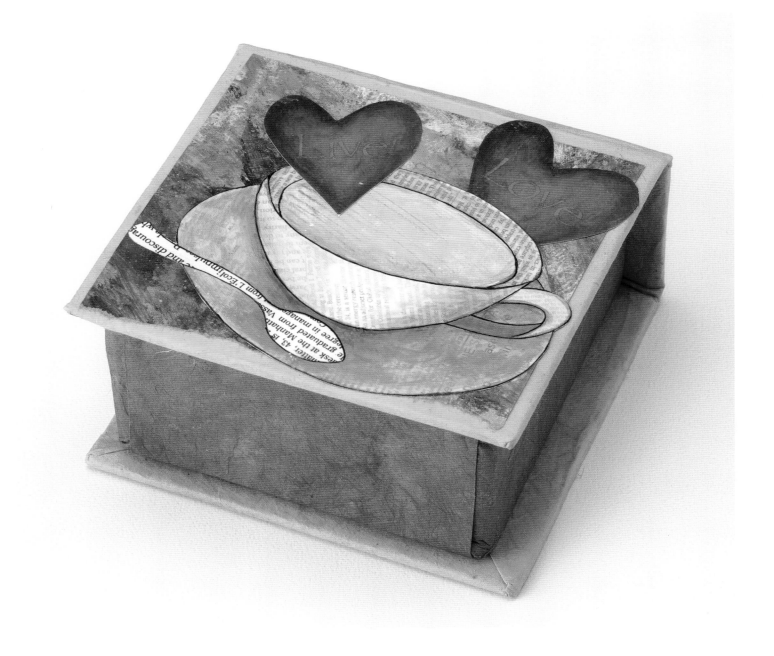

In addition to using store-bought or found objects for embellishing your projects, you can create unique "gems" with little more than a few papers and a glue gun.

◀ **JANE DAVIES:** *Paper mosaic jewel box.*

This is a two-piece lidded box, made using the same technique as the box part of the hinged box. Simply make two of them, one about ¼ inch bigger than the other. (If it's small and made of thin cardboard, ⅛ inch bigger would probably work better.) The excuse for this box is to use my paper mosaic technique, along with glue gems and paper gems. And, of course, it functions beautifully as a place to put my "jewels"!

Glue Gems

Here's yet another use for your glue gun. You can make these sparkly, glitzy gems with just a shot of hot glue and some foil paper, with or without extra glitter.

You'll need:
- A hot glue gun with plenty of glue sticks
- Foil origami paper (not transfer foil, such as Jones Tones)
- Glitter embossing powder

1. Squeeze out a drop of hot glue from your glue gun onto a sheet of foil paper. While the glue is hot, sprinkle glitter embossing powder onto it (see photo above, right.) The glitter embossing powder melts into the hot glue, making it sparkle.

2. Let it cool completely before cutting around the edge with scissors and applying the gem to your project. The resulting gem has a crisp sparkle.

Variations of glue gem technique
There are many variations you can try when making glue gems. Apply hot glue over a drop of glitter glue; try different colors of foil, and even iridescent, glitter, or pearlescent paper. You can place a rhinestone or crystal in the glob of glue before it cools or squeeze out a swirl of glitter glue on top of the hot glue before it cools.

Paper Gems

Paper gems are made by coating painted paper with several layers of clear embossing powder with accents of glitter and Angelina fiber. I start with paper that I've prepared in the same way as for paper mosaic (see page 63), but you could experiment with different possibilities. As long as the base paper is relatively stiff, like your basic paper, it should work. Paper gems are easy and quick to do, but make sure to work very small.

1. Coat a small section of your paper, an area about 2 inches square, with embossing ink or a very thin coat of matte medium. Pour clear embossing powder over the coated area, and shake off the excess onto the sheet of copy paper. Pick up the copy paper and use it, folded, to guide the embossing powder back into the jar. Apply heat with the heat gun until all the embossing powder is melted. (See photo **A**.)

2. Quickly sprinkle on more clear embossing powder while the first coat is still wet, and apply more heat. Do this a few more times until you have a nice thick glaze on your paper. (See photo **B**.)

3. While this glaze is still wet, sprinkle in a little glitter embossing powder; heat and repeat if you want to add more glitter. (See photo **C**.)

4. Now comes the fun part. Put your Angelina fiber very close by, but not so close that the heat gun will blow it away. Heat your glazed paper again, put down the heat gun (and turn it off), and quickly lay some Angelina fiber over the surface while it's still wet. (See photo **D**.)

5. Heat again briefly to make sure the Angelina is well integrated into the glaze. At this point, if you heat the surface too much, the Angelina will lose its shimmer, so add it just once, and you're done. Do not repeat this step.

6. Now you have the material for a paper gem, and all you have to do is cut it out into whatever shape you choose and apply it to your project. I used paper gems on my jewel box and on a handbag (page 33). You can also make paper jewelry out of it adding more embellishments as you like. Paper gems, like glue gems, come to life with a little bead embroidery around the edge.

You'll need:

- Your basic paper (see Paper, page 12), painted to your liking
- Clear embossing powder or UTEE (ultrathick embossing enamel)
- Glitter embossing powder
- Sheet of copy paper
- A tiny bit of Angelina fiber
- Heat gun
- Embossing ink or matte medium (embossing ink is better because it doesn't dry, but if you don't have any on hand, matte medium will work if you work quickly)

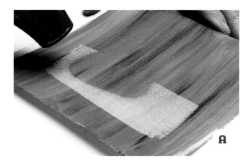

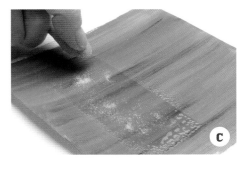

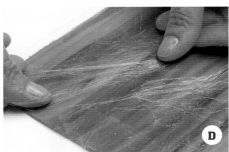

▲ **JANE DAVIES:** *Heart Pin.* I made this heart pin by cutting a heart out of a pink paper gem. I glued the heart onto a piece of black Ultrasuede, and then embroidered beads around it. The beads include 11° gold filled hex cut Delicas, and 10° rocailles. I glued two dyed feathers to the back, and then added the pin back.

Bead Embroidery

A row of beads embroidered around the edge gives your glue gem, or any flat-backed embellishment, a finished look. This technique is useful for embellishing any fabric project with beads. Unless you're beading on a wearable garment, it's a good idea to secure the stitching by applying a coat of matte medium to the back or even gluing on a sheet of rice paper.

You'll need:

- Your glue or paper gem
- A small piece of heavy, non-woven interfacing or Ultrasuede for backing
- White glue or PVA
- Beading thread and a needle
- A few dozen beads, either 11° Delicas or other seed beads, or 15° rocailles (see Embellishments, page 16)

1. Glue the gem to the interfacing or Ultrasuede and let it dry. Thread your needle with a couple feet of beading thread and tie a knot in the end. I used black thread in the photographs for easy viewing. It's better to use a color closer to that of your backing material. Bring the thread up through the backing right at the edge of the glue gem, and make a little backstitch to secure it. Thread three beads onto your thread. (See photo **A**.)

2. Holding the beads down along side the glue gem, bring the needle and thread back through the backing, again right at the edge of the glue gem. Pull taut, then come back up through the backing between the second and third beads. (See photo **B**.) You've made a little back-stitch the length of one bead. Thread the needle through the third bead. (See photo **C**.) Repeat all the way around the glue gem.

3. When you come back to the first bead, bring the thread through the first few beads again before going back through the backing and securing the thread with a knot.

4. Apply a coat of matte medium or glue to the back of your piece to secure the stitching. When it's dry, cut away the backing as close to the beads as you can without cutting the thread.

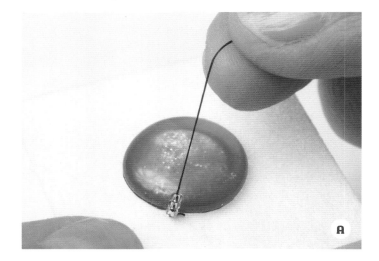

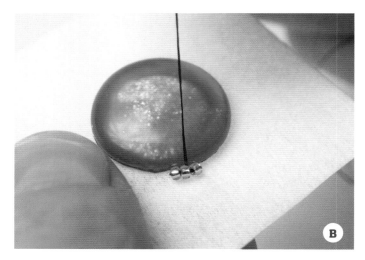

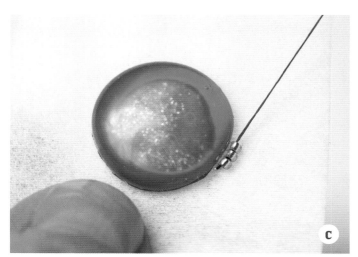

Paper Mosaic

There are many approaches to paper mosaic. This one is intended to simulate stained "opal" glass mosaic, which uses opaque bits of glass that have a characteristic directional variation in color.

To paint papers for mosaic, I use acrylic glazes—paints mixed with glazing medium—and paints. First I apply a coat of the main color. Then I load the brush with another color (usually a darker or lighter version of the main color) and white and apply that over the main color, working the brush in one direction. It's important not to overwork the paint, otherwise the colors will mix too much and lose the streaky effect.

Paper mosaic is a very time-consuming...I mean, *meditative* technique, but well worth the effort on small pieces. I start by cutting my mosaic paper into strips about ½ inch wide and then cut those into irregular rectangles and squares. Then I cut each piece to fit as I go, leaving some, but not too much, space between them. I love incorporating the paper gems and glue gems into a mosaic piece, as they add sparkle.

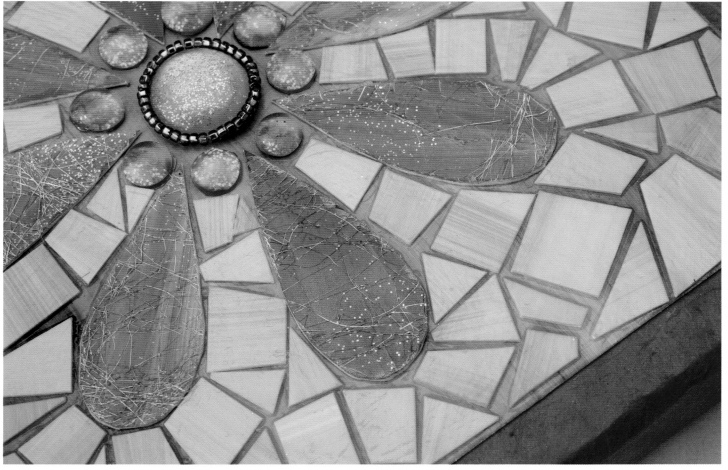

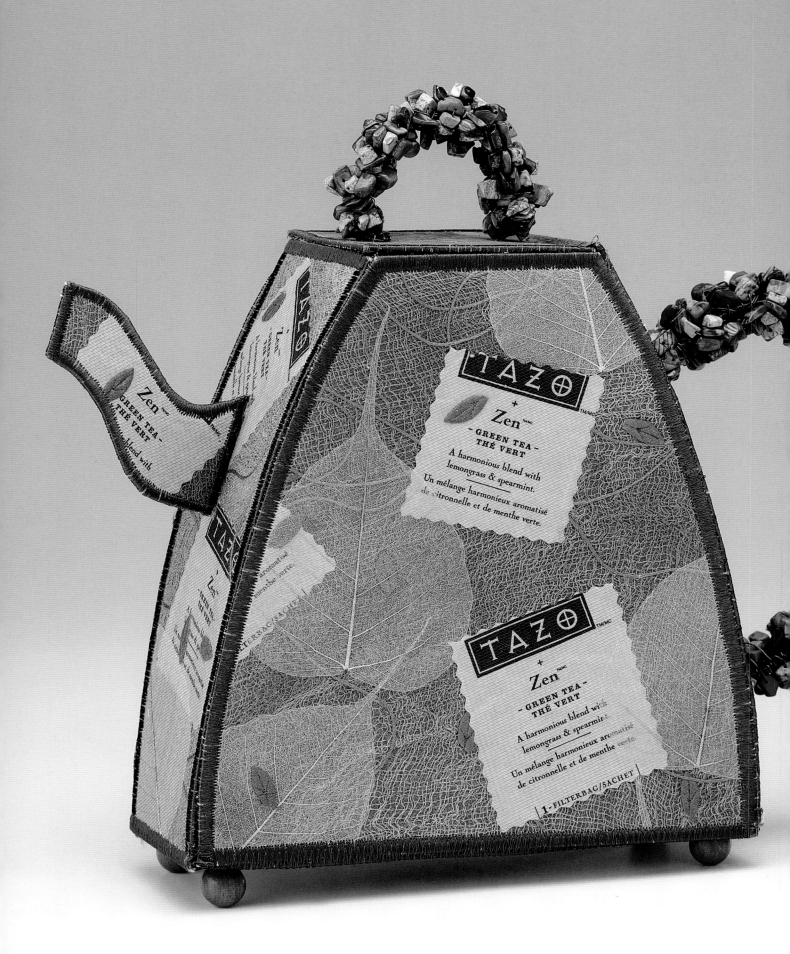

Fusion Fabric and Fiber

This chapter is about hot fusion—that is, binding materials together using a bonding agent and heat. Hot fusion is different from other adhesive techniques in that you can prepare and arrange your materials first, whether you're working with fabric, paper, or fiber, then all at once bond them together quickly with the application of heat. The bonding agents—fusible web and bonding powder— add very little substance to the fused material and, unlike liquid adhesives such as glue, don't impose a particular finish or handling quality. Hot fusion is an especially good technique for working with fabric, as it allows the fabric to retain its drape and surface. The main source of heat for these projects is a standard iron, though the heat gun comes in handy for Tyvek beads (see page 87).

◄ **Sue Bleiweiss:** Fusion fabric teapot.

FUSION FABRIC

Fusion fabric is a method of creating a complex collage surface by layering bits of paper, fabric, fiber, and thread between sheets of fusible web and bonding them together with heat. Since you're bonding these materials to a base fabric, the resulting piece can be stitched and further embellished with quilting, embroidery (machine or hand), and beads. I started exploring this technique a few years ago and then came across the work of Sue Bleiweiss, who has created some fun projects and construction techniques. She has graciously allowed me to share them.

Fusible Web

Fusible web, available by the yard or in prepackaged pieces in the interfacing section of most fabric stores, is a non-woven synthetic fiber that melts when heated. When you sandwich it between two pieces of fabric or paper and iron, the two materials bond together.

You'll find fusible web available in a variety of weights. For fusion fabric, I recommend the lightest weight you can find. Mistyfuse is a very light-weight fusible web used for sheers and projects where you don't want to add bulk to your fabric. But there are other brands that offer similar lightweight products. Many fusible webs come with a paper backing, so that you iron it onto the fabric and then peel off the paper. Others, including Mistyfuse, do not have this backing, so you have to protect your iron by placing a piece of baking parchment or a Teflon sheet over it before pressing.

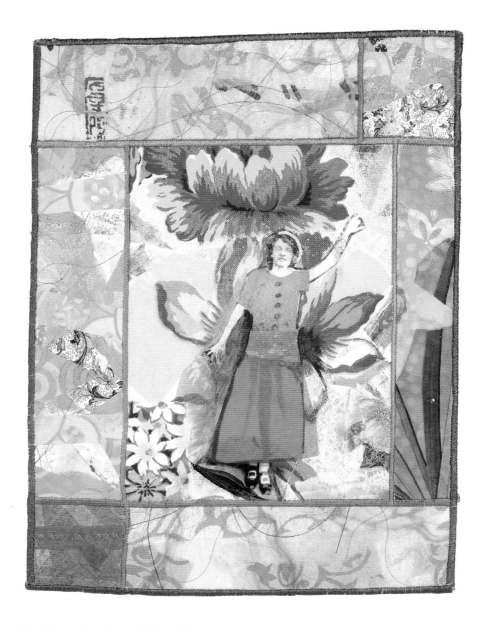

▲ **JANE DAVIES:** *Caro* fusion fabric quilt.

I made this small fusion fabric quilt to honor my late great-aunt Caro, who was an artist and a designer. This photo of her was taken early in the twentieth century.

◄ Mistyfuse is one brand of sheer, lightweight fusible web. I recommend cutting it on a dark surface so that you can see it better.

OVERCOMING CREATIVE BLOCKS

Mixed media is a great realm in which to overcome creative blocks or get jumpstarted if you're out of practice. We would all like to have a continuous flow of creative energy and inspiration, producing piece after piece without interruption. If only the creative path were a smooth one with no roadblocks!

Whether you're a new or experienced artist, we all have times when inspiration eludes us and we just don't feel particularly creative. This is a good time to start from the standpoint of materials and techniques. Sometimes just putting materials together in a new way is enough to get the juices flowing again. This avenue is always open to you. Feeling stuck? Pick up some materials and start fooling around. Follow instructions for a project in a book (this book!), or take a workshop that focuses on a particular project or technique.

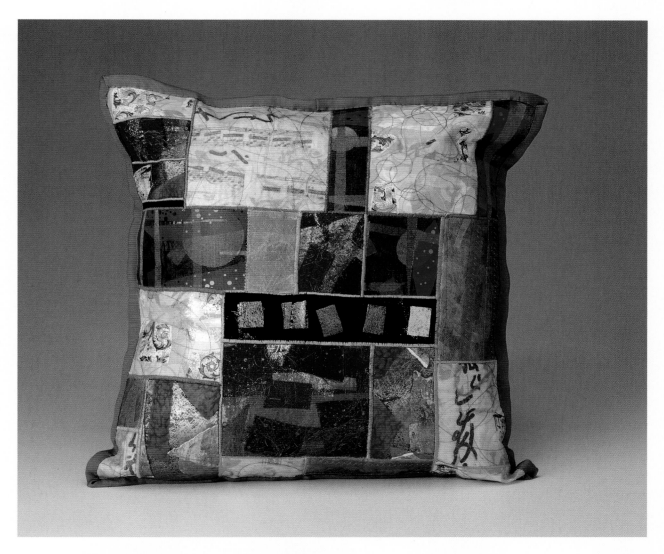

▲ **JANE DAVIES:** Fusion fabric pillow. This pillow was inspired by Indian patchwork that is made with discarded ceremonial garments, rich with embroidery, beading, and shisha mirrors. Fusion fabric is much easier and quicker to make than all that hand stitching, but the effects of putting a few elements together in a simple patchwork can be just as spectacular.

TECHNIQUE: **BASIC PROCESS FOR FUSION FABRIC**

Choose your base fabric, which can be any fabric with some body. Felt, quilt-weight cotton, silk shantung, denim from an old pair of jeans, and anything that isn't too drapey or lightweight will do if it can stand some heat. It can be a plain solid color, or a bright print. Though most of the base fabric will be covered in the process, its pattern and color are likely to inform your initial choices of fusion collage materials. I like to start with a bright cotton print, partly because I have a lot of cotton prints, but also I find it an interesting challenge to incorporate other materials and still maintain some sense of the base fabric in the final piece.

You'll need:

- Fabric for the substrate, about the size of a "fat quarter"—about 18 x 22 inches or slightly smaller is sufficient
- Baking parchment or Teflon sheets
- Threads and fibers
- Several sheets of Mistyfuse, or other sheer-weight fusible web
- A variety of fabrics in small pieces
- Bits of various collage papers
- Iron and ironing board

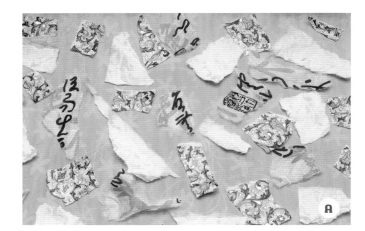

1. Cut your fabric to a size you find comfortable to work with. I usually cut mine no wider than my ironing board, and about 20 inches in length, which is the width of the Mistyfuse fusible web I use for this process. Place a piece of parchment paper, slightly bigger than your fabric, on your ironing board. Then lay the fabric on top, right side up. Scatter threads or fibers on the fabric. Iron with a hot, dry iron. Let cool before peeling off the parchment. If the fusible web isn't completely adhered, replace the parchment and iron again and peel off the parchment when cool.

2. Now the fun begins! Scatter scraps of torn paper and fabric over the fabric, making sure not to overlap the pieces (See photo **A**.) If the pieces overlap, they will not be bonded together completely, resulting in a weaker material. The bigger the variety you have to work with, the better. Scatter some threads and fibers over the paper and fabric scraps, cover with a sheet of parchment, and press with a hot iron to fuse. (See photos **B** and **C**.)

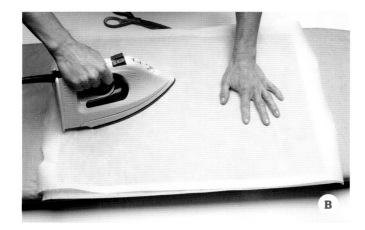

3. Lay down another sheet of fusible web, cover with a sheet of parchment, and fuse with an iron. You could also scatter more threads over the first layer of paper pieces before fusing. Though the threads don't adhere to the paper, they adhere to the exposed fusible web on the background fabric. The next layer of fusible web will adhere them to the paper.

4. Place more bits of paper and fabric over the surface and repeat the process. (See photo **D**.)

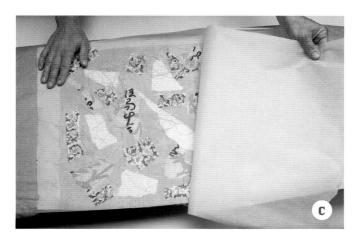

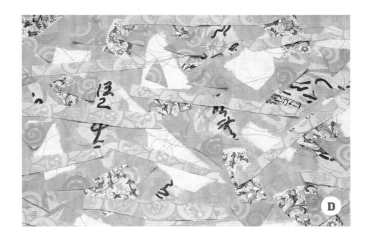

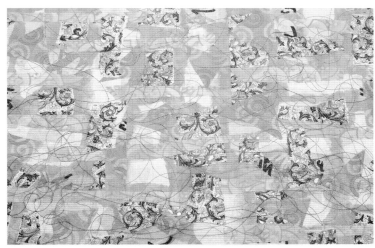

You can build as many layers as you like this way, layering the fabric/collage materials and threads between sheets of fusible web until you have a surface you're pleased with.

Note: If you want to be a bit more spontaneous with this process, you can go ahead and let your collage materials overlap between layers of fusible web. Then, when the piece is finished, fuse a layer of sheer fabric over the top. This ensures that all of the collage materials are fused down and the edges won't peel. A layer of sheer also gives the surface a cohesive finish. In addition to this final layer, you could stitch over the top to "quilt" the layers together, adding yet another layer of pattern and texture.

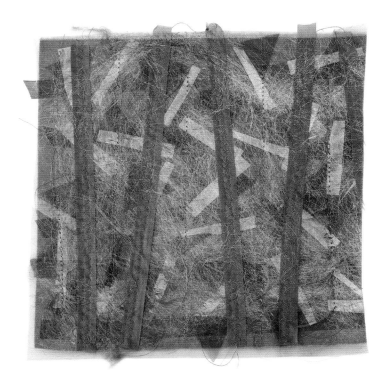

▲ In this sheet of fusion fabric, I incorporated bits of Angelina film (see page 77) as well as fiber. I covered it with sheer tulle and stitched it with gold thread. Once you add Angelina to your fusion fabric, be careful how much you iron it further. The Angelina can lose its sheen from too much ironing or if the iron is too hot.

▲ This simple sheet of fusion fabric is one of my favorites. Limiting the color palette lets you explore texture and motif.

Foil on Fusion Fabric

Another way to add sparkle and glitz to your fusion fabric is to use craft foil such as Jones Tones. Place it *foil side up* over the fusion fabric and press it with a dry iron over a sheet of parchment. Let it cool, then peel up the foil. It will have fused to the exposed bits of fusible web. As you can see, it shows the weblike structure of the Mistyfuse I used for this piece. For demonstration purposes, I left a lot of fusible web exposed before applying the foil, but you could be more subtle with your foil application.

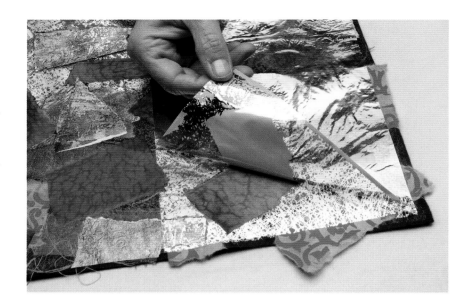

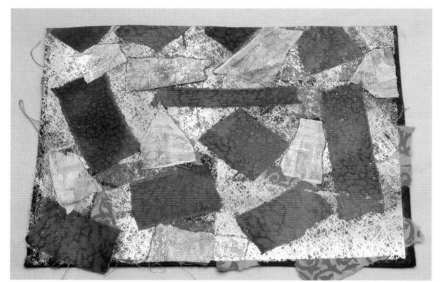

▶ The foil application clearly reveals the weblike structure of the Mistyfuse. Other brands of fusible web would look a little different.

INTERFACINGS AND STABILIZERS

Interfacings and stabilizers (the terms can be used interchangeably for most purposes) are used to add body and stability to fabrics. In clothing construction, they're usually used in cuffs, collars, waistbands, etc., where the clothing takes a little more wear and tear or where it needs to hold its shape. The interfacings appropriate for the projects in this chapter generally need to have more body than those used for clothing. When choosing an interfacing, consider that it will be the main structural support of your project. I use Timtex for the fan, the box, and the fused fiber vessel because it's very stiff and thick yet is very easy to handle and to sew. Pelmet Vilene is another very stiff interfacing, used widely by British and European fiber

artists, but is not as widely available in the United States. Any heavyweight "craft" interfacing is likely to be stiff enough for the projects in this chapter. For the mini-quilts, you can generally get away with interfacing not quite so stiff, but if you're going to hang embellishments from it, then Timtex or something similar would be the best choice.

Some interfacings are "fusible" and some not. Fusible interfacing has a heat-sensitive adhesive on one side, so that you can fuse it directly to your fabric with an iron. For the projects in this chapter, I assume you're using non-fusible interfacing, so I instruct you to fuse it to your fabric using fusible web. If you're using a fusible interfacing, such as Fast2fuse Heavyweight, then fusible web isn't necessary.

PROJECT: FUSION FABRIC FAN

This project is designed to get you started with fusion fabric quickly. It's simple to construct and uses four different small sheets of fusion fabric. The fan hangs on the wall. You could certainly do this fan with three pieces if you prefer. Another variation is to cut all the pieces from one sheet of fusion fabric.

You'll need:

- Template 7 (see page 134)
- Tools and materials to make four sheets of fusion fabric (see "Basic Process for Fusion Fabric," page 68)
- Scissors
- Stiff interfacing
- Fusible web
- Thread
- Backing fabric
- White glue
- Beads or other embellishments
- Craft wire (optional hanger for your fan)

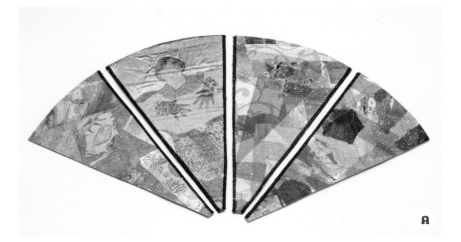

1. Create four small sheets of fusion fabric. You could make them all with the same group of materials so that they coordinate, or use different materials. This is a good opportunity to experiment with different approaches to fusion fabric and make a variety of small sheets quickly. Fuse each sheet of fusion fabric to a sheet of Timtex or other stiff interfacing using fusible web.

2. Using the template provided, mark off four wedges of even or uneven widths to make templates for your fan segments. Then cut out one fan segment from each sheet.

3. Decide the placement of your fan segments, and satin-stitch along both outer edges of the two center pieces and just the inside edges of the outside pieces. (See photo **A**.)

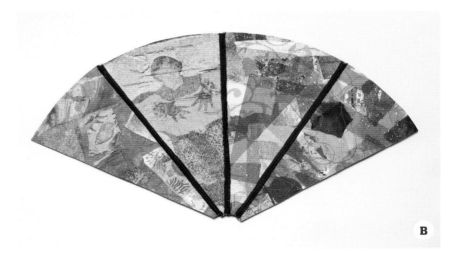

4. Using a longer zigzag stitch (the same width as the satin stitch in step 2, but more space between stitches), stitch together the adjacent segments, assembling your fan into one piece. (See photo **B**.)

5. Cut a piece of your backing fabric slightly bigger than your fan. Use fusible web to fuse it to the back of your fan. Trim the edges of the backing fabric flush with the fan. Then satin stitch around the entire outside edge.

6. Sew on a tassel, a beaded tassel, or other embellishment if you like. (See photo **C**.) After it's sewn, I apply a drop of white glue to each sewing station on the back to ensure that the sewing will not come undone.

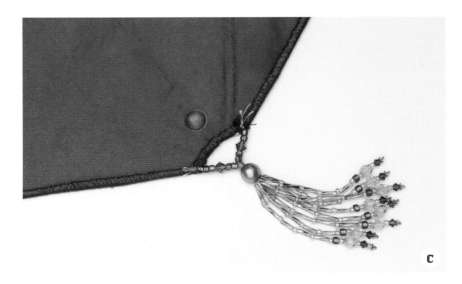

7. To make a hanger for the fan, cut a short length of craft wire and bend it into a half-round curve. Alternatively, you could use memory wire, which holds its curved shape. Bend about ¼ inch in a 90-degree angle, facing out, at each end of the curve, creating an Omega shape (Ω), but with the ends spread apart. Poke two holes in the backing fabric of the fan, and insert the two ends of the wire. (See photo **D**.) In addition to the wire hanging mechanism, you could also add a little plastic bumper to the back of your fan so that it hangs slightly away from the wall. (See photo **C**, page 71.)

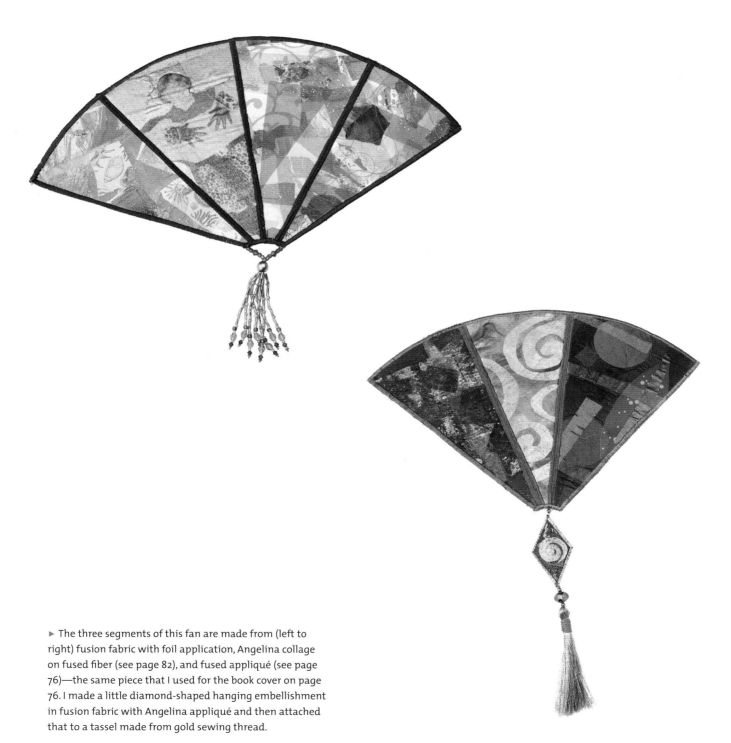

▶ The three segments of this fan are made from (left to right) fusion fabric with foil application, Angelina collage on fused fiber (see page 82), and fused appliqué (see page 76)—the same piece that I used for the book cover on page 76. I made a little diamond-shaped hanging embellishment in fusion fabric with Angelina appliqué and then attached that to a tassel made from gold sewing thread.

TECHNIQUE: MAKING A BEADED TASSEL

Making a beaded tassel is a lot simpler than the results would suggest. All you need is basic bead-stringing equipment: beads, beading thread (any strong thread will do), and a fine needle that will fit through the beads. The tassel consists of beaded strands all gathered together and threaded through a larger bead "head." The threads can then be knotted or else divided and further strung with beads, as I did for the fusion fabric fan.

You'll need:

- Beads for the tassel strands (11° seed beads, bugle beads, 15° seed beads for the "turnaround," and some larger beads for the ends of your tassels)
- One large bead with a reasonably big hole for the tassel head
- Beading thread
- A beading needle or any fine needle that will fit through your smallest bead
- Scissors

1. First, choose your beads. You'll be making eight identical strands for this tassel, and the beading will go a lot faster if you alternate between bugle beads (long, skinny beads) and ordinary 11° seed beads for the length of the strand and then add a larger bead or two toward the end. Choose three smaller beads, such as 15° seed beads, for the turnaround at the end. (See photo **A**.)

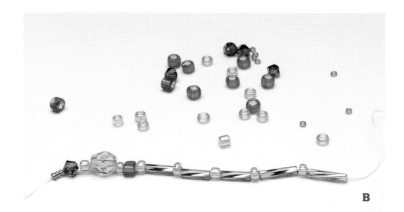

2. String the beads on beading thread with a beading needle, ending with three of the smallest beads. (See photo **B**.) Put the needle back through all of the beads, starting with the one preceding the three small ones—in this case, the bi-cone crystal. Cut the thread, leaving at least 6 inches of tail, and start with a fresh threaded needle for the next strand.

3. Repeat seven times so that you have eight strands of beads. I make the strands slightly different lengths by varying the number of beads in the main part of the strand (the accent beads and turnaround beads are the same) so that the tassel looks more interesting. (See photo **C**.)

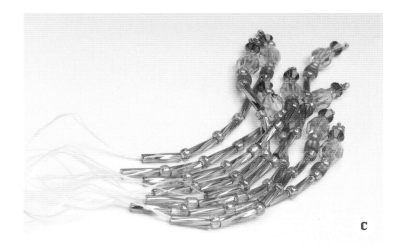

4. Thread all of the threads through the hole of your larger bead for the tassel head. For this step, I fold a fine wire, which acts like a needle threading tool, and put it through the head bead, put all the threads through the wire loop, and then pull it back through the bead, taking all the threads with it. (See photo **D**.)

5. At this point you can knot all the threads together just above the head bead and add a drop of glue for extra security. Otherwise, you can divide the threads and continue beading onto them, as I did for the fan (see "Fusion Fabric Fan" page 71). I made knots at the ends of the short bead strands, then stitched them to the back of the fan. I added a drop of glue over each knot to prevent the knots from coming loose.

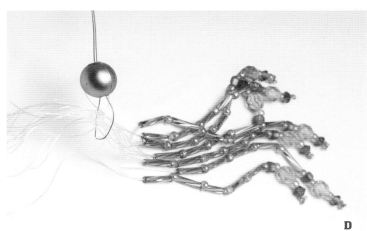

PROJECT: FUSION FABRIC BOX

This project introduces you to a technique of making three-dimensional objects from fusion fabric. You begin by making a sheet of fusion fabric as described above and fuse it to a sheet of heavy interfacing, such as Timtex, and then fuse that to your backing fabric, as we did for the fan. Make your box templates (or use the ones provided). I made my box 2½ inches wide, 3½ inches long, and 2½ inches high. I made the lid approximately ⅛ inch larger than the top and ¾ inch high. It's important to make the lid slightly larger than the box but not so large that it fits loosely. An eighth of an inch seems to be about right.

You'll need:
- Template 8 (see page 135)
- Fusion fabric, enough for box parts (see "Basic Process for Fusion Fabric," page 68)
- Scissors
- Stiff interfacing
- Fusible web
- Thread
- Backing fabric
- White glue

1. Fuse your fusion fabric to a sheet of stiff interlacing, and then to your backing fabric. Cut out your box parts from the sheet of prepared fusion fabric. Use a machine satin stitch (dense zigzag) along the outside edges of each part. (To see the box parts and lid cut out and stitched, see photos **A** and **B**.)

2. Zigzag-stitch the box parts together, and do the same for the lid. (See photo **C**.)

3. Fold the box sides up so they form corners. Now, using the same color of thread as the satin stitch, hand-sew up the sides of the box and the lid. (See photo **D**.)

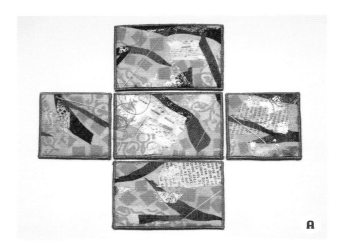

A

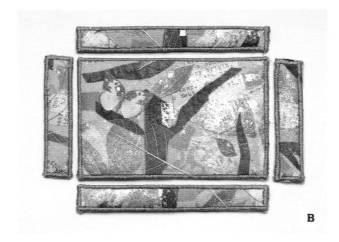

B

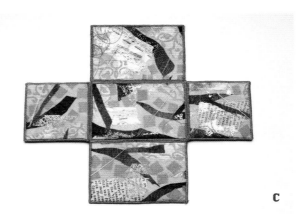

C

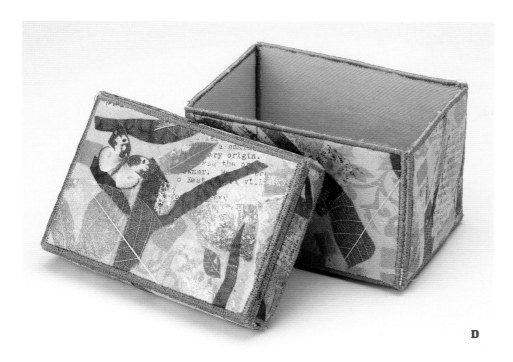

D

▼ **SUE BLEIWEISS:** Chest of drawers.

Sue Bleiweiss's chest of drawers box is a slightly more complicated version of our box project. She uses dyed cheesecloth and deconstructed fabric flowers in this fusion fabric.

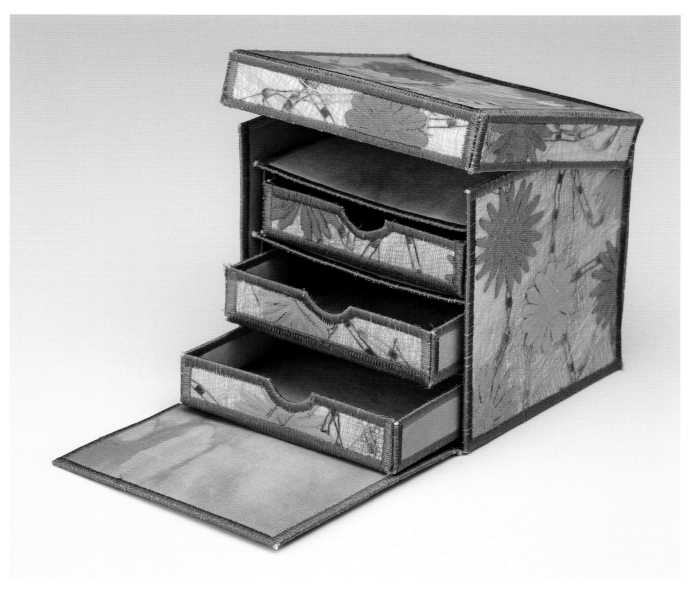

TECHNIQUE: **FUSED APPLIQUÉ**

Fused appliqué is similar to fusion fabric, but it involves more deliberate cutting and placing of pieces before fusing them together.

You'll need:

- Background fabric (see "Basic Process for Fusion Fabric," page 68)
- Fabrics for your appliqué composition
- Fusible web
- Fabric scissors

1. Gather several fabrics that you want to use in your composition, whether it's an all-over design or an image. Fuse a sheet of fusible web to the backside of each fabric.

2. Cut out shapes from these, and play around with them on your background fabric until you have a composition you like. If you have included sheers in your composition fabrics, pay particular attention to how they affect the layers underneath. You may want to test fuse layers of fabric on a scrap piece of the background fabric before committing them to your piece.

3. Once you have your composition placed, fuse the fabrics to a background, using a hot iron over baking parchment or Teflon.

Beyond this basic process, you can stitch, bead, embroider, or paint over your composition. Try hand- or machine-stitching around the main shapes of your composition or adding details with beads or buttons. To make your piece into a mini-quilt, fuse it to a sheet of stiff interfacing and then to a backing fabric. Cut all the edges flush, and use a machine satin stitch (dense zigzag) around the edge.

▲ **JANE DAVIES:** *Teacup Quilt.*

The background for this piece is upholstery fabric with a large-scale floral pattern. I painted over parts of it and then fused the small leaves to the painted background. The tablecloth is a piece of dish-towel material, and the cup is scribble-painted paper (see "Scribble Painting," page 25). I stitched around the teacup and then attached the tea tag before fusing the whole thing to a backing.

◄ I made this book cover from a sheet of fused appliqué, incorporating sheers, metallic fabrics, and silks. It's sewn into a book using the multi-signature technique demonstrated in "Multi-Signature Hardcover Book" on page 52.

ANGELINA FIBER AND FILM

Angelina fiber is a fine, sparkly fiber made from very thin strips of iridescent polyester film. It's both light reflective and light refractive (meaning that it breaks up light into rainbows), so you get more sparkle than with ordinary metallic fibers. Angelina fiber and film is a special case of fusion in which the material and bonding agent are one and the same. Angelina fibers are heat fusible to themselves, which means that they bond to each other when ironed or exposed to heat. They don't bond to other materials (except to your hot iron if you don't protect it). Angelina film is thin sheets of the same material, not cut into fibers. It's equally dazzling and can be fused in layers with the fiber or on its own. Angelina injects a healthy dose of "wow" factor into your projects, so I suggest you use it sparingly.

TECHNIQUE: MAKING BASIC ANGELINA SHEETS

By ironing a tuft of Angelina fiber between two sheets of Teflon or baking parchment, you can create dazzling Angelina sheets.

You'll need:
- A small tuft of Angelina fiber
- Two sheets of baking parchment or Teflon
- An iron and ironing surface

1. Place a tuft of Angelina fiber on a sheet of baking parchment or Teflon. This can be one color of Angelina or several pieces mixed or layered together. (See photo **A**.)

2. Lay another sheet of baking parchment or Teflon over the Angelina, and iron briefly with your iron set at polyester. This only takes a few seconds unless you have a very thick layer of fibers.

3. Remove the top sheet of parchment. Once you iron the Angelina fiber, it turns into a crisp, sparkling wafer that can be stitched or glued into your mixed-media pieces.

A

Not-So-Basic Angelina

Once you have a basic sheet of Angelina fiber, you can fuse more fiber to it or fuse pieces of Angelina film to it. You can also create an image or pattern by fusing cut-out shapes of one Angelina sheet to a background sheet. Another variation on your basic Angelina sheet is to incorporate other materials such as threads, fibers, sequins, or small bits of fabric or paper. (See below.)

Embossed Angelina

Angelina fiber will take on the texture of the surface on which it's ironed. To make a sheet of "embossed" Angelina, place your tuft of fiber on a textured surface. (See photo **A**.) The texture should be deep and distinct such as a piece of wavy corrugated card or a carved rubber stamp. After ironing the fiber under a sheet of baking parchment, you'll find the texture imprinted on the sheet. (See photo **B**.)

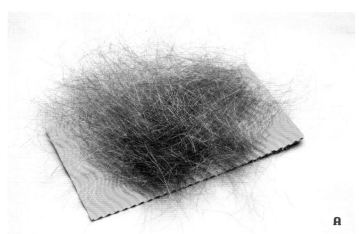

A

B

◄ For these samples, I used, in addition, the wavy corrugated card, straight corrugated card (yellow), and sequin waste (pink). The sequin waste also melts at a low temperature, so be careful to iron quickly.

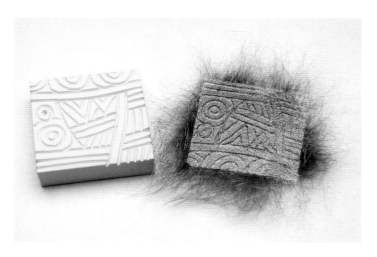

▲ My rubber stamp design shows up beautifully on the peacock blue Angelina fiber.

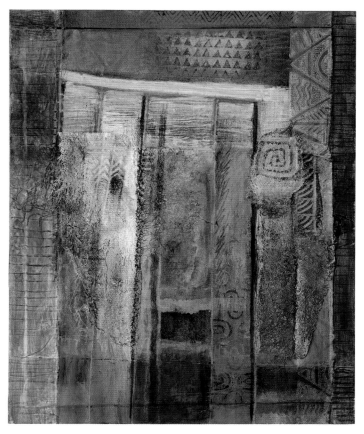

▲ **SHERRILL KAHN:** Untitled collage.

Sherrill Kahn uses embossed Angelina in her mixed-media collages, often intentionally overheating it, which makes it lose some of its sheen but leaves a unique texture. Sherrill even paints over embossed Angelina, further emphasizing the texture by adding contrast.

▲ These pins are made from foam core wrapped in paper and then embellished with Angelina, wire, and beads. Put one of these in a handmade box, and you have a glitzy but inexpensive gift!

► I made these earrings in the same manner as the pins. I wrapped foam core squares in paper and then painted them gold. I glued black Ultrasuede to the front and then the little square of Angelina. The wire spirals are tacked on with thread. See chapter 6 for more details on working with foam core.

FUSING FIBER WITH BONDING POWDER

Bonding powder is a heat-bondable fabric adhesive in powder form. It's available from fabric stores and specialty fiber art suppliers. Sprinkle a little on a piece of fabric, cover with another fabric, then cover that with a sheet of baking parchment or Teflon. Finally, iron with a hot iron. Your fabrics will fuse together as if you had used a sheet of fusible web. It's suitable for quick fabric repairs and hems. Perhaps a more interesting use of bonding powder is to create fabric from loose silk or SoySilk fibers. With bonding powder, you can fuse these fibers much like Angelina, even though they're not bondable in themselves. The result is a beautiful, silky sheet of felt-like fabric with a matte finish. I consider bonding fibers in this way to be a quicker, less messy alternative to silk fusion, a process by which you fuse loose silk or other fibers by soaking them with a very wet solution of textile acrylic medium and letting it dry overnight. However, fibers bonded with bonding powder produce a more delicate fabric, which is best used for decorative, not wearable, pieces.

▲ For this piece I started with white (or natural) and two variegated dyed colors of SoySilk fiber. SoySilk, silk roving, and other such fibers are usually available in small packages, so you can try a variety of fibers and colors for this process.

TECHNIQUE: MAKING A SHEET OF FUSED FIBER

For this process I like to use SoySilk, a fiber made from the residue of soybeans left after tofu manufacture. It's soft and fine like silk roving (loose fiber drawn into long but uneven strands), but I find it's less sticky and easier to work with. If you're accustomed to using silk or wool roving for other projects, such as spinning, then by all means use it for this process as well. Since dyed SoySilk is more expensive than plain white, I start with a layer of white fibers and then lay down the colors. For richer color, use all dyed fiber. Dyed fibers come in single colors or in variegated colors. I like the variegated colors. Another method of creating this type of fabric is to sandwich sheets of Mistyfuse in between layers of fiber.

You'll need:
- Two sheets of baking parchment or Teflon
- A sheet of fusible web as big as you want your fused fiber fabric
- SoySilk, silk, or similar fiber in several colors plus white (white is optional)
- A container of bonding powder
- An iron and ironing board

1. Lay a sheet of baking parchment or Teflon on your ironing surface. Lay the piece of fusible web over this, and tease out a layer of white (or dyed) fiber into an even layer. Make sure to vary the orientation of the fibers so that they cross each other in many places. This will produce a stronger fabric. Over the white, tease out a layer of colored fiber in an even layer. (See photo **A**.)

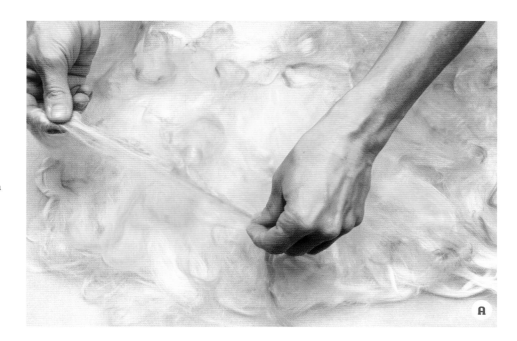

2. Sprinkle bonding powder liberally over the whole surface, and work it in with your fingers, making sure it sifts down into all layers of the fiber. (See photo **B**.)

3. Cover with a sheet of baking parchment or Teflon and iron on a hot setting until the fibers are fused. Let cool before peeling up the top sheet, and if there are still visible granules of fusing powder, iron again over parchment. If the sheet is too thin, add more fiber and bonding powder, and iron again under parchment.

Note: To make this fabric stronger, I recommend doing some decorative stitching over the whole surface, even if you aren't going to proceed with the following Angelina collage process.

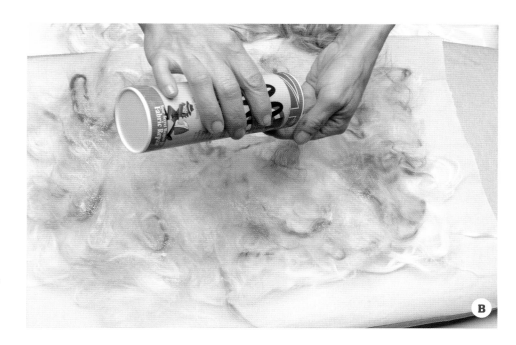

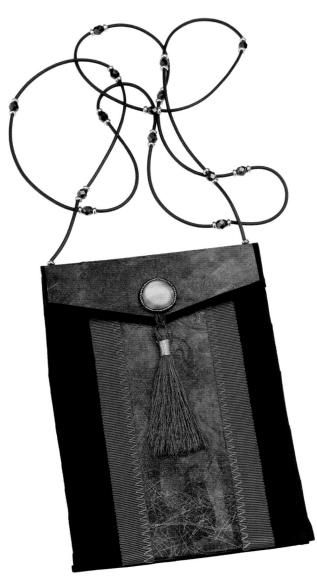

◄ A simple purse featuring a sheet of fused fiber. To add a little sparkle, you can include a sprinkling of Angelina fibers in with the silk or SoySilk, as I did for the center and flap panels of this Ultrasuede pouch. This piece is finished with a handmade tassel (page 29) and a glue gem (page 60).

PROJECT: ANGELINA COLLAGE ON FUSED FIBER

I love pairing Angelina sheets with fused fiber fabric because of their contrasting surfaces. Angelina is so shiny and sparkly, while the fused fiber is matte and soft. (See photo below.) I took my inspiration for this project from a quilter friend of mine, Polly Stone, who creates beautiful quilted vessels of hand-dyed fabrics.

You'll need:

- A sheet of fused fiber (see "Making a Sheet of Fused Fiber," page 80) big enough to fit the template for the vessel
- A sheet of Angelina fabric (see "Basic Angelina Sheets," page 77). Its size is determined only by how much coverage you want in your design.
- A sheet of Mistyfuse or other lightweight fusible web as big as your Angelina fabric
- Two sheets of baking parchment or Teflon
- Iron and ironing board
- A sheet of Timtex or other stiff interfacing
- Thread, if you're doing decorative stitching over the top of the collage

1. Fuse a sheet of fusible web such as Mistyfuse to one side of the Angelina sheet, using a low to medium setting on your iron. Overheating the Angelina will reduce its sparkly quality.

2. Cut the Angelina fabric into small pieces of any shape you choose. For this project, I cut random long, skinny pieces from the Angelina sheet, varying the length and width. *Make sure to keep track of which side is covered in fusible web!*

3. Lay these pieces on the sheet of fused fiber fabric in whatever arrangement you choose, fusible web side down. Place a sheet of baking parchment or Teflon over it and fuse with a warm iron. Peel back the parchment and check to see that the Angelina is fused to the fused fiber. If not, cover with parchment again and iron some more. *Note:* Higher heat results in a stronger bond when using fusible web, but it can severely alter the quality of the Angelina fiber. The trick here is to find a happy medium. Iron on a low to medium setting, but repeat in short increments. Go slowly, and check for bonding frequently.

4. Use a sheet of fusible web to fuse the fiber sheet to a stiff interfacing such as Timtex. Then, if you like, do some decorative stitching over the whole sheet.

PROJECT: FUSED FIBER VESSEL

You can use this technique and template (or your own variation on the template) to make fiber vessels in fusion fabric, quilted fabric, fabric paper, or other media of your imagination. For this vessel, I used the sheet collaged with Angelina on page 82.

You'll need:

- Template 9 (see page 136)
- A sheet of fused fiber (see "Making a Sheet of Fused Fiber," page 80) big enough to fit the template for the vessel (mine or your own)
- A sheet of fusible web as big as your fused fiber sheet
- Fabric for backing the fiber sheet and for making the base
- Fusible web
- Paper for the template
- Iron and ironing board
- Sewing machine and thread
- Hand-sewing needle
- An embellishment of your choice
- Hot glue for attaching the embellishment

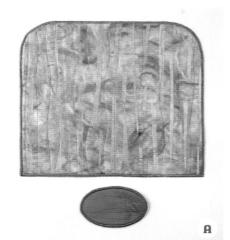

1. Fuse your fused fiber sheet to a backing fabric, (make sure it's been fused to a sheet of stiff interfacing) such as cotton or silk, using fusible web. Make the base by fusing fabrics to either side of a sheet of heavy interfacing. Cut out the oval base using the pattern. I recommend that you make the base out of the backing fabric on both sides, not the fused fiber fabric.

2. Satin-stitch (dense zigzag) around the edges of both pieces. (See photo **A**.)

3. Roll the rectangle so that the two front (stitched) edges meet. Wrap a rubber band around this cylinder so that it holds its shape. Using the same thread that you used for the edging, stitch up the front center seam by hand.

4. Place the cylinder on the oval, and stitch around the base, again using the same thread. Sew or glue on an embellishment of your choice. This is my finished fused fiber vase. I made the embellishment in PaperClay, pressing it into a hand-carved rubber stamp. When it was dry, I painted it with acrylic and glued it to a little tuft of partially fused Angelina fiber. I attached the embellishment with hot glue.

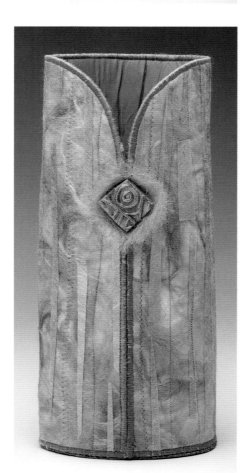

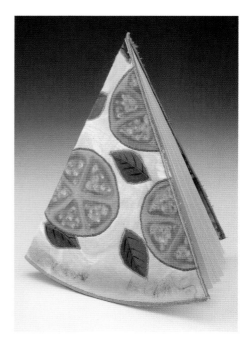

▲ **JANE DAVIES:** *Pizza Book.*

Pizza Book is made with a sheet of fused fiber, which is then painted at the bottom to resemble a pizza crust. The tomatoes and leaves are appliquéd with fusible web and then stitched around the edges. I added a little bead embellishment to make the tomato seeds sparkle.

TECHNIQUE: **TYVEK TECHNIQUES**

Tyvek, which is made of high-density polyethylene spun fibers, has recently become a favorite with mixed-media artists for qualities that are basically byproducts of those for which it was designed. It was developed for its strength, light weight, and durability, but its behavior when exposed to heat is one of its more interesting features. When you apply heat to Tyvek, it shrinks away from the heat source. Tyvek reacts unpredictably when you iron it, morphing into an uneven reptilian texture with bumps, crevices, and depressions. If you iron in short intervals, you can begin to control how much the material shrinks and buckles. I'm sure you'll come up with your own ways to use Tyvek in your mixed-media projects, but here are a few starting points. For these techniques, I'm using hard-structure Tyvek, the kind used in mailing envelopes. Tyvek is also available as a fabric from specialty mixed-media suppliers.

Paint, then Iron

1. Paint a sheet of Tyvek with metallic acrylics such as Lumière. Use a few different colors if you like, blending them into one another. (See photo **A**.)

2. Iron on medium heat between two sheets of baking parchment. The results can be pretty unpredictable, but it is always interesting. (See photo **B**.)

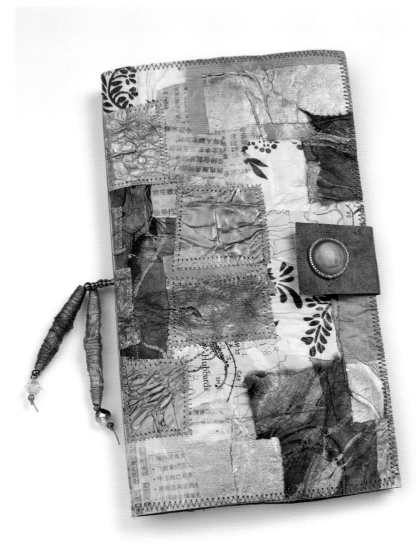

◄ I made this book using the Tyvek patchwork as its cover. The closure is made from a double thickness of lokta with Velcro underneath. It's embellished with a glue gem (see "Embellishing with Paper and Glue," page 60), and Tyvek beads (see "Tyvek Beads," page 87) at the spine.

Iron, then Paint

For a slightly different look, iron the Tyvek first and then paint it with metallic acrylics.

Paint, Iron, then Paint Again

1. Paint your Tyvek with black or other dark, nonmetallic, acrylic paint.

2. Iron until the texture is to your liking.

3. Apply metallic acrylic paints to the upper surfaces of the texture, leaving the crevices black. This creates a pretty dramatic effect.

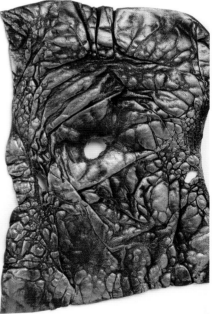

▲ The black piece on the left is Tyvek painted black and then ironed; the piece on the right is like the piece on the left (painted and ironed) but painted again with metallic paints.

Collage, then Iron

1. Use the Basic Collage Technique (see page 35) to make a collage on a sheet of Tyvek. Leave some spaces where the Tyvek support shows through. (See photo **A**.)

2. Iron your collage between two sheets of parchment. You may have to iron quite a lot to have the Tyvek shrink away and actually create holes where there's no collage material. (See photo **B**.)

3. Use other pieces of ironed, painted Tyvek to patch the holes in your patchwork, using a zigzag stitch. (See photo **C**.)

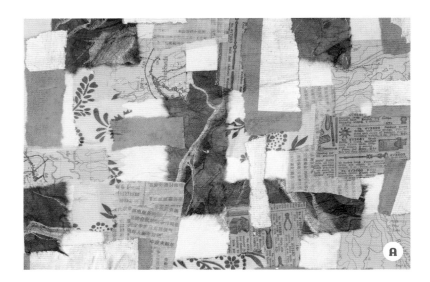

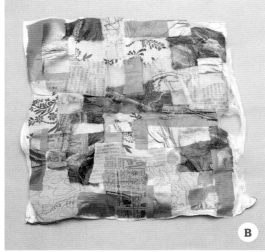

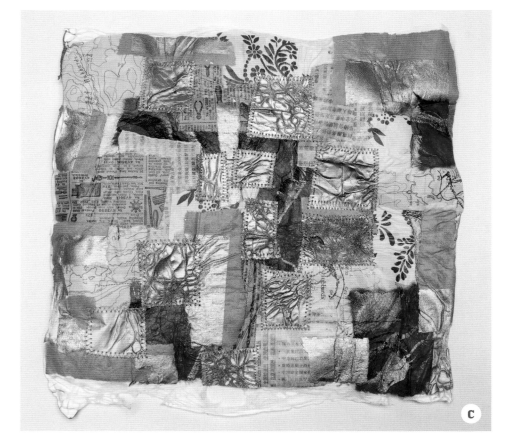

Now you have a solid sheet of Tyvek patchwork that can be used in any number of projects. I used mine as a book cover. First I backed it with a sheet of lokta, weighting it down with heavy books overnight while the glue dried. Then I cut out the cover and stitched around the edge with a zigzag. It's a simple pamphlet-stitch book embellished with . . . you got it, Tyvek beads.

Tyvek Beads

You'll need:

- A sheet of Tyvek
- Acrylic paint, preferably metallic paint, though I encourage you to experiment. I used Lumière for this demonstration.
- A wooden skewer
- A dab of glue or matte medium
- A heat gun

1. Cut a long, skinny symmetrical triangle out of the Tyvek, and paint it with at least two coats of acrylic paint. Let it dry.

2. Starting at the base of the triangle, roll it up around the skewer. Secure the end with a dab of glue or matte medium. (See photo **A**.)

3. Apply heat to your Tyvek roll-up using the heat gun. Move it around so that the Tyvek heats evenly. When the Tyvek bead is shrunken and distorted to your liking, let it cool to the touch and slide it off the skewer. (See photo **B**.) Don't let it cool completely, or it may be difficult to remove. The finished beads can be seen on the book on page 84.

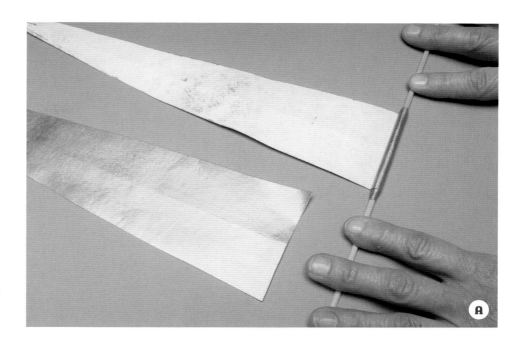

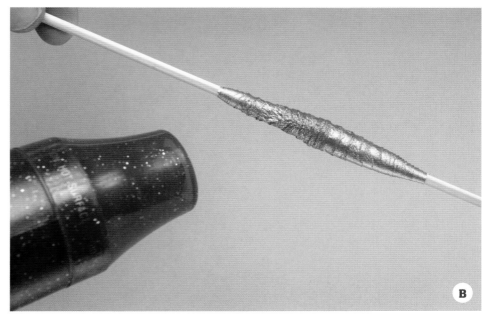

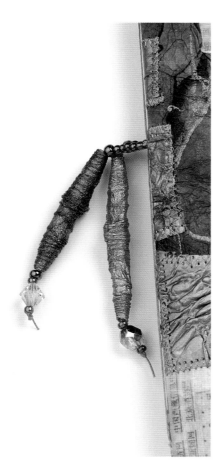

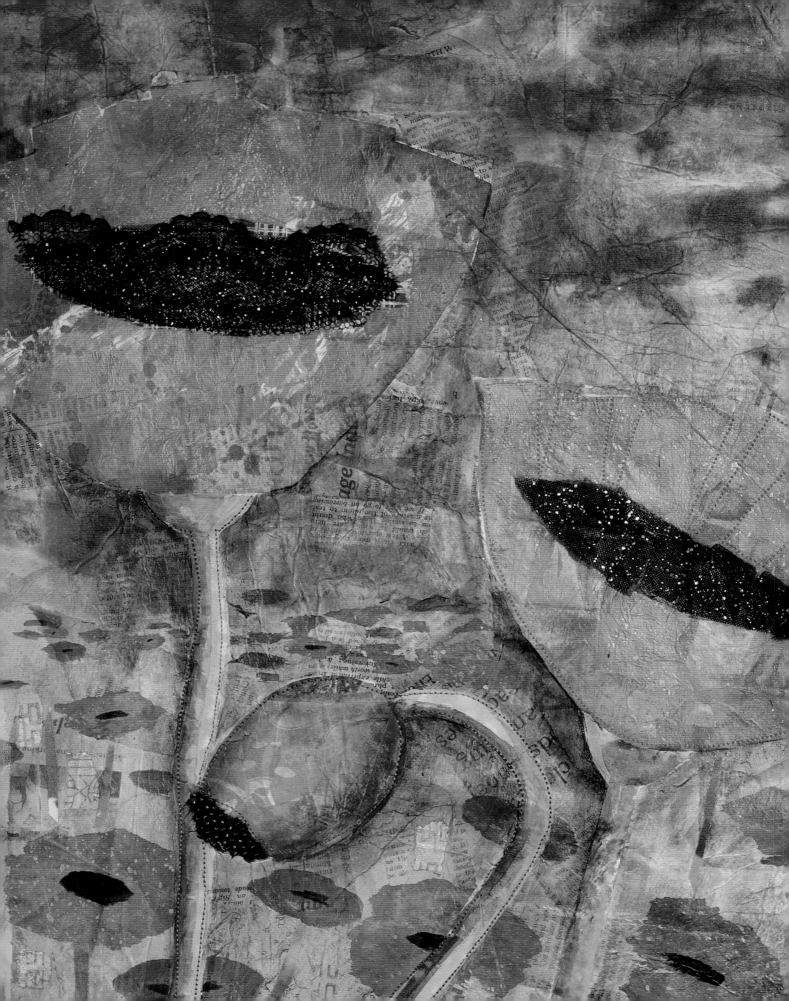

Paper Quilts & Cloth Collage

My favorite thing about fabric paper is that it is somewhere between collage and quilting. I love fabric and stitching, but I don't have the patience or the skill to make quilts or art quilts in the traditional sense. I'm much more comfortable with paper as a textile medium, or fabric as a collage medium, and fabric paper strikes this balance perfectly.

◄ JANE DAVIES: *Poppy Field*, detail.

PAPER MEETS FABRIC

Fabric paper, as its name suggests, is a hybrid of fabric and paper, having the versatility of paper and the strength of fabric. It's made by layering fabric with tissue paper and scraps of fabric and paper, using diluted PVA or white glue, and coloring with inks or paints if you like. This is a great way to repurpose fabric scraps, newspapers, and tissue paper, and the resulting material can be used like paper or like fabric. You can incorporate imagery by using paper images or by printing out images on ink-jet printable fabrics such as cotton or organza. I'll demonstrate two approaches to fabric paper: one that's random, resulting in an overall pattern, and one in which you deliberately build up layers of paper and fabric collage into an image. Each approach provides its own parameters for expression, and both result in rich, layered surfaces. Fabric paper can be used for wall quilts, decorative pillows, book covers, purses, tote bags, in collage and doll making, and for many other mixed-media projects.

▶ **JANE DAVIES:** Paper fabric quilt.

Instead of stitching the parts together to make this fabric paper mini-quilt, I simply backed each piece with fusible web and assembled them on a sheet of heavy interfacing. I made sure that all the edges were lining up, and then fused with a hot iron over a sheet of baking parchment. The effect is more of a collage than a quilt.

CREATIVE ANXIETY

While creating is often a fun, exhilarating experience and a welcome release from the everyday world, you may on occasion feel stuck or uncertain about what to do. Creating is about exploration, intuition, and not knowing. You may experience anxiety when you aren't sure what to do next, or if you're afraid to ruin a piece by adding "this" and not "that," even if your gut is telling you "this" is the right choice. It's perfectly normal for artists of all levels of experience to have some degree of creative anxiety. In fact, I believe there's almost always some level of anxiety when you're really creating something new. If you find yourself anxious while working on a project because you're not sure where it's going or what to do next, you're probably challenging yourself creatively, which is a good thing.

One thing I see in the creative process is a continuum between a high level of creative anxiety—like when every move you make on a piece is a huge effort—and a blissful level of relaxation in which creating lulls you into a happy sense of well-being. Creativity can work either way. You can use it to push your boundaries, challenge your comfort zone, and break through to new possibilities. Or, on the other hand, you can use it as a means to relax, focus your mind, and tune out the outside world for a while. I suggest tuning in to which way you want to go before beginning a project. That way you can avoid frustration when all you wanted was a little playtime, or embrace the anxiety that's a natural part of pushing boundaries.

Of course it would be pleasant if all creating were on the latter end of this continuum. Imagine if every time you picked up your materials you became relaxed and content and created beautiful, meaningful pieces effortlessly. My hunch, though, is that the more anxiety you experience, the more you're challenging your creative comfort zone. This isn't to say that a high state of creative anxiety is in any way an ideal. I think that you have to find a balance between challenge and ease. If creating were pure anxiety, few of us would engage in it. What I'm suggesting is that occasional anxiety is often part of the process. For some, including me, it seems to be a necessary part. I know many artists who routinely experience bouts of anxiety between bouts of inspiration, as well as periods of even-keel art making. The most important thing is to work through this stage, accept a certain amount (and only you can tell what amount) of creative anxiety, and move forward. Make that decision, choose that color, go with that idea even if you have doubts about it, follow your heart and inspiration, and know that the ups and downs are part of the process. This uneven and unpredictable journey is what makes creating an adventure.

◄ **JANE DAVIES:** *Drawing Parallels.*

I made this piece by first assembling the main quilt blocks with a heavy satin stitch. I then added a few collage accents: The red squares in the top and bottom panels are pieces of scribble painted papers (page 25) glued on after stitching.

For this technique we are taking the all-over pattern approach rather than the image-making approach to fabric paper. I suggest that you begin with only a few fabrics, papers, and tissue papers. As the piece develops, you may add more, but it is easier to establish a strong pattern with fewer elements.

You'll need:

- Background fabric—it can be plain muslin or something bright or patterned. Cotton is a good choice because it will readily absorb the diluted glue.
- Freezer paper
- Iron and ironing board
- Sheet of baking parchment or Teflon
- White glue or PVA, and a container for mixing it
- Foam brush, 1½ or 2 inches
- Cut and torn pieces of fabric and paper
- Cut and torn pieces of tissue paper

1. Cut a piece of background fabric that's a comfortable size to work with and slightly narrower than the width of your freezer paper roll. Cut a sheet of freezer paper 1 inch bigger all around than your piece of fabric. Lay your sheet of freezer paper down shiny side up on the ironing board, then place your background fabric right side up, and finally put a sheet of parchment paper on top. Make sure your parchment paper covers the entire freezer paper, as you don't want to place the iron directly on the shiny side of the freezer paper.

2. Mix your glue solution, diluting the glue with water in a water/glue ratio of about 2:1. Using a foam brush, brush the diluted glue onto the fabric, soaking it completely. (See photo **A**.)

3. Lay your pieces of paper or fabric on the soaked background fabric and apply more glue over them. (See photo **B**.) Layer some strips of tissue paper over those and apply more glue. To reduce air bubbles, gently smooth them over with your finger while the paper is wet. (See photo **C**.)

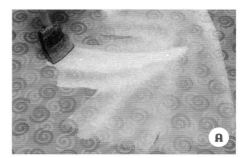

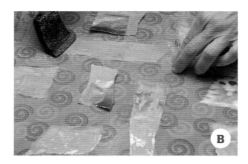

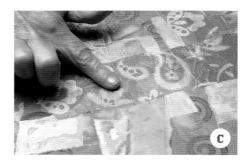

4. Keep layering bits of paper and/or fabric in this manner with the diluted glue until you're satisfied with the overall design. (See photo **D**.) Your piece will be very wet, so let it dry overnight. Once dry, it will peel off the freezer paper easily. I recommend ironing your sheet of fabric paper under a layer of parchment with a warm iron after it has completely dried.

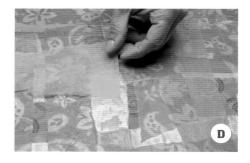

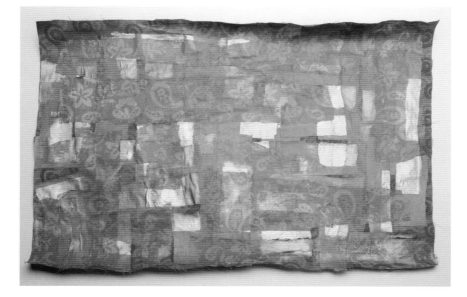

◄ The primary elements in this sheet of fabric paper are the big loopy handwriting, transparent dress pattern paper, and sewing instructions. I applied a wash of quinacridone gold acrylic paint to unify the elements.

▼ During the wet-in-wet process or after the piece has dried to the touch (or both), you can add color with acrylic paints, inks, or watercolors. For this piece (see photo below) I added little accents of metallic and pearlescent colors in acrylics after the piece was dry to the touch.

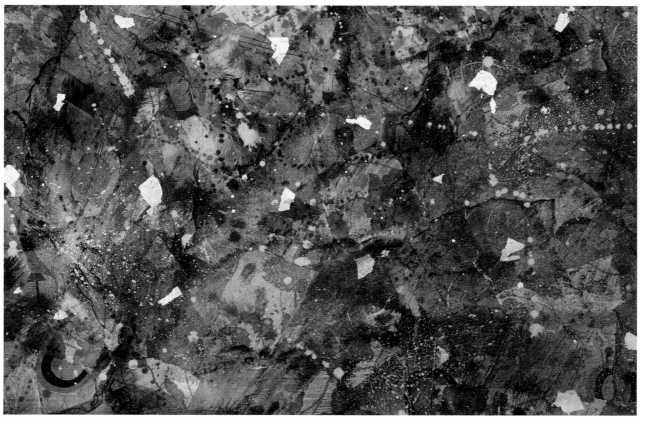

 PROJECT: **FABRIC-PAPER ZIPPER POUCH**

This simple, yet very useful little pouch makes a great first project for fabric paper. It uses only a small amount of material, is quick to make, and makes a great gift. Fill it with travel-size toiletries, pencils, and a handmade notebook or collage post cards!

You'll need:

- A sheet of fabric paper at least 10 x 15 inches
- 7-inch zipper
- Sewing machine with a zipper foot
- Thread
- Iron and ironing board
- Fabric for lining the pouch (cotton is easiest to work with)
- Scissors
- Ruler
- Hand-sewing needle

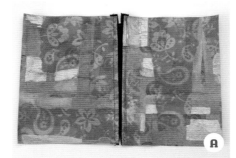

1. Cut your fabric paper into two pieces, each measuring 8½ by 6½ inches. Turn over the top edge of each piece toward the wrong side about ½ inch, and iron (use baking parchment to protect your iron from melting glue).

2. Sew the zipper to the two using a zipper foot on your machine. This zipper pouch is super-easy even if you've never sewn in a zipper. (See photo **A**.)

3. Unzip the zipper, then fold so that the right sides of the pouch are together. Sew around the sides and bottom, leaving a ¼-inch to ½-inch seam allowance. (See photo **B**.)

4. Clip excess fabric paper from the two bottom corners and turn the pouch right side out.

5. Cut two pieces of lining fabric to the same dimensions as the pouch, and sew them together, right sides together, around the sides and bottom. (See photo **C**.)

6. Turn over the top edge, with wrong sides together, about ½ inch and press with the iron. Do not turn it right side out.

7. Fit this lining inside your zipper pouch, and pin it to the opening, all the way around. If it buckles, just make sure the excess fabric is on either end, not on one of the sides, and it won't show. Stitch the lining to the pouch by hand. (See photo **D**.)

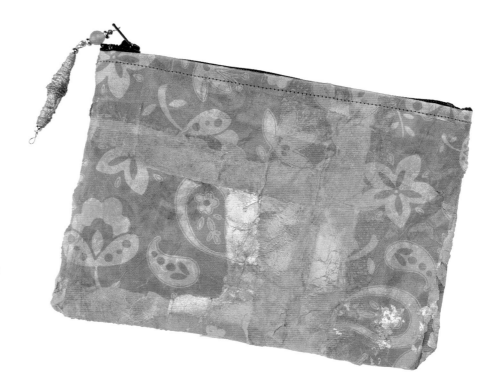

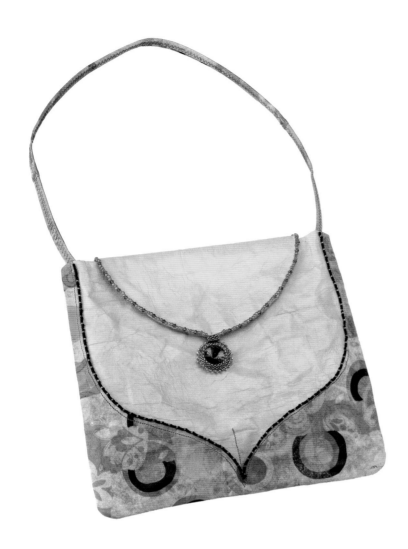

◄ **JANE DAVIES:** *Cleavage Purse*

Cleavage Purse is made with fabric paper and lined with quilting cotton. I couldn't resist making a "necklace" from the edge of the flap with bead embroidery. The pendant is a beaded crystal, and the cleavage itself is simply machine-stitched.

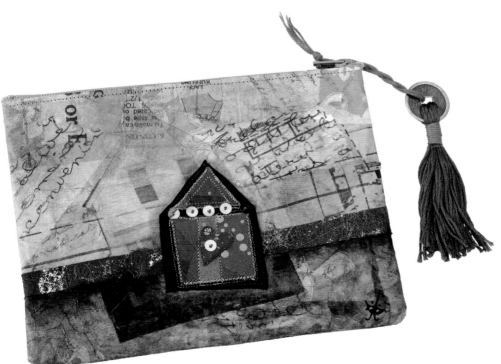

◄ **JANE DAVIES:** Fabric paper zipper pouch.

After creating this sheet of fabric paper (see page 93), I cut the parts for a zipper pouch and embellished them with collage, stitching, and paint before assembling it. I included bits of fusion fabric, as well as beads and sequins, to create the house image. To finish it off, I added a handmade tassel to the zipper pull.

TECHNIQUE: BUILDING AN IMAGE IN FABRIC PAPER

In addition to making endless sheets of beautiful fabric papers for collage and stitching projects, the technique lends itself nicely to image building. For *Poppy Field,* I began by creating a neutral background of fabric paper, using newspaper, torn book pages, and tissue papers. Then I used my own hand-painted tissue papers (see below) to make the poppy flowers. The stems and seed pod are made from green papers and fabrics, and enhanced with paint. I filled in the background with paint and bits of paper and fabric, and as the image developed I used more paint to define shapes and add shading. Decorative stitching, glitter tulle (in the large poppy centers), and bead embroidery add even more accents and sparkle to the final image.

The fabric paper technique—using diluted glue to build layers of collage on fabric—is particularly exciting for creating imagery, as you can go back and forth between collage, paint, and stitch. Some parts of your image can be entirely painted, while others rely on the texture of stitching, beading, or collage. This is where fabric paper really shows its versatility, and the results can be as rich as your imagination.

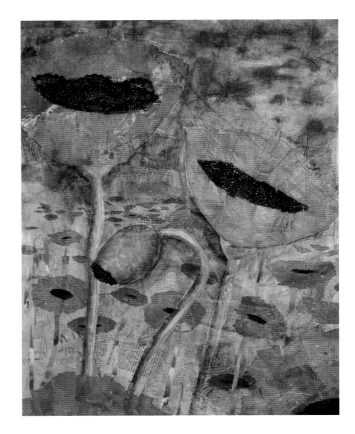

▲ **JANE DAVIES:** *Poppy Field.*
After building the main image in this piece, I painted extensively with acrylics and added more paper and fabric collage. Finally, I did some stitching around the large poppy on the right and the large stems on the left, and added some beads to the seedpod.

TIPS FOR PAINTING TISSUE PAPER

- Since tissue paper is delicate, I find it easier to work with if you iron it to freezer paper first. For other projects (fabric paper, for example) I reuse freezer paper several times. For painting tissue paper, however, it's important to use only fresh freezer paper. Otherwise it doesn't release easily, and the tissue paper tears.
- Iron the tissue to the freezer paper lightly, just enough for it to stick. Otherwise it can be difficult to release.
- Don't overdo the painting, especially scraping with a credit card. Otherwise the tissue paper can tear or be difficult to release from the freezer paper.
- Acrylic paint on tissue paper works well to quickly create beautiful translucent collage material.
- You can use all the "scribble painting" techniques described on pages 25 and 26 to paint tissue paper. However, avoid using the hair dryer to dry between paint applications; the additional heat will make it difficult to release the painted tissue paper from the freezer paper.

 PROJECT: FABRIC-PAPER MINI-QUILT

This approach to fabric paper can be seen as quilting with paper or collaging with fabric, depending on your perspective. In fact, it is both. I use more of a quilt approach in that I'm stitching the parts together. If you're not comfortable with a sewing machine, feel free to adhere your fabric-paper composition to a support like a collage, or else do the stitching by hand. The beauty of fabric paper is that it lends itself equally well to either treatment.

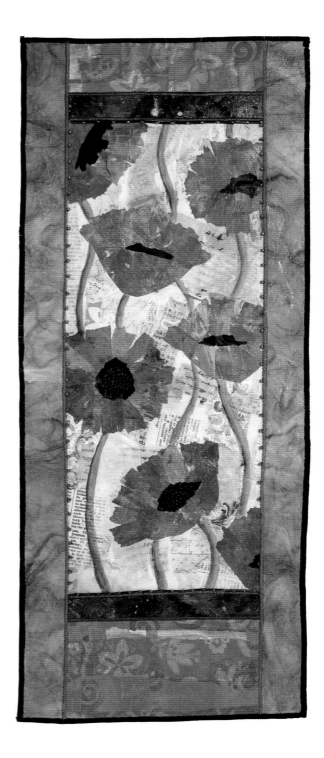

1. Make several sheets of fabric paper. I created this poppy-patterned fabric paper on muslin. First I made a neutral background with newspaper, ephemera, white unryu, and accents of decorative paper. Then I made the flower petals from hand-painted tissue paper and painted the centers in black acrylic.

2. Cut your fabric paper and other materials you wish to use (I used fused fiber made with bonding powder for the outer vertical strips), and arrange them into a composition. This, of course, is the crucial step in the creative process and I'm not giving you any step-by-step directions; this is your mini-quilt and should reflect your inspiration and ideas, not mine. If this is your first mini-quilt, I suggest using no more than three or four fabric papers and keeping the arrangement simple. If you like, simply copy my composition using your own materials. I used one main design, the poppies, and a few others that coordinate.

3. Baste the pieces together using a long, straight stitch on the sewing machine, overlapping the pieces as little as possible. Alternately, you could spot-glue them from the back or tape them together at regular intervals with masking tape, again from the back. Since the back will be covered, the tape won't show.

4. Use a machine satin stitch (dense zigzag) to stitch the pieces together. Choose your thread colors carefully, as these form significant lines in the composition. I chose a dark olive green for the top and bottom horizontal lines and bright orange-red for the two verticals.

5. After sewing the pieces together, paint, bead, stitch, or otherwise embellish to your heart's content. Or not, as you wish. I used acrylics to paint the poppy stems and then sewed beads into two of the centers to add texture. I then beaded the two vertical red lines and the top and bottom horizontal lines right around the poppy pattern. *Note:* After beading or hand-stitching your fabric paper, glue a piece of lightweight paper, such as rice paper, to the back of the stitches to make sure they do not come out.

6. Fuse the entire piece to a sheet of stiff interfacing and then to a backing fabric such as muslin or printed cotton.

7. Cut the outside edges flush, and stitch all around with satin stitch.

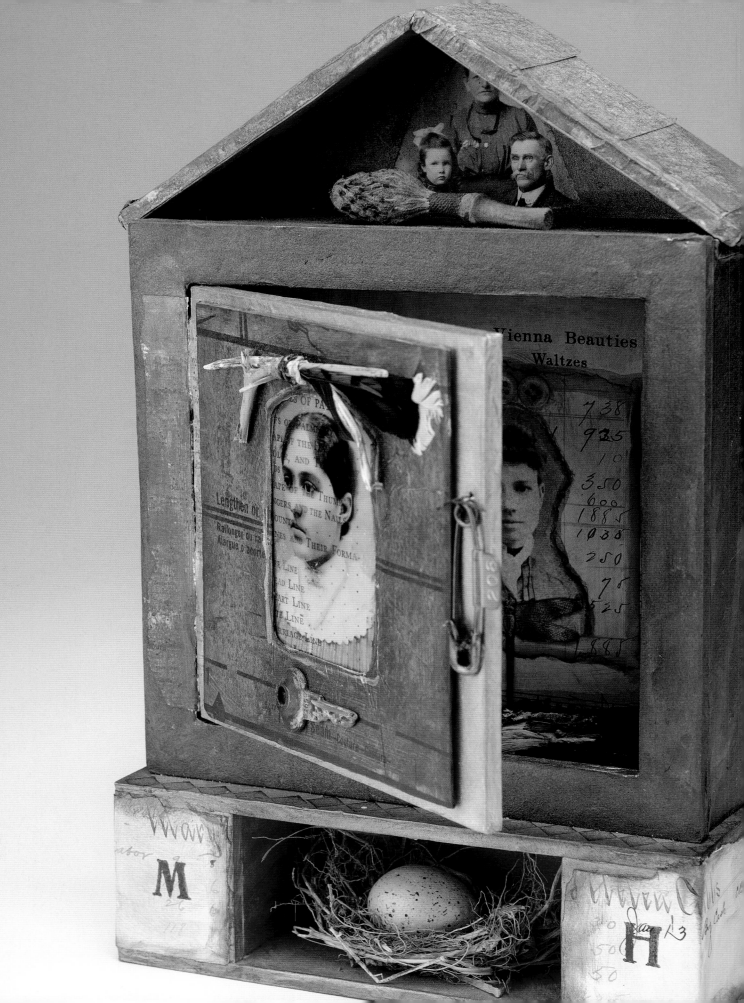

Shrines and Ornaments

What do shrines and ornaments have in common such that they deserve to share a chapter? Materials and techniques. Foam core turns out to be a great substrate for collage and mixed media projects, and we explore its potential in this chapter. In the bird ornament and framed photograph you will learn the basics of cutting, covering, and then collaging on foam core. The spirit house, inspired by Carol Owen's shrines, takes foam core construction into the third dimension, incorporating objects and embellishments.

◄ CAROL OWEN: *Vienna.*

FOAM CORE

I was first inspired to use foam core as a collage support and building material when I read Carol Owen's book *Crafting Personal Shrines*. Until then, I'd thought of it as a practical material for framing and for building lightweight, transportable trade show furniture (really, a table or pedestal made of foam core can hold a surprising amount of weight!). I even made a dictionary stand out of foam core, which holds a 3½-pound book. As a collage support it has some distinct advantages. Foam core can convey the visual weight of canvas or wood panel, giving your collages a more object-like quality than a flat sheet of paper, but it's cheaper and lighter than canvas or wood and can be cut easily to whatever size and shape you want with a craft knife. As a building material for shadowboxes and three-dimensional works in mixed media, it requires no carpentry skills or tools. No sawdust. I consider ³⁄₁₆-inch foam core to be standard, and it's adequately sturdy for the projects in this chapter.

One thing I like about foam core constructions is all the different surfaces you get to play with. Even in a simple flat ornament or wall plaque, you have the edges. Things can be stuck into foam core, like the feathers I used on the bird ornaments or the wire hanging mechanisms. I like to exploit this property of foam core. It's another advantage over canvas or wood.

◄ One thing I like about foam core is that you can stick things in it, like these little carpet tacks for hanging the letters. This was made as a housewarming gift.

► Foam core lends itself easily to multipart ornament construction. Simply put hanging loops on the tops and bottoms of several pieces and attach them with wires, ribbons, or beaded eye pins.

FOAM CORE ALERT

For all foam core projects, apply a coat of matte medium to each side of the foam core and let it dry completely before proceeding. I do this to each sheet before cutting it. If you don't do this, your foam core will warp when you apply the rice paper or paint. If you do, your foam core will remain flat and true, and you'll be glad you took the time to heed this alert.

PROJECT: **BIRD ORNAMENT**

These bird ornaments are fun because you can stick feathers, beaded wires, wire curli-
cues, or other fanciful embellishments in them. Birds are a great canvas for decorating,
and they carry so much symbolic potential—freedom (flying), domesticity (protecting
their eggs)—specific birds even more so. Ravens, doves, and blackbirds, for example,
each have their own symbolic associations. I made my bird ornaments purely from imagi-
nation. They're not modeled after any birds I've ever seen. The technique of wrapping
the bird-shaped foam core in rice paper applies to wrapping any curved shape.

To make these, I first established several basic bird shapes on paper. You'll undoubt-
edly create your own variations.

You'll need:

- Template 10 (see page 137) or your own
- A small piece of foam core
- The basic tool kit (see Tools, page 18)
- Two pieces of rice paper, for wrapping the foam core
- Collage and paint material
- Paper or Angelina fabric (see "Basic Angelina Sheets,"
 page 77) for the wing
- Craft wire
- Jewelry pliers
- Awl or pushpin
- Feathers of your choice
- Ribbon for hanging
- Foam core coated with matte medium

1. Trace the template (or make your own bird—as you can see, the
shape is open to interpretation) onto your foam core and cut it
out with a craft knife.

2. Glue the foam core bird to the piece of rice paper, and then cut
the rice paper so that there's about ¾-inch overhang all the way
around the bird.

3. Make cuts in the rice paper from the edge of the bird to the
edge of the paper, all the way around the bird. (See photo **A**.)

4. Fold and glue the rice paper over to the backside of the bird,
allowing the tabs to overlap or spread out as necessary. They will
overlap on the outside curves and spread out on the inside curves.
Clip where necessary. (See photo **B**.)

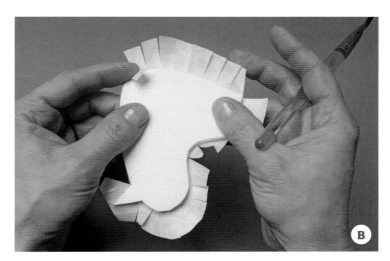

5. Cut out the bird shape from a second piece of rice paper and
glue it to the back of the foam core bird, covering the turned-
under tabs.

6. Paint and collage the bird as you like on either one or both
sides. I used various papers with green in them and then painted
over them with green acrylic paint.

7. Using your jewelry pliers, twist a length of craft wire into two
or more "toes," and then cut the ends of the wire, leaving an inch
or more extending from the "foot" to form a leg. Repeat with
another length of wire for the second foot. (See photo **C**.)

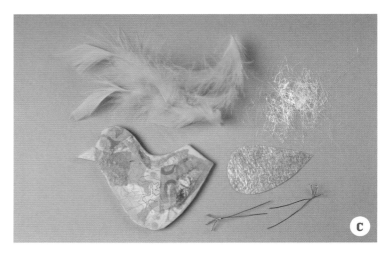

8. Cut out the wing from your chosen material. I used a small sheet of Angelina fabric. I also made a small sheet of very loose Angelina fabric to further embellish the wing, but this optional and entirely up to you.

9. To attach the feathers, use your awl or a pushpin to poke holes in the flat back end of the bird about 1/8-inch apart. Stagger the holes rather than place them in a straight line for a fuller feathery effect. Strip about ¼ inch off the base of each feather. One at a time, poke a feather into a hole, and add a tiny drop of glue. Once the feathers are all in, let the glue dry completely.

10. Attach the feet by poking holes in the bottom and pushing them in. Add a drop of glue to each hole. You can add little head ornaments as well if you like (see above right and opposite, top).

11. For the hanging mechanism, make a little loop of craft wire and twist the ends together. Cut the twisted end to about ½ inch. Attach this to the top of the bird. (See photo **D**.)

12. Glue on the wing(s) and the optional Angelina embellishment using a small dab of white glue or PVA.

13. When all the glue is dry, thread a ribbon through the hanging loop, and your bird is finished.

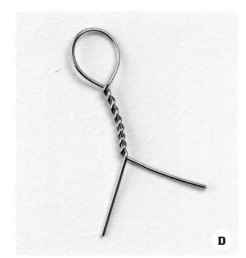

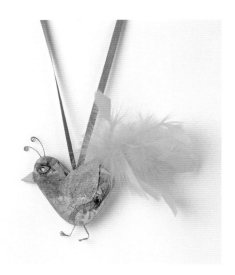

D

► This bird ornament got her very own handmade gift box (see "Message Box," page 57) and a nest of purple silk fibers. She even laid a few eggs!

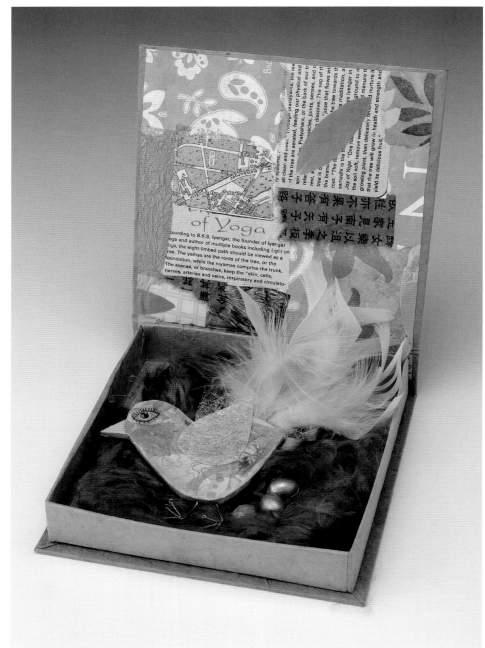

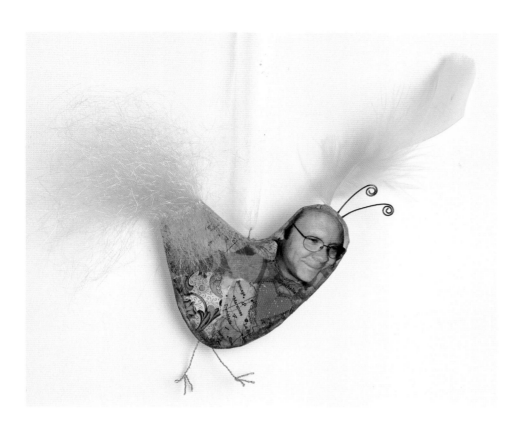

◄ I made a similar bird using my sweetie's photo for the face. I made this tail out of Angelina fiber rather than feathers.

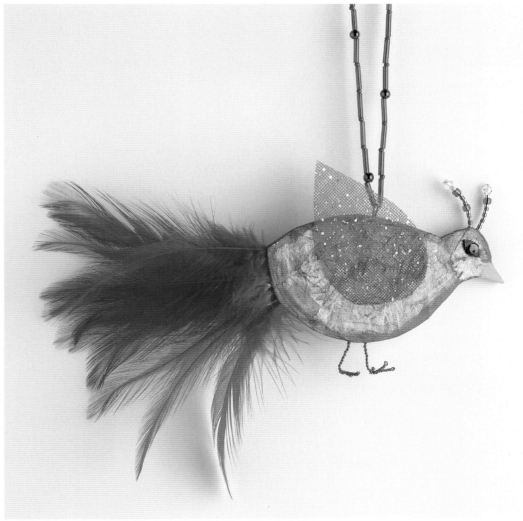

► My red bird ornament sports beaded headgear and a beaded hanger. The wing is made from two layers of glitter tulle fused together.

IMAGERY

I encourage readers to incorporate imagery in their projects where appropriate. I believe it's a vital part of making art that's personal and meaningful, even in the most functional or decorative formats. Imagery in the broad sense includes pictures and patterns. Types of imagery include photographs, illustrations, maps, diagrams, doodles, patterns, paintings, handwriting, and more. All of these visual sources evoke associations of one kind or another, subconsciously if not consciously. Think, for example, of a damask wallpaper pattern, a nineteenth-century sepia photograph, a magazine picture of a fashion model, a contemporary road map, a page of doodles you did while on the phone. These all evoke associations of one sort or another, some universal and some personal.

The context in which you see images, of course, greatly affects their associations as well. And that's part of the fun! Putting images and patterns, colors, and textures into a new context is the essence of mixed media. This new context can be very deliberate, or completely surprising. Often associations crop up organically. For example, several weeks after I made the "Junk and Myth" book (page 39), I noticed that the Greek pottery images I had used purely for their color were, in fact, mythological figures, so the "Myth" part of the title actually made sense. I had tacked the name onto the piece at the last minute, without even thinking about the imagery.

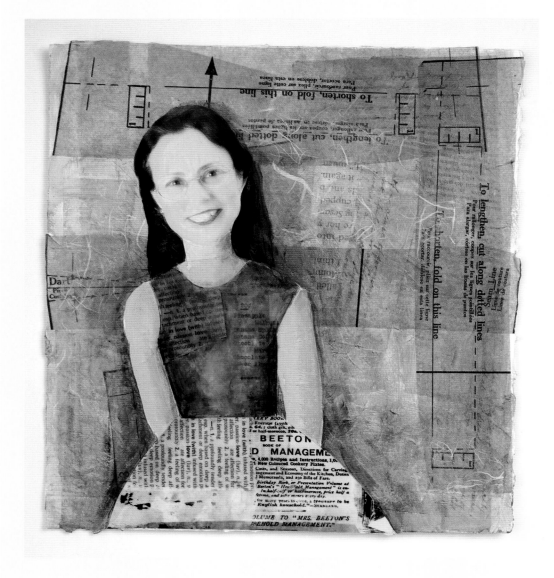

◄ **JANE DAVIES:** *Self Portrait with Sewing Patterns.*

I made this self-portrait as a tongue-in-cheek version of Kelly Rae Roberts's gorgeous collage figures. I'm not comfortable with drawing faces, but painting on a photograph seemed doable. I scanned the original and have used the image in many collage pieces.

Sources of Imagery

Imagery is everywhere, from junk mail to reproductions of paintings to snapshots, news-papers, paper napkins, postcards, and, of course, the World Wide Web. There's no getting away from it. So how do you choose imagery for collage and mixed-media projects? I collect imagery from the stuff of everyday life—I go to paper stores (I love decorative papers!), I gather images on the Web for inspiration, and I scan a lot of things. Collecting imagery for your mixed-media work is an ongoing process. Pay attention to what kinds of images appeal to you. Are you intrigued by portraits? Do you prefer images of the natural world, such as insects and leaves? Do images of birds speak to you? Are maps particularly fascinating? Are you drawn to clocks, houses, or old shoes? Maybe rivers or islands have meaningful associations for you. Many collage artists' stashes of imagery are pretty diverse, and you see various themes emerge through their work. When you're collecting imagery, try not to edit. That's for later when you're working on a particular piece. Better to have too big a stash than too small.

Creating your own imagery is a vital part of making art. Even if you don't come from a background of painting, drawing, or photography, it doesn't mean you can't generate your own imagery. Taking photographs, altering photographs, painting over ready-made images (such as magazine photos), doodling, carving your own stamps, making collages, and scribble painting all count as generating imagery. Using your own imagery can make your work more personal, and you don't have to worry about copyright infringement.

Note: If you're gathering images off the Web, be sure to read the copyright notices and comply with them. If you're making a piece for personal exploration or as a gift, it's almost always okay to incorporate someone else's image. If you're publishing the work or selling it, it's almost always *not* okay, unless you have altered it enough to make it your own.

▼ **JANE DAVIES:** *Potrait of Home.*

I made this collage using various parts of other collages and photos, scanned, sometimes altered, and printed out. You can see my portrait off to the right. Then I scanned this original and had printed it as greet-ing cards (my own Portrait of Home stationery!) and used it on other projects like this little pamphlet-stitch journal. I included my two cats, our dog, and my Sweetie peeking out of the upstairs window.

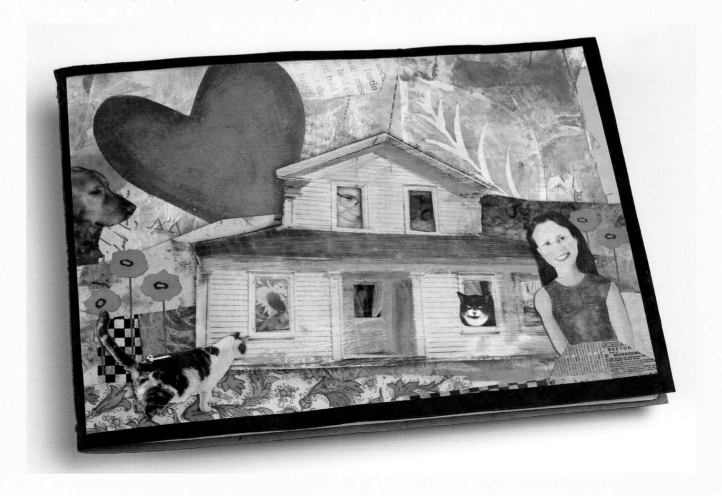

PROJECT: FRAMED PHOTO

This project is basically a foam core picture frame, but it has two layers of the same photograph—one on paper and one on transparent organza. When viewed straight on, the photograph looks normal, but from any angle, it begins to blur because of the organza layer, giving it a three-dimensional effect. You could, of course, make it without the organza layer.

You'll need:

- Two squares of foam core, 8 x 8 inches
- One square of foam core, 5 x 5 inches
- Rice paper to cover all foam core pieces
- Four tabs of rice paper, approximately 1½ inches x ¾ inch each
- White glue or PVA
- The basic tool kit (see Tools, page 18)
- Paint and collage materials
- Digital photograph that's 4¼ x 4¼ inches: one copy printed on paper and one copy printed on printable organza (ExtravOrganza made by Jacquard or organza ironed to a sheet of freezer paper and cut to 8½ x 11 inches)
- Light-duty staple gun
- A strip of decorative paper to go around the outside of the finished piece

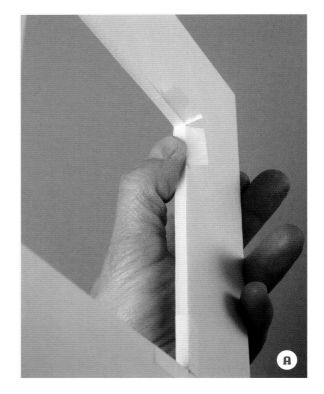

1. Glue a sheet of rice paper to one of the larger squares of foam core, leaving about an inch of overhang all around. Cut the corners to a 45-degree angle, leaving about a ¼-inch space between the corner of the foam core and the edge of the paper, and fold up the sides and glue in place.

2. Cut a 4 x 4–inch square opening out of the center of the second large square of foam core, which leaves a 2-inch border all the way around the opening.

3. To cover this frame piece, start by covering the inside corners of the opening with the little tabs of rice paper. Fold one tab in half widthwise and glue it to one of the inside corners of the frame. Make cuts on each side of the tab at the fold, and fold over both sides of the foam core. Repeat for the other three corners. (See photo **A**.)

4. Cover this frame piece in a sheet of rice paper as you did the first 8-inch square. Make sure to apply the glue to the foam core frame, rather than the paper.

5. Cut out a square from the center, about an inch in from the opening. Make a diagonal cut from each inner corner to the edge of the paper. (See photo **B**.)

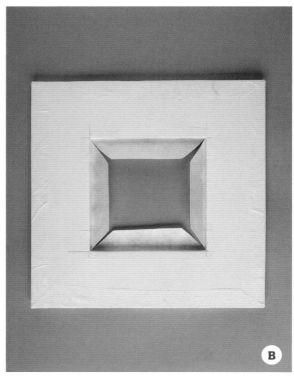

6. Apply glue to the resulting tabs, and fold over to cover each of the four inner edges of the frame opening.

7. On the first 8-inch square (the one without the opening), mark where the opening in the frame will be on the side not covered in rice paper. Glue the picture to the center so that it overhangs about ⅛ inch on all sides. Cut the organza so that there's about ½ inch extra on all sides around the boundaries

of the photograph. Make sure to center the printed photograph on the foam core, and check it by placing the frame (the 8-inch square with the opening) over it to see that it's positioned correctly. The organza print should be exactly the same size as the paper print. (See photo **C**.)

8. Paint the inner edges of the frame piece, then paint and collage the front to your liking. For my collage, I used bits of maps and letters pertaining to the place—La Have, Nova Scotia—where this picture of me and my sweetie was taken. Then I applied several layers of acrylic glaze, wiping away the excess each time, building up the layers of color gradually (see page 36). I even sanded the surface at one point and added more collage and paint.

9. Glue the frame to the foam core piece with the photograph.

10. Cut a 4 x 4–inch opening from the center of the 5-inch square of foam core, creating a ½-inch-wide frame. Cover it with rice paper as you did the larger frame, starting with the inner corners. Paint the front, sides, and inner edges of this piece.

11. Place the organza over the opening in the large frame, and staple it in place. Make sure the organza doesn't extend beyond the ½-inch width of the smaller frame. Then glue the smaller frame over it so that the inner edges line up with those of the larger frame.

12. Finally, to cover the outer edges of your piece, cut strips of decorative paper (I recommend lokta for its strength and flexibility) about 1 inch wide. Check to make sure they will easily wrap around the outside edges without covering too much of your collage. Cut four strips about 7½ inches long and glue them to the four sides of the piece. Then cut four small pieces and cover the corners.

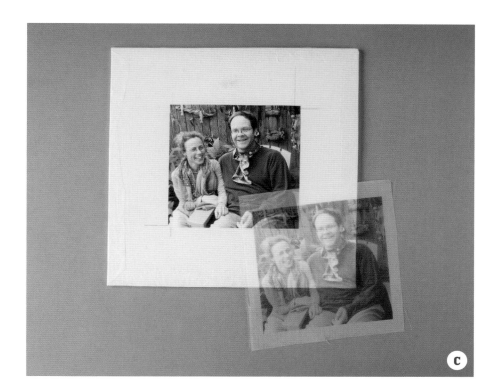

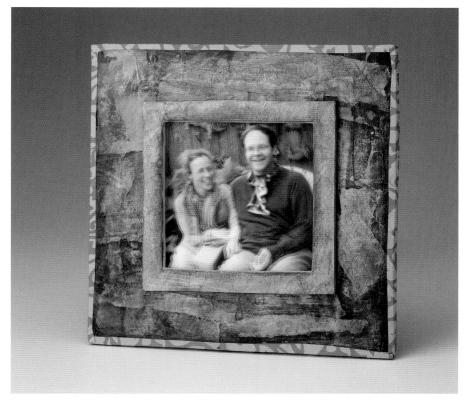

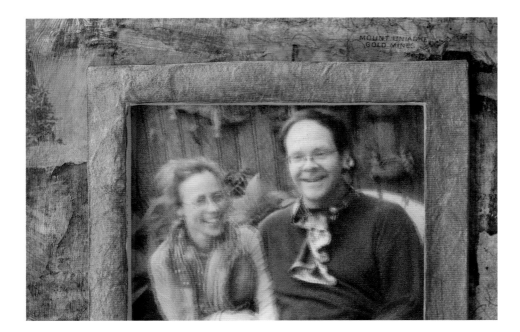

◄ When viewed straight on, the photograph looks normal, but from any angle, it begins to blur because of the organza layer, giving it a three-dimensional effect.

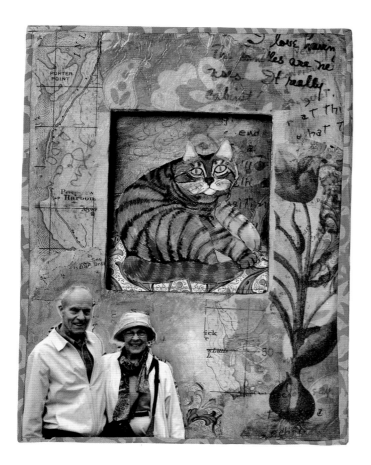

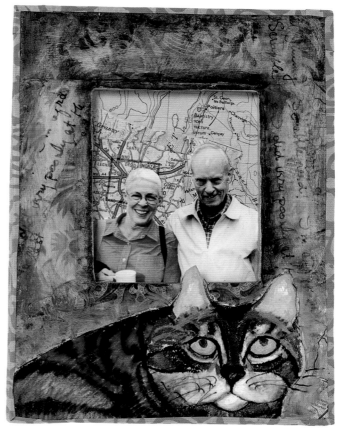

▲ I made this pair of framed pictures for my parents. Rather than being straightforward frames surrounding pictures, I integrated the collage into both parts of each composition, reversing the positions of the parents and the cat. I used maps, samples of my mother's handwriting, and decorative papers for the collage. The cat comes from a painting by a family friend.

PROJECT: SPIRIT HOUSE OR SHRINE

This piece consists of two box constructions, one with a door and the other, which functions as a base, open to the front. I have shaped the back and front of the main box to make them more decorative. Once you master the basic foam core building technique, you'll come up with your own variations.

You'll need:

- Template 11 (page 138)
- Foam core, enough to cut out all the pieces in the template
- Rice paper to cover all the parts
- White glue or PVA
- The basic tool kit (see Tools, page 18)
- Four 1½-inch lengths of linen tape (available at bookbinding suppliers) or grosgrain ribbon for the door hinges
- Paint and collage materials
- Three-dimensional objects to put in your spirit house
- Embellishments of your choice (I used beads attached with head pins)

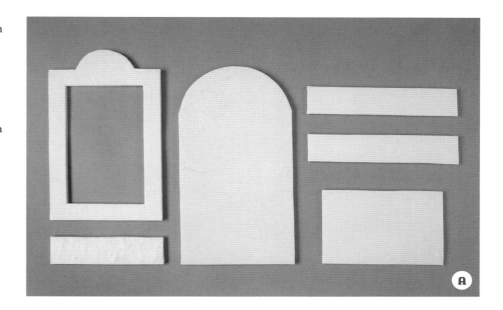

1. Using the template provided, cut out the foam core pieces for the main body of the shrine using a craft knife. These include the back, the front (the frame piece), the door (which is the cutout from the frame piece), the sides, and the top. (See photo **A**.)

2. Cut about ⅛ inch off of each the top and side of the door piece so that it will fit easily into the door frame when both are covered with rice paper.

3. Cover all the pieces with rice paper using the directions in the Framed Photo project (page 106) for guidance.

4. Glue the two sides to the back so that the bottoms are flush. Then glue the top to the tops of the sides and to the back. (See photo **B**.)

5. To make the door hinges, glue about ½ inch of one of the linen tapes to the front of the door about ¼ inch from the top, and do the same at the bottom. Then glue the third length of tape the same way to the back of the door, just under the top ribbon. Glue the fourth length of tape to the back of the door just above the bottom tape. This shows you how the door hinge works (see photo **C**), but make sure to paint the door—especially the edge where the hinges are attached—before installing it.

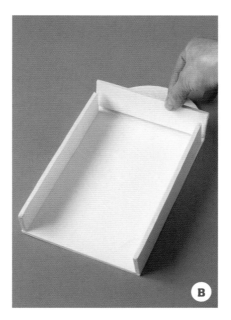

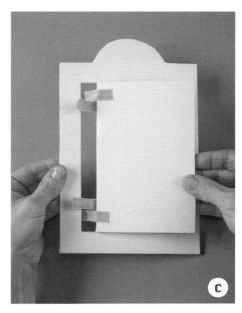

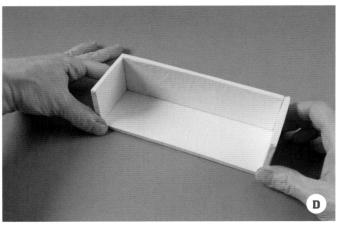

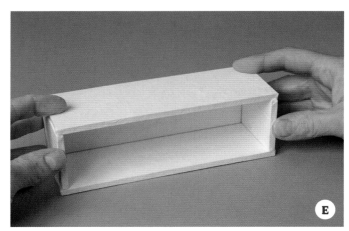

6. Now make the base of the shrine, which is a box open at the front. Cut the five pieces of foam core from the template, and cover them with rice paper.

7. Glue the two ends (the small pieces) to the bottom, so that they sit on top of the bottom. Then glue the back on so that it sits between the two ends. (See photo **D**.)

8. Now glue the top onto the box. (See photo **E**.)

9. Paint the door—don't forget the edges. Paint and/or collage the frame/front of the spirit house.

10. Assemble the door: Fold the front tapes to the back and the back tapes to the front, and set the door inside the frame. Then glue the ends of the back tapes to the front of the frame and the ends of the front tapes to the back.

11. Paint and collage the inside of the spirit house. Then glue the front/door assembly to the front of the house.

12. Paint and collage the outside of the house.

13. Paint the inside and the outside of the box base.

14. Glue the spirit house to the base.

15. Embellish as you wish!

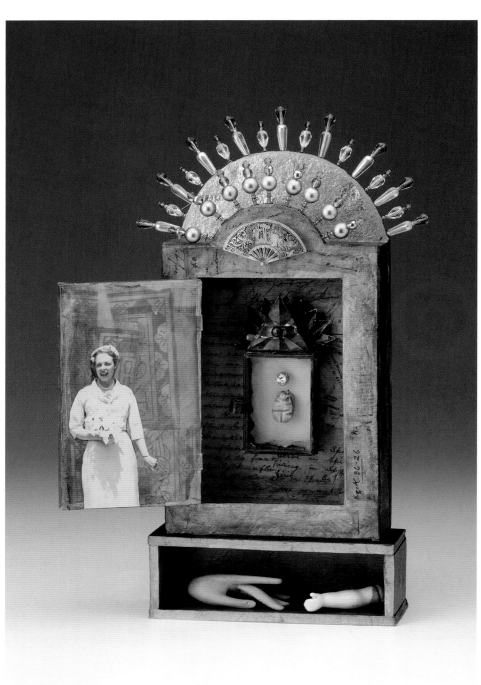

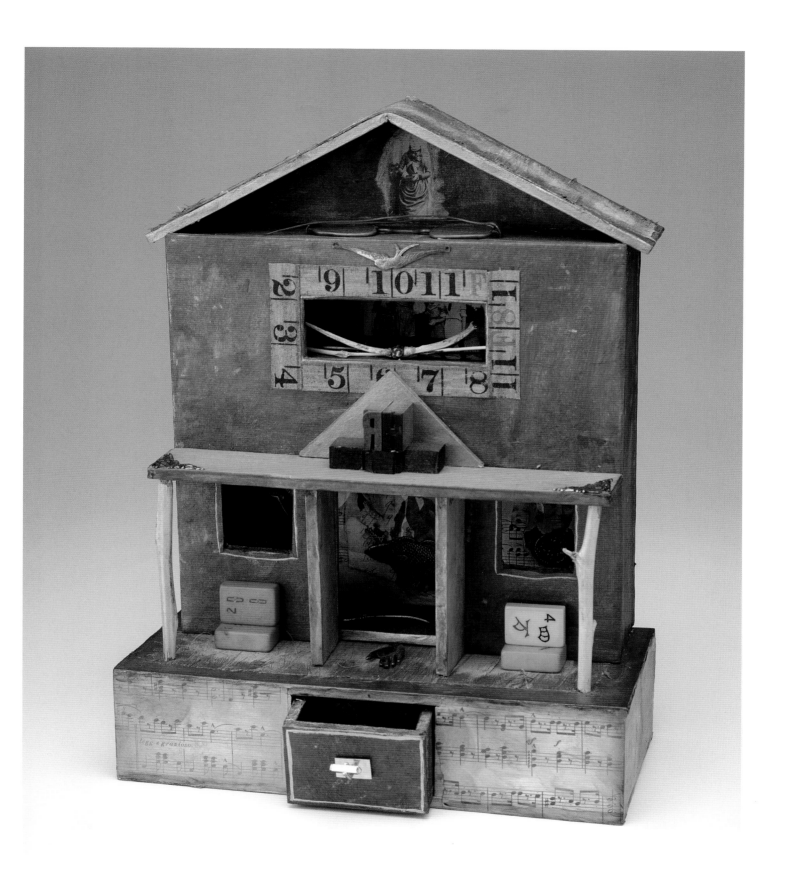

▲ **CAROL OWEN:** *October.*

This piece, to me, looks very masculine; perhaps it's the cufflink drawer pull, the pair of glasses in the top, the carpenter's tape, or the paint-can opener that appears to be just inside the door. The Mah Jong tiles look to me like benches on the porch. Carol's way of giving new context to familiar and unfamiliar objects is uniquely evocative and expressive.

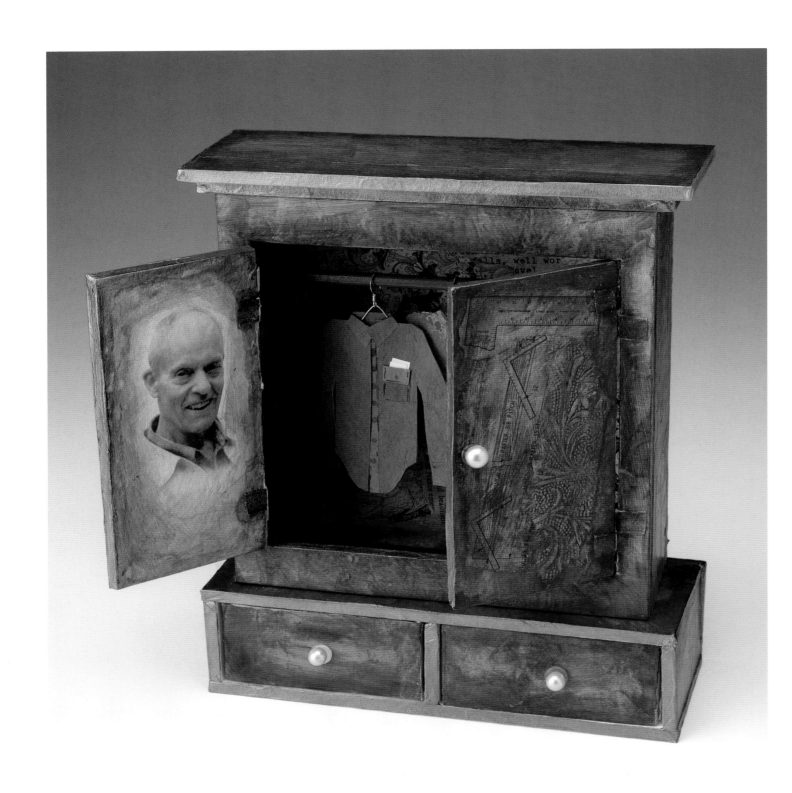

▲ **Jane Davies:** *Jimmy's Closet.*

I made *Jimmy's Closet* as a Christmas present for my father. The only things on his Christmas list were several varieties of blue shirts. BORING! So I thought I'd make him a few blue shirts and a closet to put them in. The collage materials I used for the piece include the photo of my father (shown, on the inside of the door) and pieces of his letters to me that include diagrams and sketches of various furniture pieces he has built for me. My father *always* carries 3 x 5 index cards in his shirt pocket so he can draw a diagram or explain something on paper if necessary. You'll see them in the pocket of the "Jimmy Action Figure" (page 116) as well.

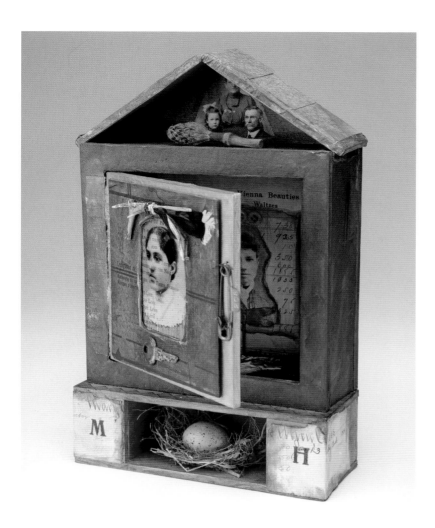

◄ **Carol Owen:** *Vienna.*

This piece includes an egg in a nest. It also includes a "fetish bundle" on the front just over the portrait and a key below. All of these objects carry symbolic meaning, but each viewer will bring to it his or her own interpretation.

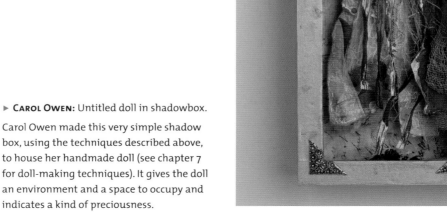

► **Carol Owen:** Untitled doll in shadowbox.

Carol Owen made this very simple shadow box, using the techniques described above, to house her handmade doll (see chapter 7 for doll-making techniques). It gives the doll an environment and a space to occupy and indicates a kind of preciousness.

Mixed-Media Dolls

Images of the human form resonate with everyone. It's an innate recognition. This is why dolls can be richly expressive even in their most basic incarnations. You can express anything with a doll—a mood, a message, a wish, a prayer, a fantasy, a proverb, a myth, an archetype, a silly thought, or your innermost secrets. There are no rules about what materials or techniques are appropriate for dolls, making them a quintessential mixed-media form.

◄ **CAROL OWEN:** One-piece paper doll.

WHAT MAKES A DOLL A DOLL?

A human form can be rendered in ideal (or at least realistic) proportions, with lifelike details such as hair, a sculpted face, finely sewn clothing, etc. Or it can emerge from abstract shapes and miscellaneous objects arranged in a particular way. Most dolls fall somewhere between these two extremes, leaving room for creativity and interpretation of the figure.

The standard representation of a human figure consists of a head, a torso, two arms and two legs, and hands and feet, if you're particular, but you can get away with a lot less than that and still have a recognizable figure. For example, neither my "Stick Doll" (see page 125) nor my "Pink Doll" (see page 123) has legs; Pamela's "The Stuff of Dreams" doll has no limbs except one forearm (see page 123). Yet nobody would hesitate to identify these as figures. This is what is so fascinating to me about making dolls. Once you imply the human figure, all of the parts fall into place. The viewer automatically identifies the parts depending on how they're situated in relation to one another. As you can see in the examples, artists use many different things to imply hands, heads, feet, legs, wings, etc., but these details are completely absent in some of the dolls.

When I first got interested in doll making, I considered it to be a time-consuming and complicated process, requiring meticulous sewing and other skills. I felt up to the challenge at the beginning—I really like hand-sewing, bead embroidery, and some of the other techniques involved—so I got some wonderful and inspiring books on doll making. But once I realized how precise I'd have to be in cutting and sewing doll parts, and how much time it took just to get the basic figure constructed, before even getting to the fun part of embellishing and giving the doll character, I knew this was not suited to my more haphazard approach. Nobody would accuse me of possessing an excess of patience when it comes to making things. I looked for techniques with more of an immediate gratification factor and found a whole host of artists making beautiful and expressive dolls with not much more than paper, fabric, paint, and glue. My kind of doll! I write this chapter to share with you a few basic construction styles of making dolls, as well as a few examples for inspiration. You can make these dolls as complex as you like, adding hand-sewn clothing, hand-knitted sweaters, and accessories of all kinds, but the basic techniques are accessible to anyone who can fold, cut, and glue.

Where to start? If the images in this chapter spark your imagination immediately, then go ahead and jump right in. If you aren't sure where to start, try some of the basic construction techniques and see where they lead you.

Suggestions for dolls as gifts or for yourself:

- Make a portrait of the recipient, emphasizing an aspect of his or her personality that you particularly appreciate. It doesn't have to be at all realistic. I made the "Jimmy Action Figure" for my father, to express my appreciation of his active nature. He is always building or fixing something (often for me) and is always on the move—swimming, sailing, skiing, hiking—even as an octogenarian.
- A guardian angel is always welcome; likewise a fairy godmother.
- Create an idealized version of the recipient; for example, if he or she has just started taking yoga classes, make a yoga doll. This would be a doll of encouragement, and everyone can use a little encouragement now and then.
- Make a self-portrait doll that expresses your aspirations or gives you encouragement.

▲ **Jane Davies:** *Margie's Angel.*

WHEN DOES ARCHETYPE BECOME CLICHÉ?

One of my students in a recent workshop had just finished a beautiful piece using foam board as the basic structure. She said she was going to attach decorative yarns and fibers that would hang off each side of the piece. I thought the piece was perfect as is and asked her why add the fiber. "Because that's what people do these days," was the reply. She was automatically following a trend and not really looking at the piece for what it was. If you find yourself adding something to a piece because you've seen that treatment in a lot of other people's work in magazines and books, I recommend that you put the piece aside and come back to it in a few days. Ask yourself if it really needs that treatment. Maybe it does. But maybe it needs something different, or nothing at all. There are some types of images that become popular in the mixed-media world, and they soon become clichés. Put wings, crowns, or dunce caps on vintage portraits, and you've got "the look." But do you have *your* look? Does your piece say what you want it to say, or does it look like you think it *should* look? Some images do seem to have universal resonance, and, thanks to the artists who have made them popular by using them in a creative way, they have struck a chord in the mixed-media world. Ideas and images can become like archetypes—symbols with universal meaning—but they can also become clichés. There is a fine line between cliché and archetype. A cliché, by definition, has been overused and has lost its impact; archetypes retain their universal resonance. The challenge is to use such images in a way that retains their evocative quality. If you're going to put wings on a heart or a crown on a vintage portrait to express your meaning, do it in a way that's personal. Give it your own twist.

- Make an environment for your doll—a "stage set"—with heavy paper, cardboard, or foam core (see chapter 6 for foam core techniques).
- Make a doll to commemorate an occasion such as a birthday, retirement, or a special anniversary.
- Make a doll inspired by a favorite book of your recipient.
- Use a mythical or historical figure that has a particular connection to your recipient as the model for a doll.
- Make a muse, a doll that inspires your recipient in some way. It could be a kitchen muse, a garden muse, or an artist muse of some kind, for example. Or make a muse just for yourself!

- Make a doll to carry your baggage, emotional or otherwise.
- Make yourself a doll named "Permission," who gives you permission to do something you've put off or been afraid of. Permission to Play, Permission to Paint, Permission to Create, Permission to Dance or Write or Sing, or Permission to Forgive Yourself (or someone else).

◄ **Jane Davies:** *Jimmy Action Figure.*

This action figure is a brad-jointed doll with hips, elbows, and shoulders but no knees. When I gave this to my father, his neighbor came over and said, "Hmm, a Jimmy action figure. I could use one of those."

As you can see from the examples, making a doll has less to do with getting each part "right," and more to do with your imaginative use of seemingly random bits and pieces. Sometimes an object will inspire a doll—a button is just longing to become a doll face, or a scrap of polymer clay from another project says "torso" all over it; an antique spoon only needs arms and some hair to become a figure, or a tiny charm is obviously a hand just waiting for an arm. At other times trying to figure out specifics of doll parts can be a stumbling block. The torso, arms, and legs are all in place, but what do I use for hands and feet? Do I need hands or feet? The head is in place, but my doll really would like a face.... Here are a few suggestions for doll parts. Once you get into your groove of making dolls, almost anything has potential, and your imagination will have a blast!

▲ **PAMELA HASTINGS:** *Famous Face Doll, or Mona Lisa with Dreadlocks*
This doll is made from pieced fabric that's stitched to the poster-board body with a layer of batting underneath, so you get a nice cushiony effect. The limbs are fabric-covered wire, and the hair speaks for itself. We have seen the Mona Lisa in a lot of contexts, but this one is unique!

Faces

If you're comfortable drawing or painting faces, then you're way ahead of the game. Paint faces on paper or fabric, glue them to the appropriate-weight material, and you have a head. If you aren't comfortable painting at doll scale, then scan your paintings or color copy, and reduce the size. But if you're like me and don't do faces, here are some options.

Simple shapes. Using only circles, ovals, squares, rectangles, and triangles, see how much expression you can create. Either cut out shapes in colored paper, or sketch faces in simple shapes. If in doubt, find a child to help you.

Photographs. Whether from your personal photos of people you know, or those taken from magazines, catalogs, vintage imagery, etc., there are lots of photographed faces for you to use. I especially like to use a photograph of the person for whom the doll is intended (see page 116). If you're familiar with photo-editing software, you can manipulate the photograph to your liking. For my self-portrait doll (see page 127), I used a photograph of my face that I had painted over, scanned, and reduced in size.

Famous faces. You can pretty easily find pictures of the Mona Lisa, a Madonna, Botticelli's Venus "on the half shell," Abraham Lincoln, Marilyn Monroe, Frida Kahlo, and on and on. These faces have iconic cultural meaning and will give instant "A-ha!" factor to your dolls. If you're using a famous face, try to push it a little to give it personal meaning. Another approach to famous faces it to find a picture of someone who has special meaning to you or to the recipient of the doll. A favorite author, historical figure, actor, political figure, or musician would be in this category.

Masks. "Tribal" masks or "primitive" sculpture are great visual inspiration for abstract faces. Do a Google Image search, and make your own sketches from what you find—on paper or in modeling compound such as PaperClay.

PaperClay or polymer clay. I occasionally use commercially available press molds to make PaperClay faces, as I did for my "Stick Doll" (see page 125). These are quick and easy. You can also sculpt your own faces. Doll-making supply retailers often sell faces, heads, and other body parts, but it's fun to challenge yourself to make your own.

No face is fine, too. This Pamela Hastings (opposite, top) doll has no face, just a shard of a ceramic piece for a head. No hands, no feet, no face, and still it reads "doll" loud and clear.

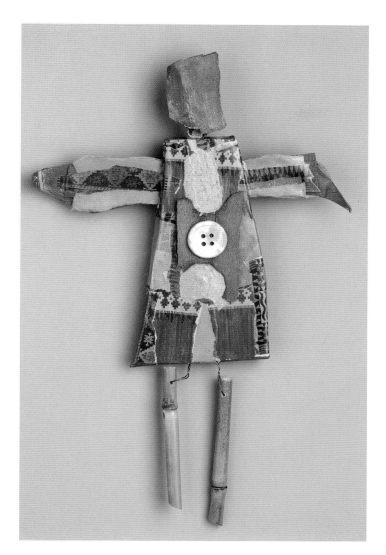

Hands and Feet

Hands and feet are another area where I get stuck because I don't draw well, especially not hands. Like faces, you can pretty easily find hand images in clothing catalogs or fashion magazines. You can also find many feet shod in the latest fashions. However, like faces, it doesn't take much to imply a hand or a foot. Put an object on the end of a limb, and it reads "hand" or "foot," as you can see from many of the examples.

Ingrid Dijkers goes in the more literal direction and sculpts hands and feet as well as other doll parts. She then makes molds from the original models and casts them in clay, fires them to a high temperature, and then finishes them with acrylic paint. Hers are truly mixed-media pieces, employing sewing techniques, collage, ceramics, and woodworking in one doll. Each set of doll parts is made in limited edition, and each doll is unique.

▲ **PAMELA HASTINGS:** Mixed media doll. Pamela Hastings's doll is made by sandwiching a popsicle stick between two pieces of foam core for the arms and body, which are then collages with photos from a rug catalog. The head is a pottery shard, and the legs are short lengths of tall grasses attached with wire to the foam core. No hands, no feet, no face, and still it reads "doll" loud and clear.

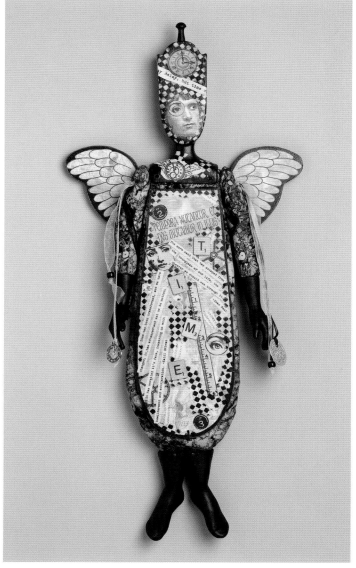

▶ **INGRID DIJKERS:** *Time.* Ingrid Dijkers develops the theme of time throughout this doll, including quotes, clocks, and wings (how time flies!). The doll's parts are made from ceramics, wood, fabric, and collage materials, as well as various embellishments.

Wings

What can I say about wings? They're everywhere! Angel wings, butterfly wings, and fairy wings are what I see most often. It's fun to make a doll into an angel, a butterfly, or a fairy, but beware of using wings as a default mode. If you're making wings for your doll, see if you can make them speak in new ways. What kinds of materials or imagery can you use for wings that will make them more personal or specific? Nothing wrong, of course, with just making a gorgeous set of wings. Butterflies, angels, and fairies make beautiful metaphors, but I suggest you push the envelope on your creativity a bit and see what unique or personal aspect you can bring to this most ubiquitous of appendages.

Simplify

How many parts does your doll need? One. See the "Your Basic Paper Doll" on page 121. Anything beyond that is gravy. If you start with this idea in mind, then you can't possibly feel intimidated about making dolls.

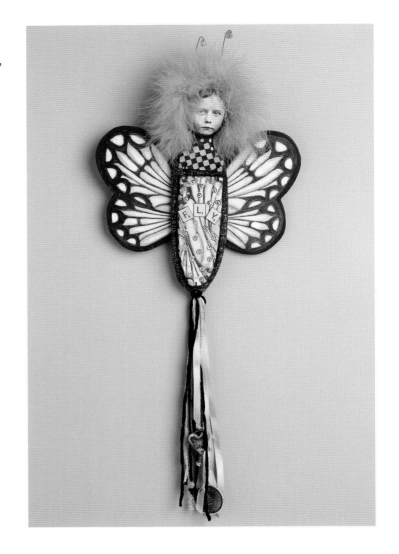

▲ **Ingrid Dijkers:** *Fly.*

◀ **Jane Davies:** Angel dolls, *Mandy* and *Venus.*
I made these paper angel dolls as greeting cards. Just fold in the arms and wings, write the greeting on the back, and stuff in an envelope. The angels will fly away from the post office and speak from the heart.

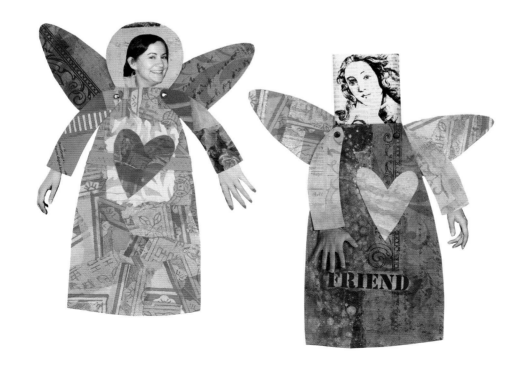

PROJECT: **YOUR BASIC PAPER DOLL**

Making a one-piece doll is about as basic as you can get, and yet a simple cutout doll can express so much. Look at Matisse's dancing cutout figures, for example. They couldn't be simpler, and yet they're full of joy and movement. I used Matisse's figure images as inspiration for these two paper dolls. Try one!

You'll need:

- Card stock, heavy paper, Bristol board, or cardboard. I used the card stock that comes in packages of printing paper. If you can find a piece of material to recycle into a doll, so much the better.
- Scrap paper for sketching
- Reference material and/or simply your imagination
- Scissors or a craft knife
- Acrylic paint and paint application tools (optional)
- Embellishments (optional)

1. If you're going to paint your card stock (or other doll material), go ahead and do this first. Paint both sides so that the card stock doesn't warp or curl.

2. Sketch some figure outlines either purely from your imagination or from reference material such as photos (magazines and clothing catalogs are abundant with figure images), illustrations, or the work of another artist whom you admire.

3. Choose one of your sketched figures and cut it out. Use it as a pattern to cut out the same shape from your painted card stock.

You could stop right here and call your doll finished, or you could add anything you want to it: a face, hair, clothing, jewelry, feathers, eyes, a crown, or tiara; you could put words on your doll, add buttons or beads, or give your doll something to hold—a book or a martini. You could also make multiple paper outfits for your doll, just like old-fashioned paper dolls, that attach with paper tabs. The possibilities are endless, and your time investment is minimal, so try a lot of different options and make a whole series of paper dolls! This is a great project to do with kids or in a group of adults.

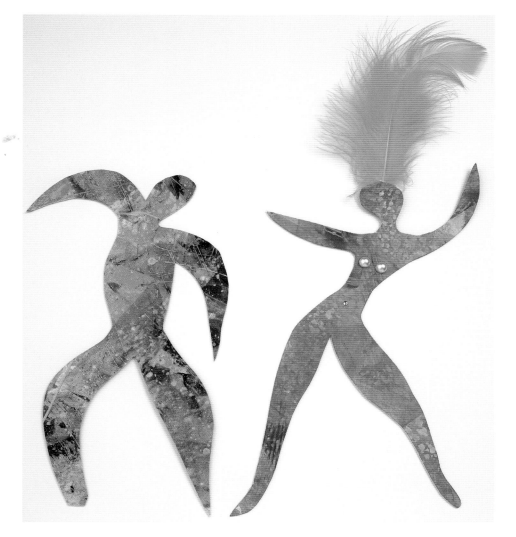

◄ These are my two one-piece dolls. The one on the left seemed not to require any embellishment. The one on the right has pearl breasts, a rhinestone belly button, and a feather hairdo.

PROJECT: JOINTED PAPER DOLL

It's not much of a step up from the one-piece paper doll to a jointed paper doll. We're still just dealing with paper, plus a bit of hardware. Unlike a one-piece doll, however, a jointed doll can express through body posture as well as embellishments. You can have your doll dancing, sitting, reclining, or doing yoga if you like. You can even put the limbs on backwards (add two right legs, or turn a hand facing up rather than down, for example) for even more possibilities.

You'll need:

- Template 12 (see page 139)
- Card stock, heavy paper, Bristol board, or cardboard
- Scissors or a craft knife
- An awl or pushpin for poking holes
- Brads or paper fasteners of your choice (and what a choice you can find if you look in scrapbooking supply stores!)
- Acrylic paint and paint application tools (optional)
- Embellishments (optional)

1. Paint your card stock if you like (see "Your Basic Paper Doll," page 121).

2. Make a template for the doll parts or use the one provided here and modify it to your liking.

3. Using the template, cut out the parts for your doll from the cardstock, painted or unpainted.

4. Poke holes with an awl or pushpin at the joints. (See photo **A**.)

5. Join the parts using brads. (See photo **B**.)

6. Clothe or otherwise embellish the doll to your heart's content!

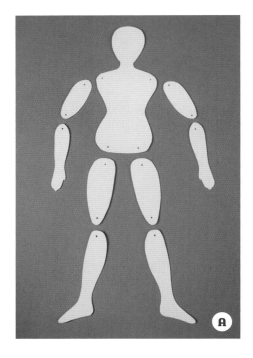

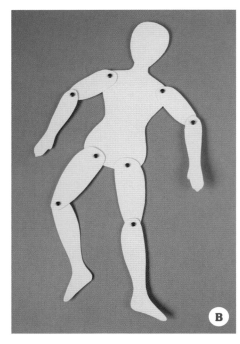

▶ I gave this exuberant gal a pleated paper 'do, a sequin headband, a rhinestone choker, and two big sequins for eyes.

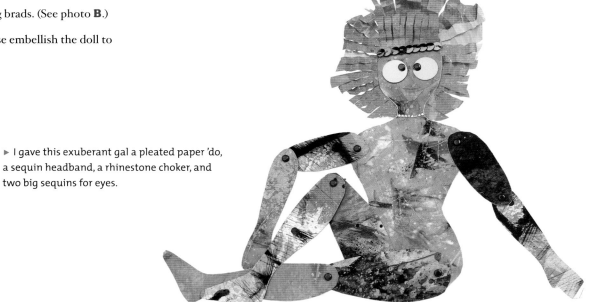

I've made my doll with shoulders, elbows, hips, and knee joints, but for more mobility you can add ankles and wrists by cutting out the hands and feet separately (leave enough overlap to allow room for the holes). You could even articulate the thumb joint or finger joints or give the waist mobility by cutting out the hips separate from the upper torso. For a dancer doll, you could articulate the feet, giving the ball of the foot a separate joint. The neck can also be jointed for a mobile head. If your doll isn't intended to represent the human figure plausibly, think of all the joints you could add! Lobster legs, jointed antennae, multiple limbs . . . there are no rules about this—it's just paper!

As you can see in the examples, brad-jointed dolls can be made by joining already-embellished pieces of card stock and paper. They don't have to have the traditional composition of a head, a torso, and four limbs. My "Pink Doll," for example, is made from torn pieces of color-collaged paper (see "Color Collage Papers," page 37) joined together at the "shoulders" to imply a figure. Pamela Hastings' "Stuff of Dreams" doll has only one brad joint, and that's at the elbow.

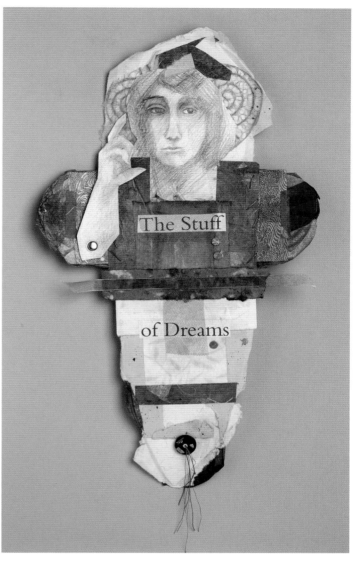

▲ **Pamela Hastings:** *The Stuff of Dreams.*

Pamela Hastings hand-rendered this portrait of Vita Sackville-West in colored pencil. The head and the forearm are all that's needed to make this paper collage into a highly expressive doll. I find the contrast of realistic drawing and abstract collage particularly effective.

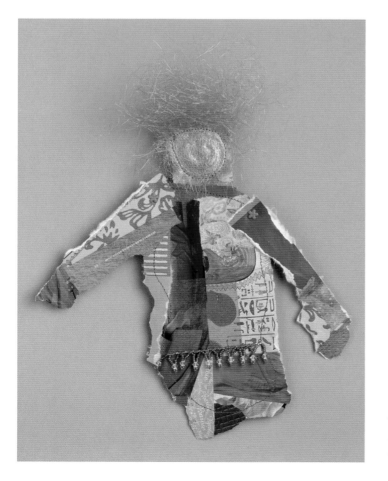

◄ **Jane Davies:** *Pink Doll.*

This doll is no more than a pink color collage with a couple of joints and an Angelina head. I added a little bead embellishment to the torso for a "skirt."

Tape-Jointed Doll

The tape-jointed doll is a modification of its brad-jointed cousin. The two are probably more like sisters, actually. I like this construction because the legs move back and forth while the arms move side to side. For this doll, I use the same basic template as for the brad-joint doll, but I modify the legs so that each is one piece rather two. I square off the tops of the legs and the bottom of the torso so that they meet flush together. You could, of course, add knee joints by doing the same with the lower legs and thighs. I use the same arm construction as for the brad-jointed doll, but this, too, could be modified if you want to use taped joints for the shoulders and elbows.

For my "Janno Doll" I began by preparing the parts as shown for the Basic Jointed Doll. I painted the parts a flesh color with acrylic paint on both sides so they wouldn't warp and then began to clothe the doll before assembling it with brads. I wrapped the torso in hand-painted purple tissue paper and made sleeves out of torn lokta paper. I used a favorite photo of Janno for the face. At that point I assembled the doll and continued to add torn paper, lace, ribbons, etc. for the clothing and headgear.

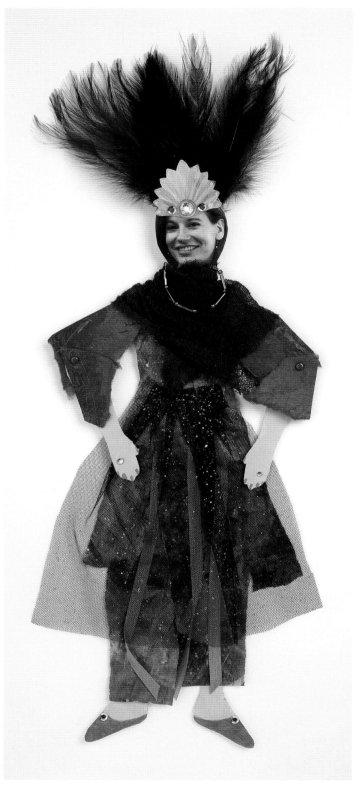

▲ **JANE DAVIES:** *Queen Janno of the Royal Purple.*

I made this doll portrait of my friend Janno to experiment with clothing and headgear options on a taped-joint doll. If you don't know where to start in doll making, make a portrait of your best friend or a family member. It's not only really fun to do, but it also gives you a focus and intention for your project.

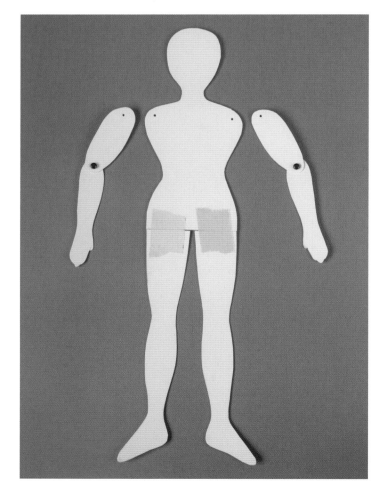

PROJECT: STICK CONSTRUCTION DOLL

The stick doll is a construction technique I learned from Pamela Hastings. Like the other construction techniques described above, it's super-simple and yet offers infinite opportunity for expression and creativity. Basically it consists of a horizontal stick that represents the arms, a torso that's folded over the stick, and a head attached at the back. Legs, hands, and other features are optional.

You'll need:

- Paper, hand-painted or otherwise (I used my hand-painted brown paper bag paper)
- A paintbrush or other suitable stick
- Scraps of tissue paper, hand-painted or otherwise
- A little bird's nest of Angelina or other fiber or yarn for the hair
- A small piece of fabric paper or felt, about 1½ x 3 inches
- A small piece of Ultrasuede the same size as the felt, or another piece of felt
- A face: I used a commercial rubber mold to make a face out of PaperClay modeling compound and painted it with acrylic. See "Faces," page 118, for other ideas
- Beads for embroidering around the face and beading supplies (optional)
- Any embellishments that you care to incorporate into your stick doll. Think jewelry, symbolism, clothing, etc.

1. For this doll, I used an old paintbrush as the stick and some of my hand-painted papers for the torso. The head is made from a scrap of fabric paper (see "Making a Sheet of Fabric Paper," page 92) sewn to a piece of Ultrasuede with Angelina fiber hair sandwiched in between. Fold your paper and cut it into a long, skinny triangle (a diamond when unfolded). The fold should fit over the paintbrush to form "shoulders" in a pleasing proportion.

2. Tear some strips of tissue paper, and glue them to the wrong side of the paper diamond so that the edges overhang by about ½ inch. This part is decorative, not structural, so arrange the tissue papers as you like. You could even cut fringe or fold pleats in it, though I chose to leave the randomly torn edges as is. (See photos **A** for the right side and **B** for the wrong side.)

A

B

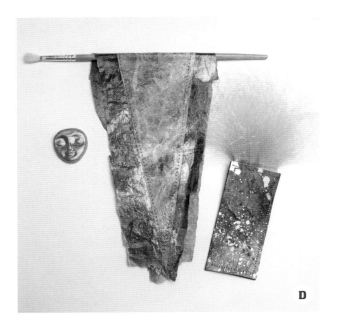

D

E

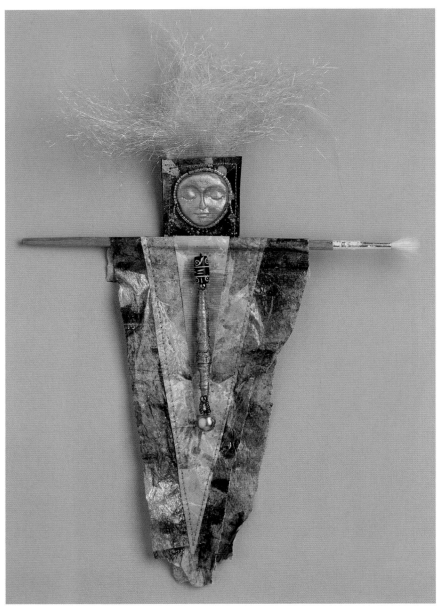

3. This step is optional. Hand- or machine-stitch a decorative line around the edge of your diamond-shaped paper, or do any decorative stitching you choose.

4. Fold the paper over the paintbrush and glue in place. (See photo **C**.)

5. To make Angelina fiber hair, arrange a tuft of fiber on a sheet of baking parchment so that the fibers are all going in roughly the same direction. Place another sheet of parchment on top of the fibers and iron one end of the tuft, leaving the rest loose. Fold over the rough edges on the sides and iron again (see "Angelina Fiber and Film," page 77). I chose pink Angelina fiber for my doll's hair (photo **D**), but you could use yarn, thread, silk or SoySilk fibers, paper, or many other materials and use the same technique of sandwiching it between the two parts of the head piece.

6. Sandwich the fused part of the hair between the two rectangles of fabric paper/Ultrasuede/felt, and machine-stitch around the edge. You can make the bond even stronger by adding a dab of glue in the sandwich before stitching.

7. Glue the face to the front side of the head piece, and bead-embroider around it if you like. (You can also do this step before assembling the head piece.)

8. Glue the head piece to the back of the doll. Add any embellishments to the front, arms, head, etc. that you like.

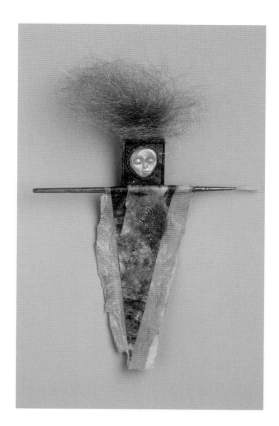

▲ This is another paintbrush doll made with similar materials. She has a fused fiber and wire embellishment on the bodice.

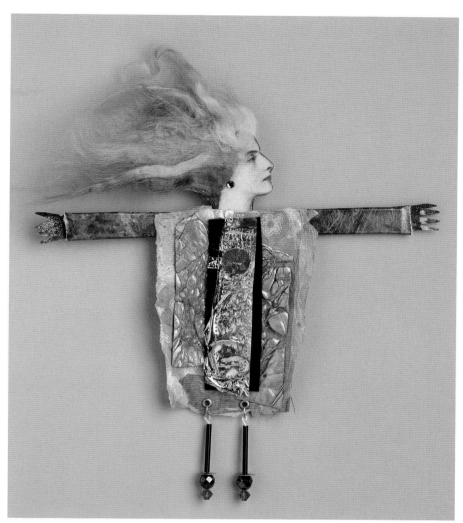

▶ **JANE DAVIES:** *Wicked Witch of Branded Products.*

Her arms are made from a long, skinny rectangle of matboard covered in hand-painted tissue paper. The torso is a piece of fabric paper folded over the stick and collaged and stitched with bits of Angelina fabric, Tyvek, a strip of Ultrasuede, and a "button" of fusion fabric. The hair is SoySilk. How many branded products could I get into one mixed-media doll? Hanging beaded legs from eyelets is a good doll technique to have up your sleeve.

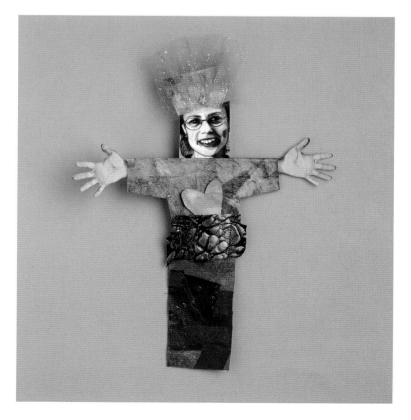

▶ **JANE DAVIES:** *Self-Portrait Doll.*

For my self-portrait doll, I not only used an altered photograph for the face, but I used printouts of my own hands, which I'd scanned and reduced. The clothing is pure whimsy, including hand-painted papers, a scrap of fusion fabric, a piece of Tyvek painted and ironed, and a piece of pleated glitter tulle for the headgear.

Template 1

OVAL BAG
Enlarge 220%

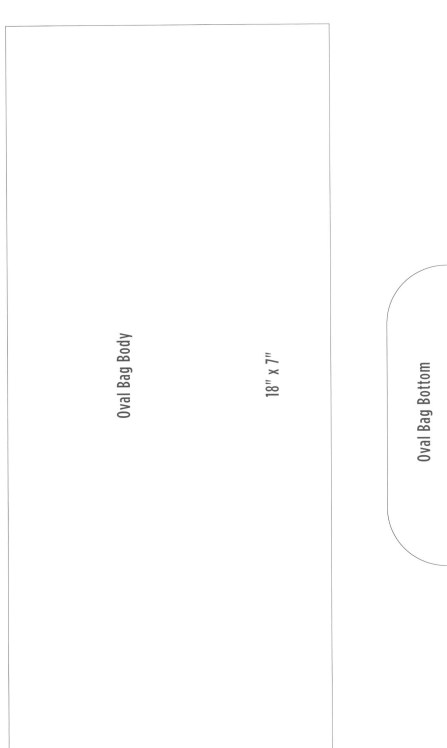

Oval Bag Body

18" x 7"

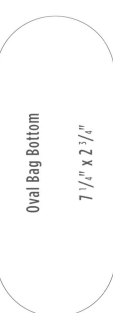

Oval Bag Bottom

7 1/4" x 2 3/4"

Template 2

PURSE-SHAPED BAG

Enlarge 140%

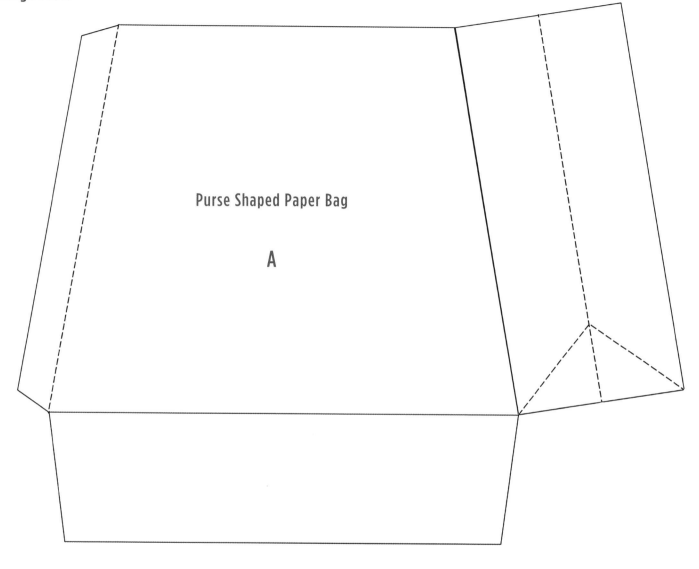

Purse Shaped Paper Bag

A

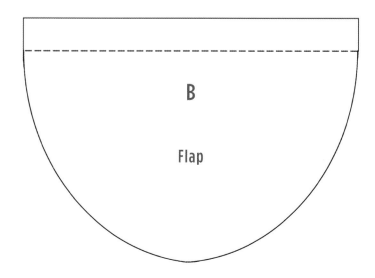

B

Flap

Template 3

BOX-WITHIN-A-BOX
Enlarge 250%

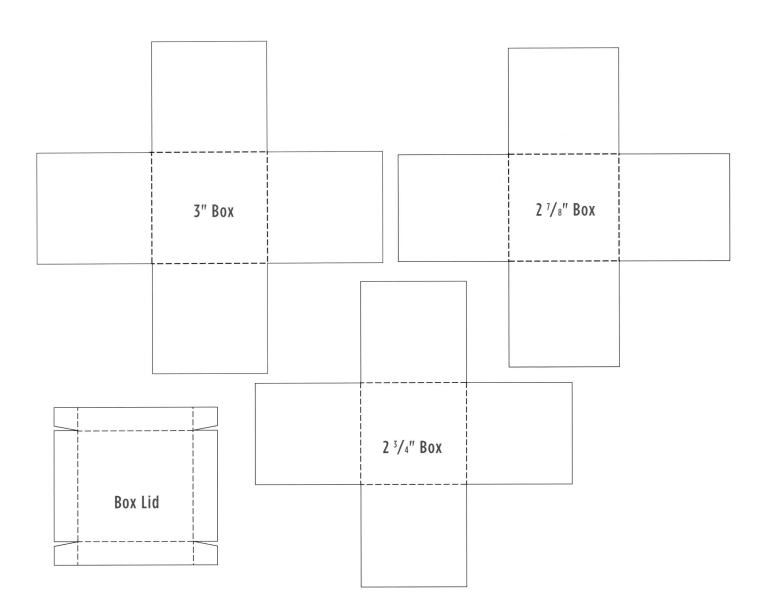

3" Box

2 $^7/_8$" Box

Box Lid

2 $^3/_4$" Box

Template 4

ACCORDION-PURSE BOOK COVER

Enlarge 160%

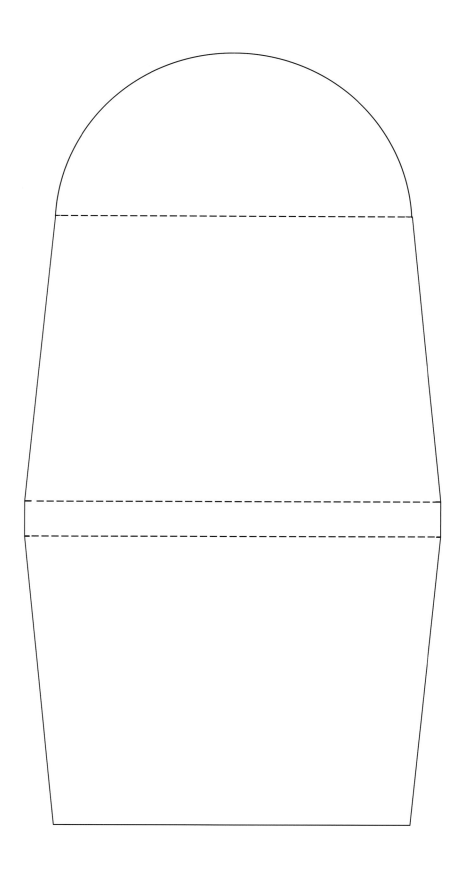

GIFT BOX
Enlarge 140%

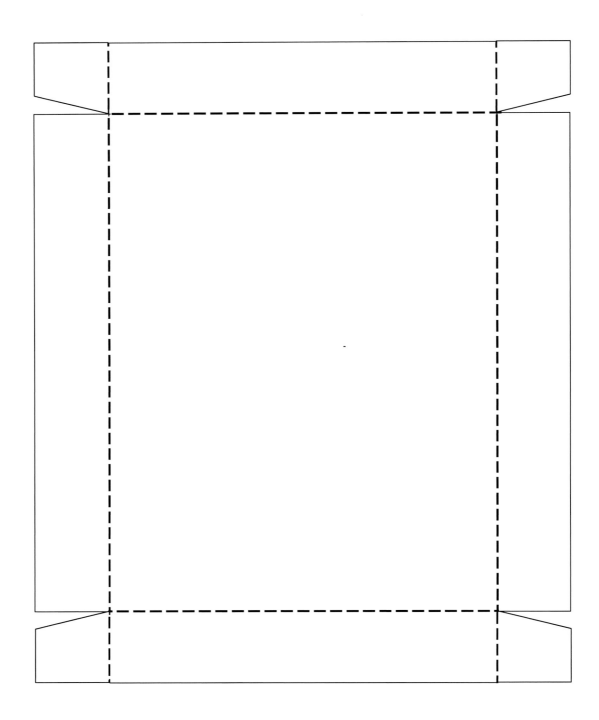

Template 6

MESSAGE BOX

Enlarge 130%

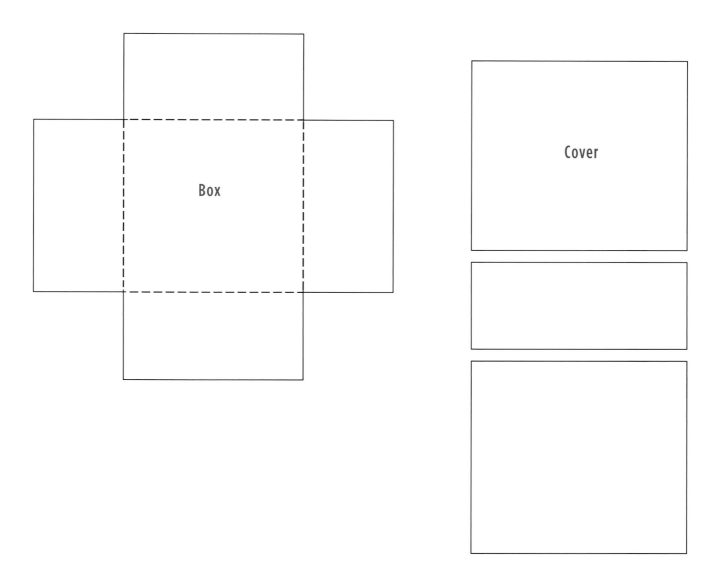

FUSION FABRIC FAN
Enlarge 200%

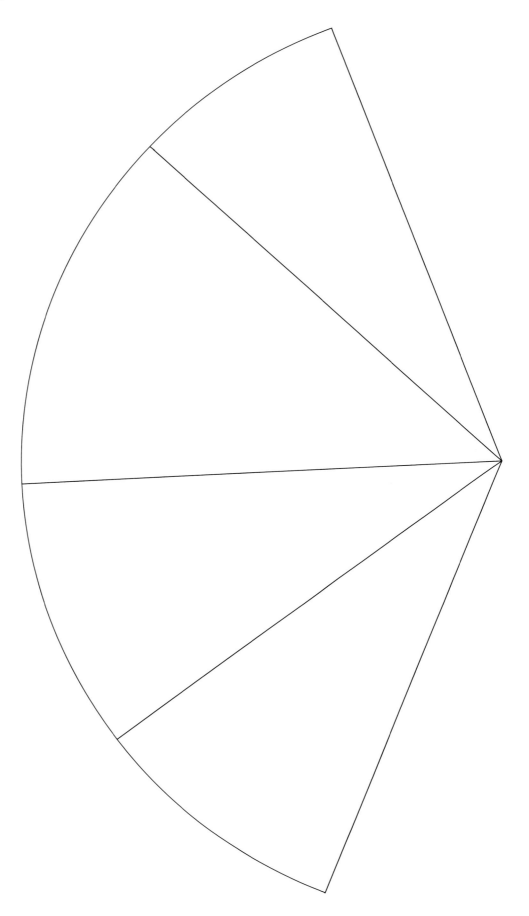

Template 8

FUSION FABRIC BOX

Enlarge 170%

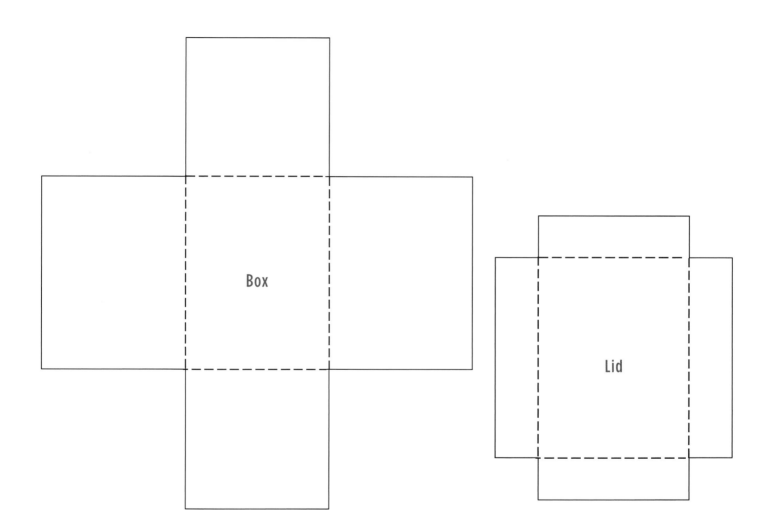

Box

Lid

FUSED FIBER VESSEL
Enlarge 180%

Template 10

BIRD ORNAMENT

Enlarge 100%

Template 11

SPIRIT HOUSE OR SHRINE
Enlarge 200%

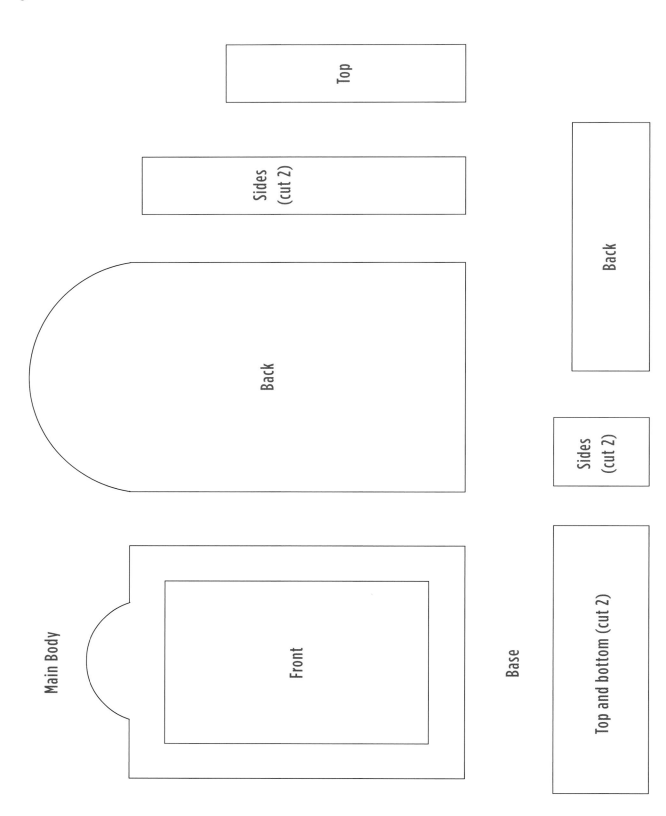

Top

Sides (cut 2)

Back

Back

Sides (cut 2)

Main Body

Front

Base

Top and bottom (cut 2)

Template 12

JOINTED PAPER DOLL
Enlarge 180%

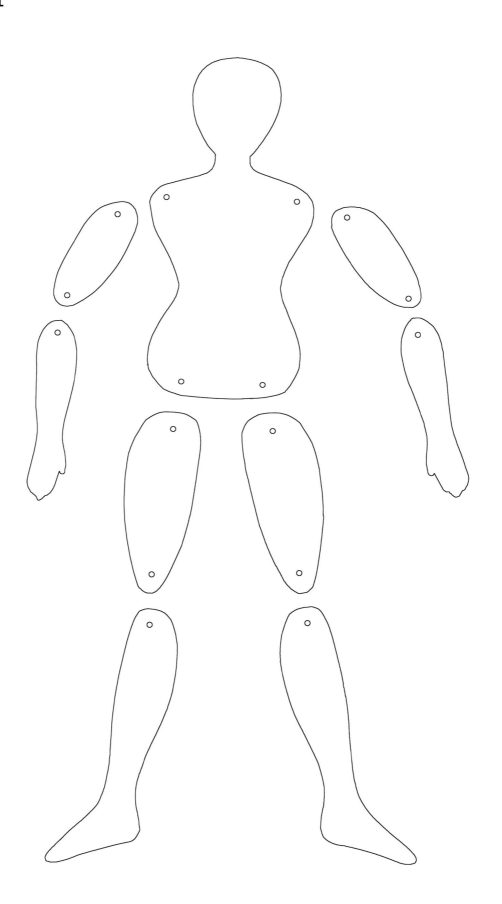

Contributing Artists

Jill Abilock
jabilock@japanlink-trans.com

Sue Bleiweiss
http://threecreativestudios.com/
http://suebleiweiss.com/blog/

Elissa Campbell
http://blueroofdesigns.com/
http://blueroofdesigns.com/blog/

Ingrid Dijkers
http://www.ingriddijkers.blogspot.com/
http://www.ingriddijkers.com/

Pamela Hastings
http://www.pamelahastings.com/
http://pamelasjournal.blogspot.com/

Autumn Hathaway
http://www.autumnhathaway.com/
http://autumnhathaway.blogspot.com/

Sherrill Kahn
http://www.impressmenow.com/

Carol Owen
http://www.carolowenart.com/

Dawne Polis
http://quiddity2.blogspot.com/

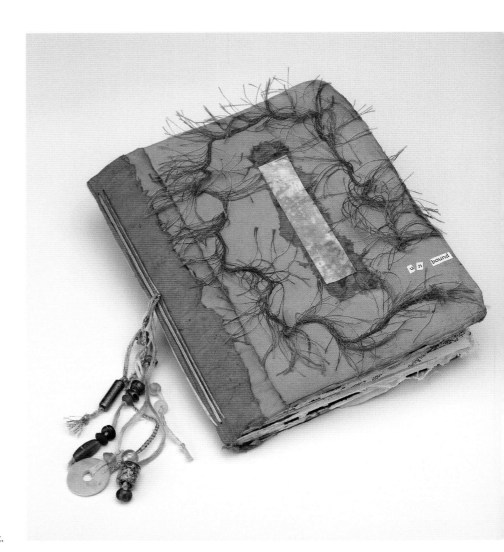

▶ **JILL ABILOCK:** softcover book.

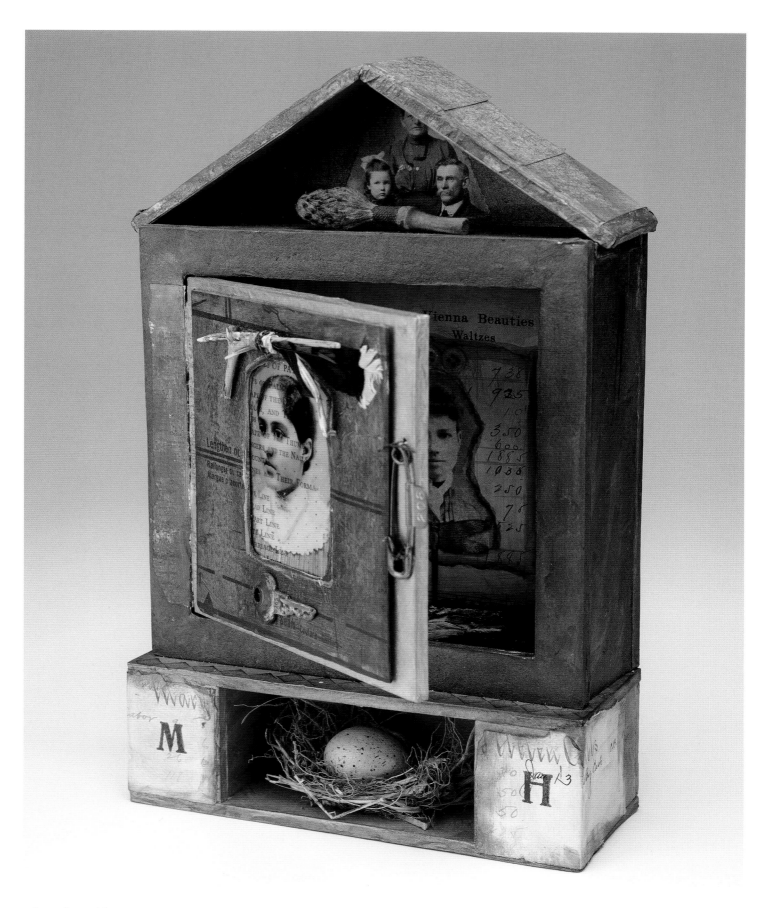

▲ **Carol Owen:** *Vienna.*

Resources

There are so very many sources—both online and bricks and mortar—for art, craft, and mixed-media supplies that it would be fruitless to try to make a comprehensive list. In addition to retail stores that have multiple locations and carry a wide range of products, I've listed some my favorite mail-order sources, which I generally rely on because I live in a rural area.

Dick Blick Art Materials

www.dickblick.com

Same great stock of basic art materials and supplies as Utrecht, plus:

- ExtravOrganza printable organza and other ink-jet printable materials such as cotton, vellum, and clear acetate
- Japanese rice papers, such as Hosho, Kozo, and Unryu
- PaperClay, polymer clay, and many other modeling materials
- Craft wire and tools
- Some decorative papers

Fire Mountain Gems

www.firemountaingems.com

Fire Mountain Gems carries a huge variety of beads, including seed beads in most sizes and more colors than you can imagine, bugle beads, all kinds of crystal beads, gemstone and glass beads, and many others. They also carry rhinestones of all sorts, and a wide variety of beading and jewelry-making materials, tools, and accessories. There are plenty of good bead suppliers on the Web, but what I like about Fire Mountain is that they offer loads of free information on their site, including tips and tutorials, charts, their EncycloBEADia, a beading dictionary, and much more. You can even "ask the experts" by sending in a question via e-mail and view questions and answers by topic.

Hollander's

www.hollanders.com

My other favorite source for decorative paper, especially patterned papers. Hollander's carries lokta paper in many colors as well as prints and textures. The solid colors are mostly "text weight," which is somewhere between the heavyweight and lightweight, and very good for the projects in this book.

Joggles

www.joggles.com

- SoySilk, silk roving, fibers and specialty threads, embroidery floss, yarns
- PaperClay, polymer clay, and other modeling materials, molds, and tools
- Fabric, including felts, sheers, and specialty fabrics
- Interfacing and stabilizers, including Timtex
- Fusible webs, including Mistyfuse
- Angelina fiber and film
- Tyvek sheets
- ExtravOrganza printable organza and other ink-jet printable fabrics
- Ultrasuede in 8½-inch squares, which is much more affordable than buying it by the yard

Kandra's Beads

www.kandrasbeads.com

I first came across Kandra's Beads when searching for crystal rivolis (crystal stones faceted to a point; these aren't beads but super-sparkly embellishments). Kandra's not only carries an unusual variety of crystal rivolis but a great selection of seed beads, glass beads, bugle beads, and many others.

The Paper Studio

www.paperstudio.com

This is one of my favorite sources of decorative papers, including heavyweight lokta in a nice range of colors and patterns. They also carry a wide variety of excellent bookbinding paper craft supplies.

Royalwood

www.royalwoodltd.com

Royalwood is primarily a basket-making supplier, but they carry the best selection of waxed linen thread that I've ever found. They offer it in over thirty colors and several thicknesses. I find it the best choice for bookbinding.

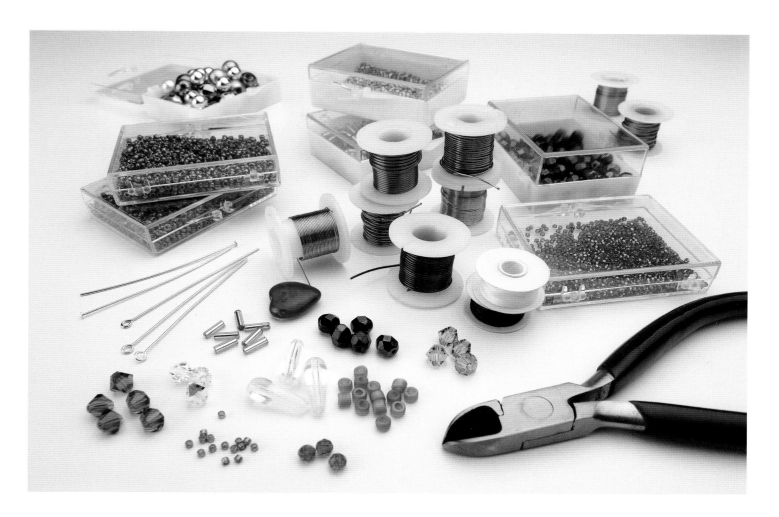

Thread Art

www.threadart.com

- Machine-sewing thread in a huge variety of colors and fibers, including rayon, polyester, cotton, metallic, sparkle, and multicolor
- Sewing tools and supplies

Utrecht

www.utrechtart.com

- Paint of all sorts, including artist- and student-grade acrylics and watercolors
- Inks
- Brushes, palette knives, palettes, and other painting tools
- Foam core, illustration board, matboard
- Acrylic matte medium and other painting media
- Your basic paper and inexpensive drawing paper, as well as many other fine art papers
- Bookbinding supplies
- PVA and other adhesives

General Crafts Supplies

A.C. Moore Arts & Crafts

www.acmoore.com

Ben Franklin

www.benfranklin.com

Hobby Lobby

www.hobbylobby.com

Jo-Ann Fabric and Crafts

www.joann.com

Michaels

www.michaels.com

Index

Note: Page numbers in *italics* indicate projects and templates.